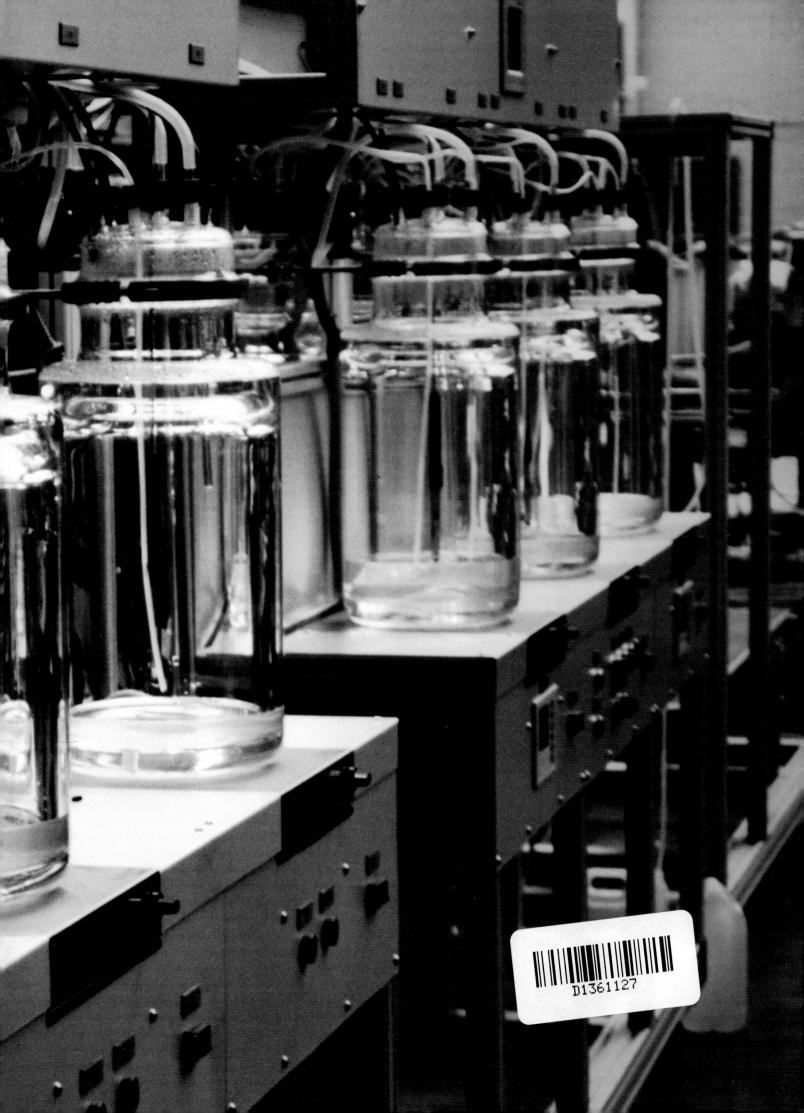

Wim Delvoye
Studies for Cloaca (1997-2006)

Published in 2007
Designed by *Wim Delvoye*
Copy-editing by *Gianni Degryse*
Photo engravure by *Cassochrome*
Printed by *C&C Offset Printing Co., Ltd.*
Edited by *Rectapublishers*

Contact : info@cloaca.be

ISBN 9789080721746
D/2007/10.742/7
Printed in China

WIM DELVOYE
Studies for Cloaca

(1997-2006)

Studies for Cloaca Original

1997-2001

1998, 65 X 50 CM (29 5/8 X 19 5/8 INCHES), PENCIL & COLOUR PENCIL ON PAPER
(PRIVATE COLLECTION, BELGIUM)

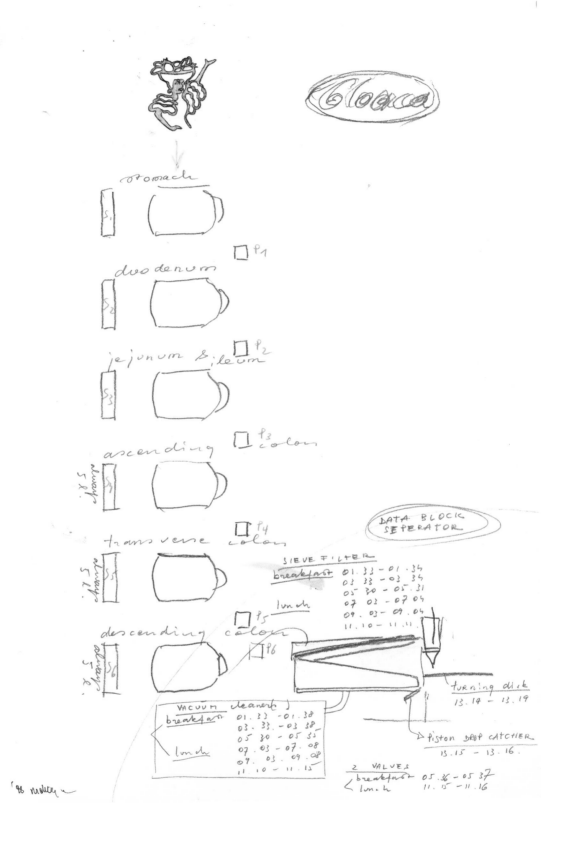

1998 – 1999, 65 X 50 CM (29 5/8 X 19 5/8 INCHES), PENCIL & COLOUR PENCIL ON PAPER
(PRIVATE COLLECTION, BELGIUM)

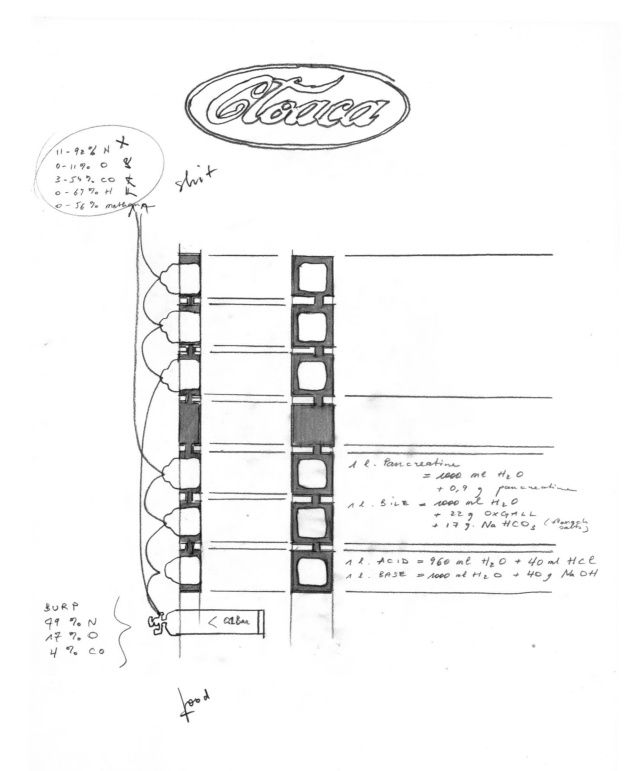

1999, 65 X 50 CM (29 5/8 X 19 5/8 INCHES), PENCIL & COLOUR PENCIL ON PAPER
(PRIVATE COLLECTION, BELGIUM)

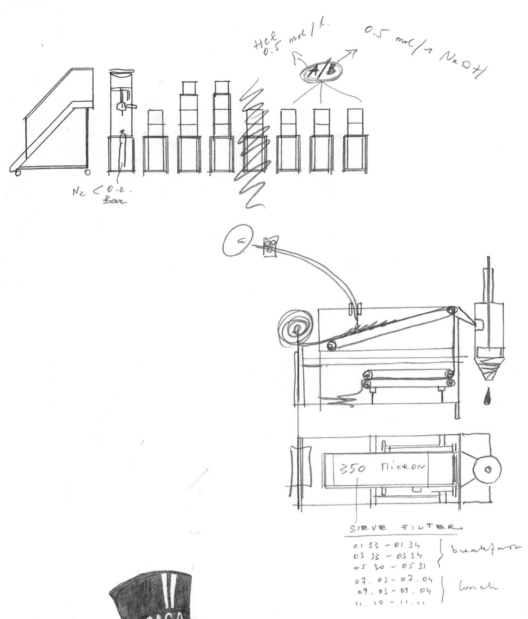

1999, 65 X 50 CM (29 5/8 X 19 5/8 INCHES), PENCIL ON PAPER
(PRIVATE COLLECTION, BELGIUM)

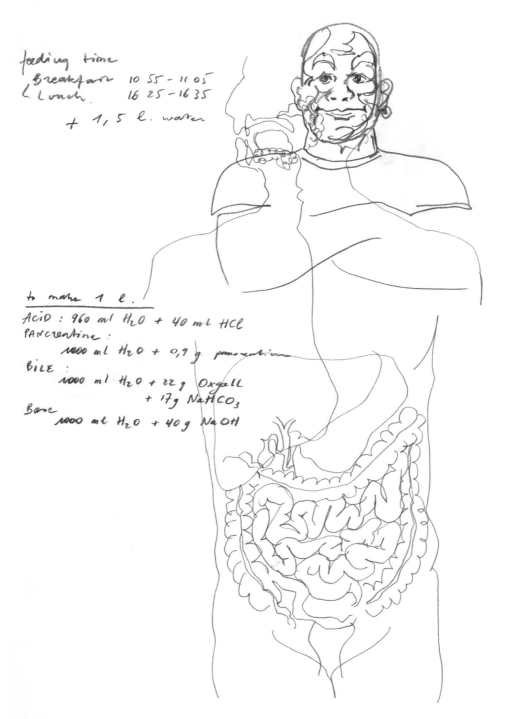

feeding time
Breakfast 10 55 - 11 05
L Lunch. 16 25 - 16 35
 + 1,5 l. water

to make 1 l.
ACID : 960 ml H_2O + 40 ml HCl
PANcreatine :
 1000 ml H_2O + 0,9 g. pancreatine
BiLE :
 1000 ml H_2O + 22 g Oxgall
 + 17 g $NaHCO_3$
Base
 1000 ml H_2O + 40 g NaOH

1999

1999, 43 X 56 CM (16 7/8 X 22 INCHES), PENCIL, COLOUR PENCIL & MARKER ON PAPER
(COLLECTION FLEMISH COMMUNITY, BELGIUM)

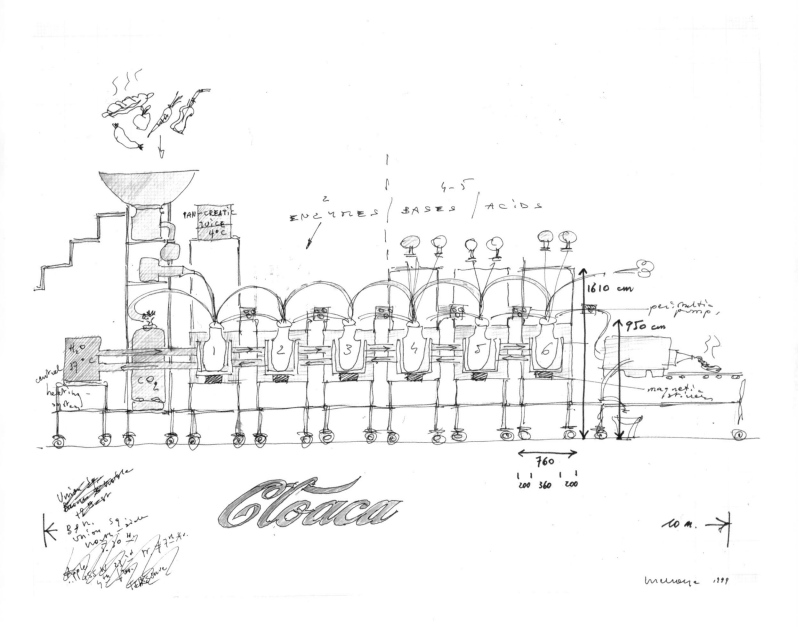

1999, 43 X 56 CM (16 7/8 X 22 INCHES), PENCIL, COLOUR PENCIL & MARKER ON PAPER
(COLLECTION FLEMISH COMMUNITY, BELGIUM)

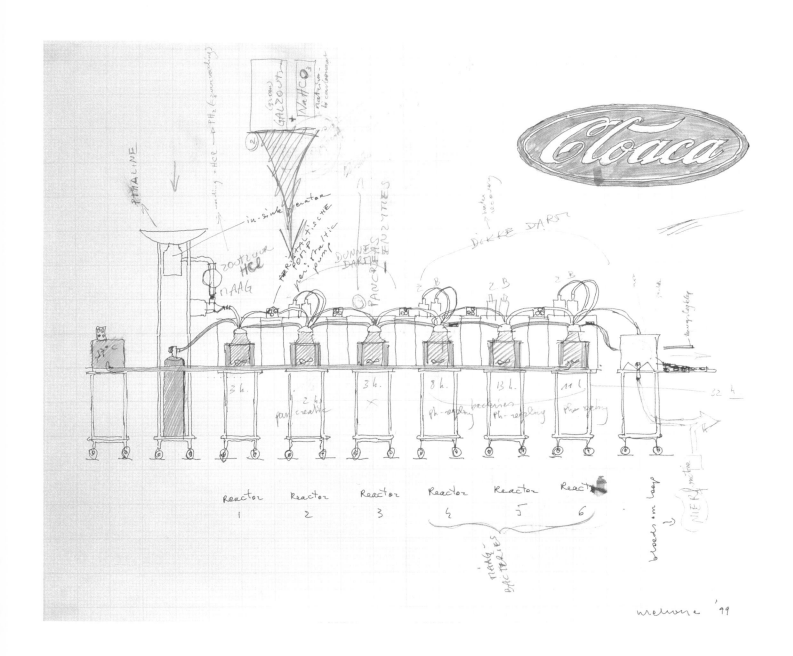

1999, 43 X 56 CM (16 7/8 X 22 INCHES), PENCIL, COLOUR PENCIL, MARKER & BALLPOINT ON PAPER
(COLLECTION FLEMISH COMMUNITY, BELGIUM)

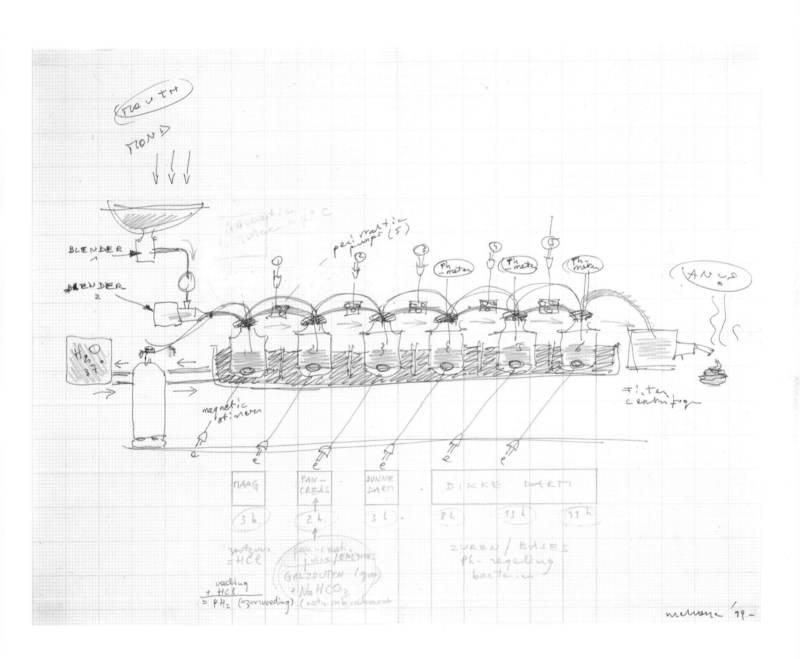

1999, 43 X 56 CM (16 7/8 X 22 INCHES), PENCIL, COLOUR PENCIL, MARKER & BALLPOINT ON PAPER
(COLLECTION FLEMISH COMMUNITY, BELGIUM)

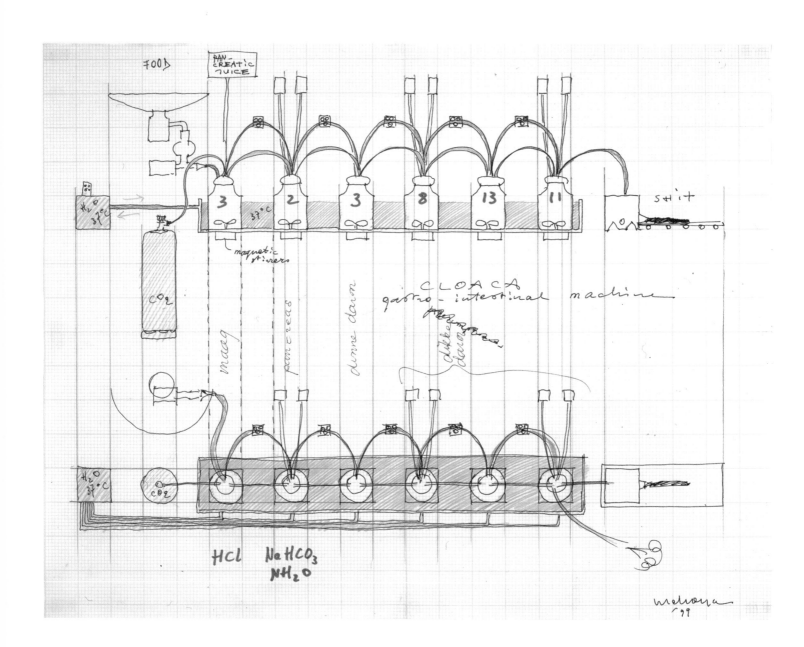

1999, 43 X 56 CM (16 7/8 X 22 INCHES), PENCIL, COLOUR PENCIL, MARKER & BALLPOINT ON PAPER
(COLLECTION FLEMISH COMMUNITY, BELGIUM)

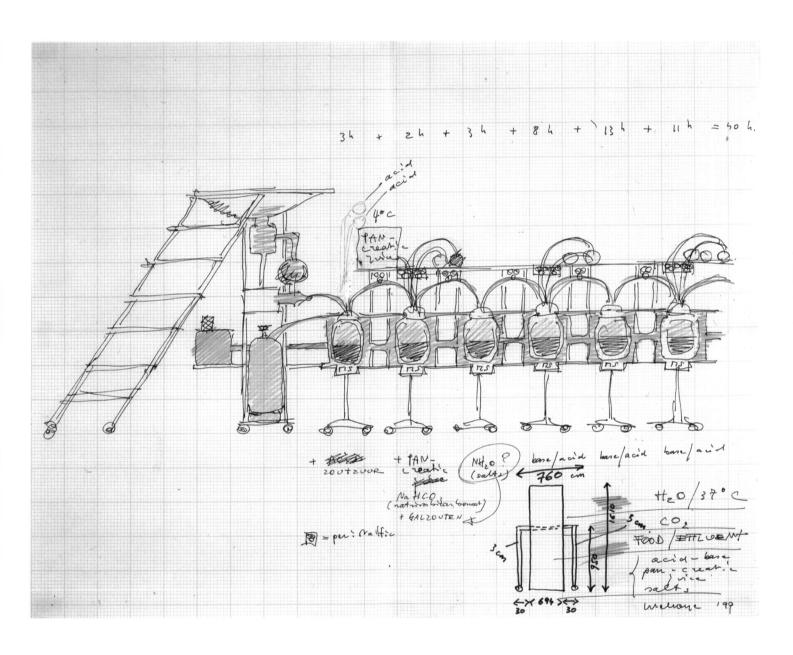

1999, 43 X 56 CM (16 7/8 X 22 INCHES), PENCIL, COLOUR PENCIL, MARKER & BALLPOINT ON PAPER
(COLLECTION FLEMISH COMMUNITY, BELGIUM)

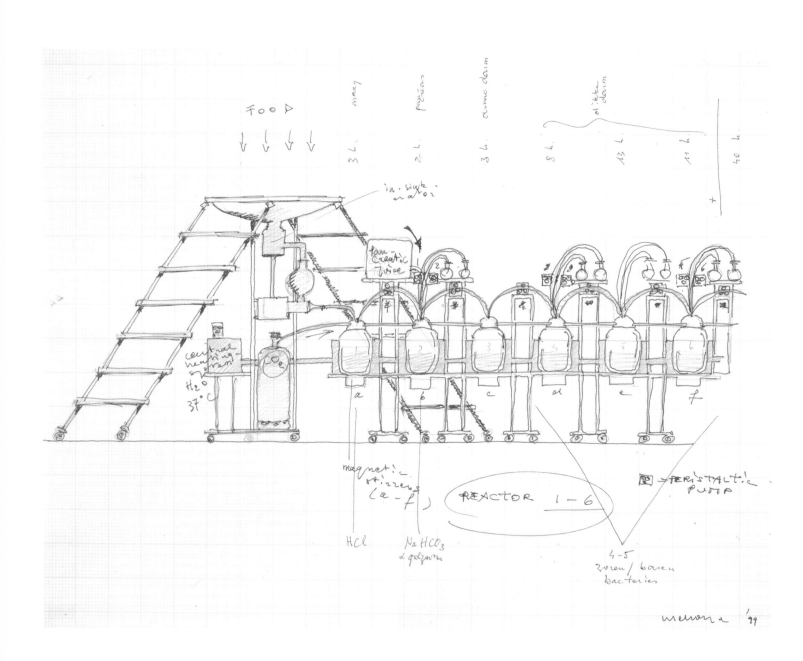

1999 – 2001, 29.5 X 41.8 CM (11 5/8 X 16 1/2 INCHES), COLOUR PENCIL, WATERCOLOUR & MARKER ON PAPER
(COLLECTION JAN BOSCHMANS, BELGIUM)

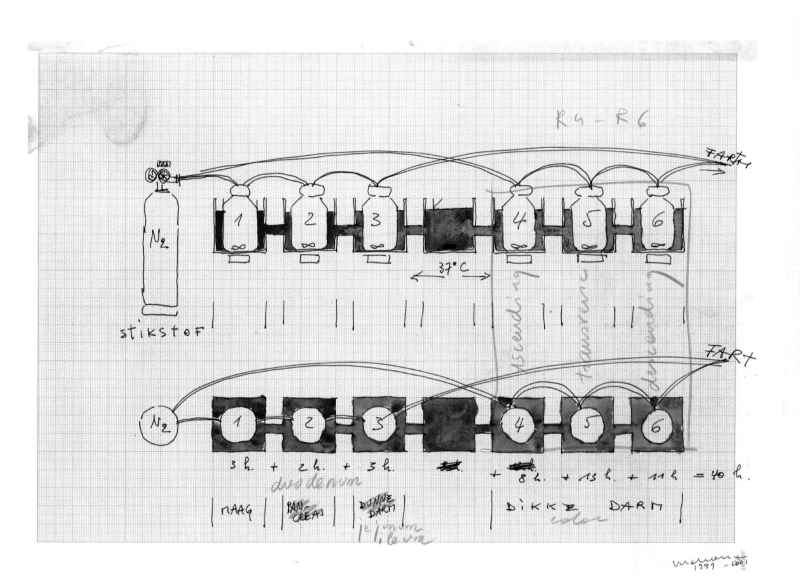

1999 – 2001, 29.5 X 41.8 CM (11 5/8 X 16 1/2 INCHES), COLOUR PENCIL, WATERCOLOUR & MARKER ON PAPER
(COLLECTION JAN BOSCHMANS, BELGIUM)

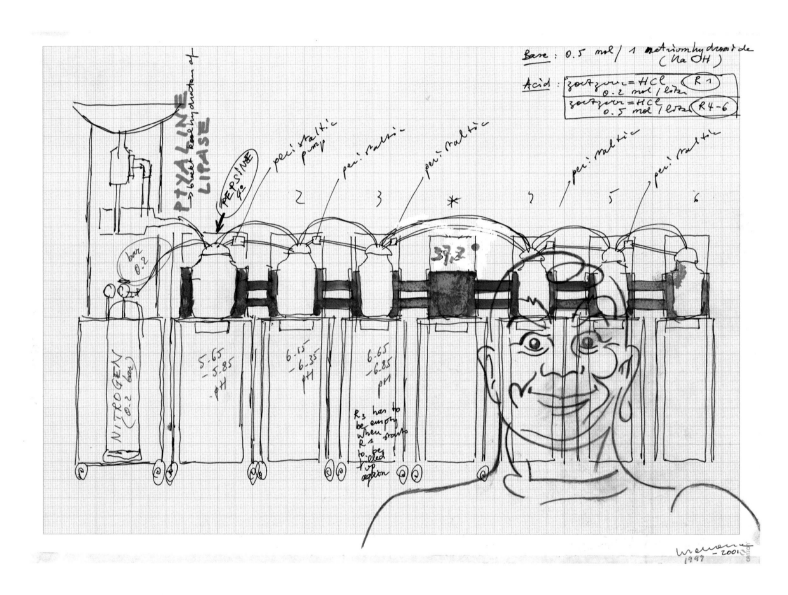

1999 – 2001, 29.5 X 41.8 CM (11 5/8 X 16 1/2 INCHES), COLOUR PENCIL, WATERCOLOUR & MARKER ON PAPER
(COLLECTION JAN BOSCHMANS, BELGIUM)

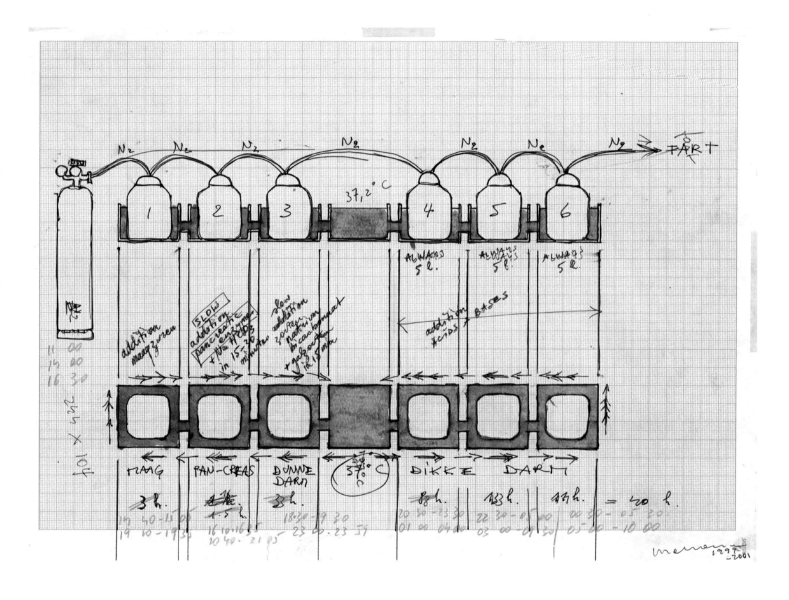

2000, 23.5 X 46 CM (9 1/4 X 18 1/8 INCHES), PENCIL, COLOUR PENCIL, MARKER & STAMP INK ON PAPER
(PRIVATE COLLECTION, BELGIUM)

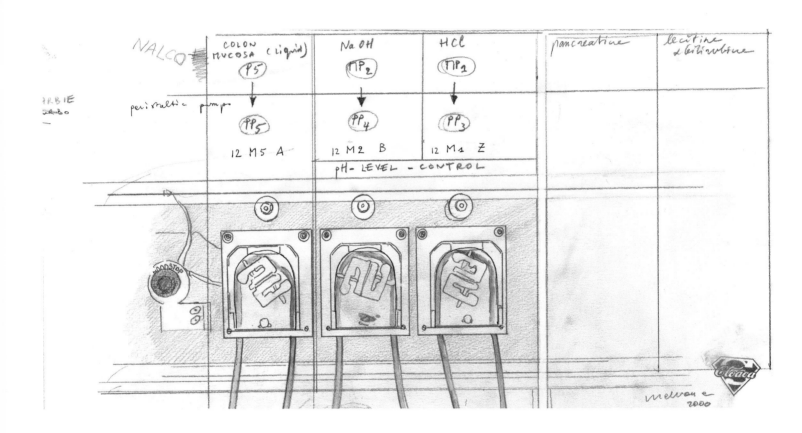

2000, 65 X 50 CM (29 5/8 X 19 5/8 INCHES), PENCIL & COLLAGE ON PAPER
(PRIVATE COLLECTION, BELGIUM)

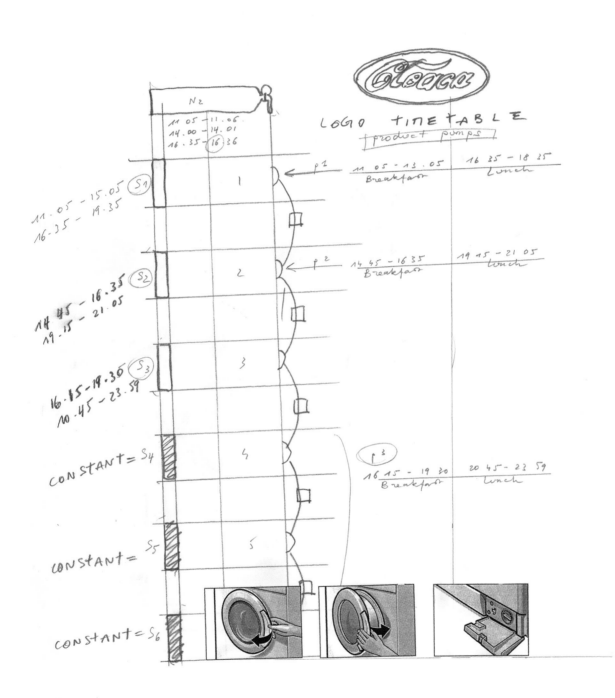

LOGO TIMETABLE

product pumps

2000

2000, 65 X 50 CM (29 5/8 X 19 5/8 INCHES), PENCIL & WATERCOLOUR ON PAPER
(PRIVATE COLLECTION, BELGIUM)

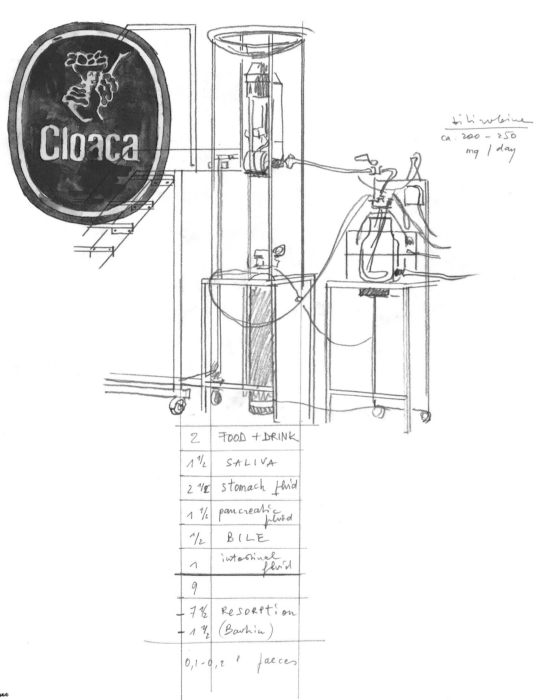

bilirubine
ca. 200 – 250
mg / day

2	FOOD + DRINK
1½	SALIVA
2½	stomach fluid
1½	pancreatic fluid
½	BILE
1	intestinal fluid
9	
– 7½	RESORPTION
– 1½	(Bauhin)
0,1 – 0,2 l	faeces

1997 – 2001, 62 X 43 CM (24 3/8 X 16 7/8 INCHES), PENCIL, WATERCOLOUR & MARKER ON PAPER
(PRIVATE COLLECTION, BELGIUM)

2 l.
FOOD/DRINK

DRINK

1,5 l.
SALIVA

2,5 l.
STOMACH
FLUID

1,5 l.
PANCREATIC
fluid

PANCREATIC
JUICE

0,5 l.
BILE

BILE

1 l.
INTESTINAL
FLUID

9 l.
—7,5 l. RESORPTION
—1,5 l. klep Bauhin

0,1 – 0,2 l.
FAECES

2,5 l.
stomach
-juice

BAUHIN

Na 30

1997 – 2001, 62 X 43 CM (24 3/8 X 16 7/8 INCHES), PENCIL & MARKER ON PAPER
(COLOUR PENCIL & STAMP INK, 2006) (PRIVATE COLLECTION, BELGIUM)

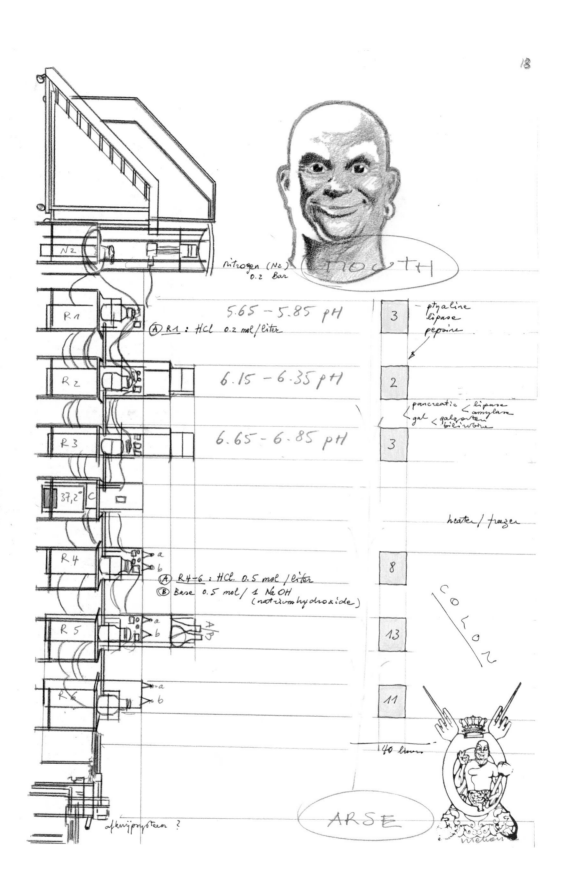

18

nitrogen (N2)
0.2 Bar

MOUTH

N2

R1 5.65 – 5.85 pH
Ⓐ R1 : HCl 0.2 mol/liter

3	ptyaline
	lipase
	pepsine

R2 6.15 – 6.35 pH

| 2 |

pancreatic < lipase
 < amylase
gal < galzouten
 < bilirubine

R3 6.65 – 6.85 pH

| 3 |

37,2° C

heater/frozen

R4
a
b
Ⓐ R4-6 : HCl 0.5 mol/liter
Ⓑ Base 0.5 mol/ 1 NaOH
 (natriumhydroxide)

| 8 |

R5
a
b

| 13 |

COLON

R6
a
b

| 11 |

140 liter

afknijpsysteem ?

ARSE

1997 – 2001, 62 X 43 CM (24 3/8 X 16 7/8 INCHES), PENCIL, WATERCOLOUR & MARKER ON PAPER
(COLOUR PENCIL & STAMP INK, 2006)

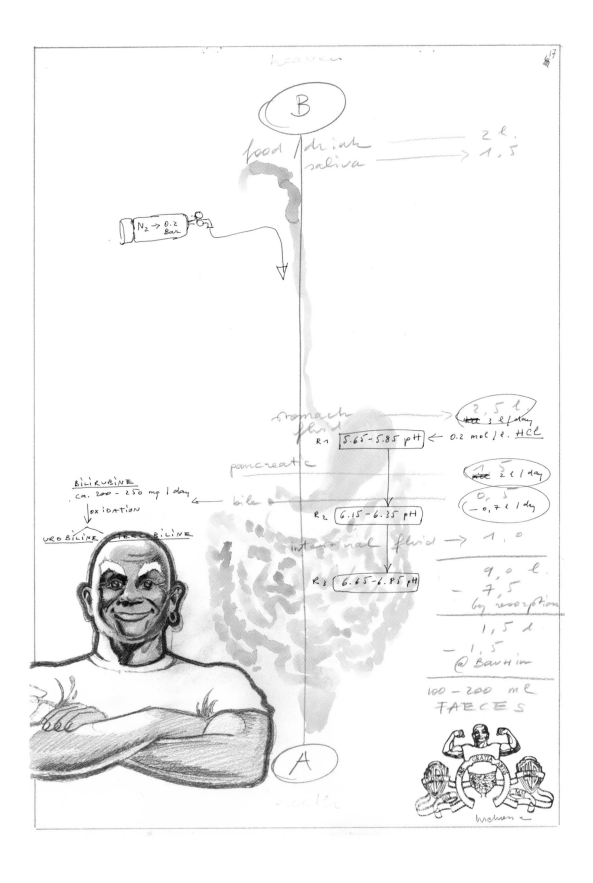

1997 – 2001, 62 X 43 CM (24 3/8 X 16 7/8 INCHES), PENCIL, COLOUR PENCIL & WATERCOLOUR ON PAPER
(PRIVATE COLLECTION, BELGIUM)

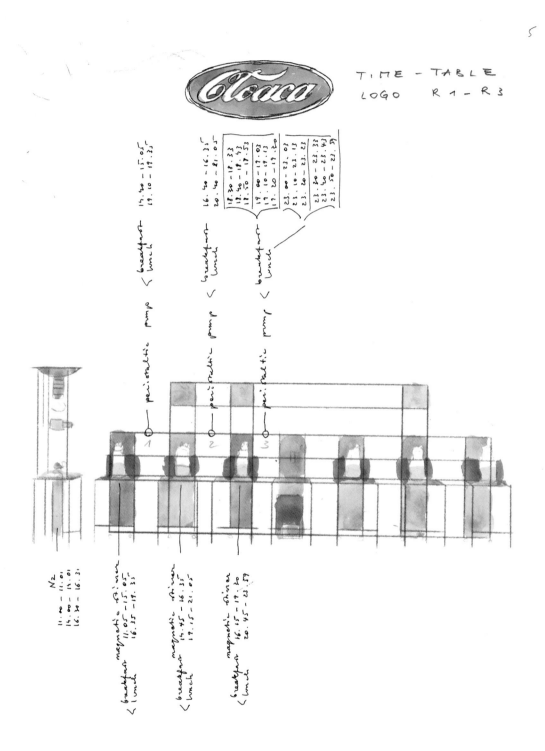

1997 – 2001, 62 X 43 CM (24 3/8 X 16 7/8 INCHES), PENCIL, WATERCOLOUR & MARKER ON PAPER
(PRIVATE COLLECTION, BELGIUM)

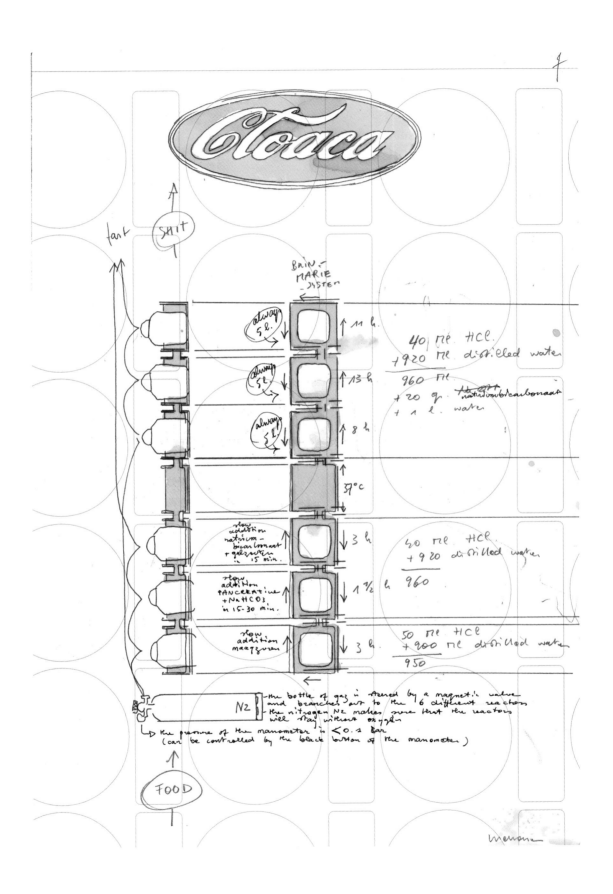

1997 – 2001, 62 X 43 CM (24 3/8 X 16 7/8 INCHES), PENCIL, WATERCOLOUR & MARKER ON PAPER
(PRIVATE COLLECTION, BELGIUM)

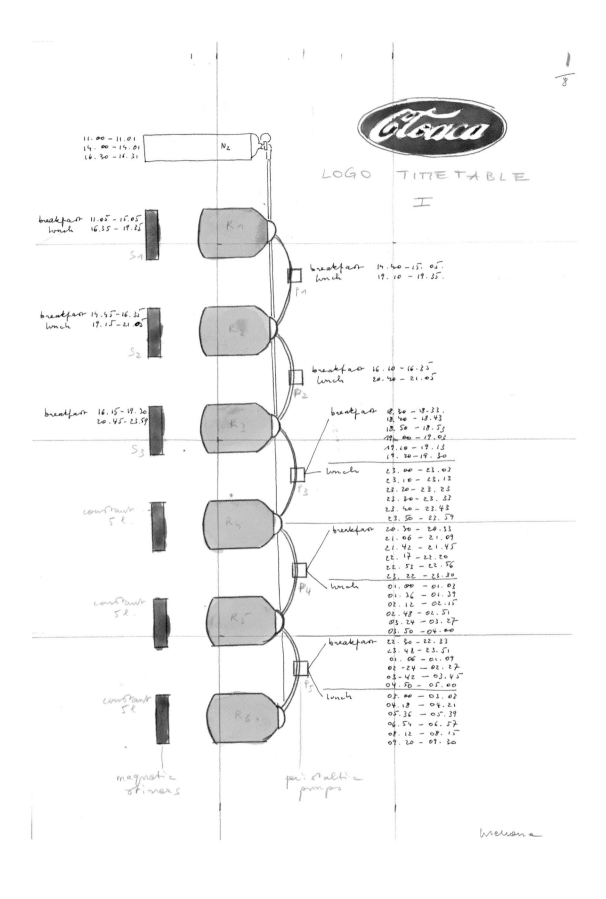

1997 – 2001, 62 X 43 CM (24 3/8 X 16 7/8 INCHES), PENCIL, WATERCOLOUR & MARKER ON PAPER
(PRIVATE COLLECTION, BELGIUM)

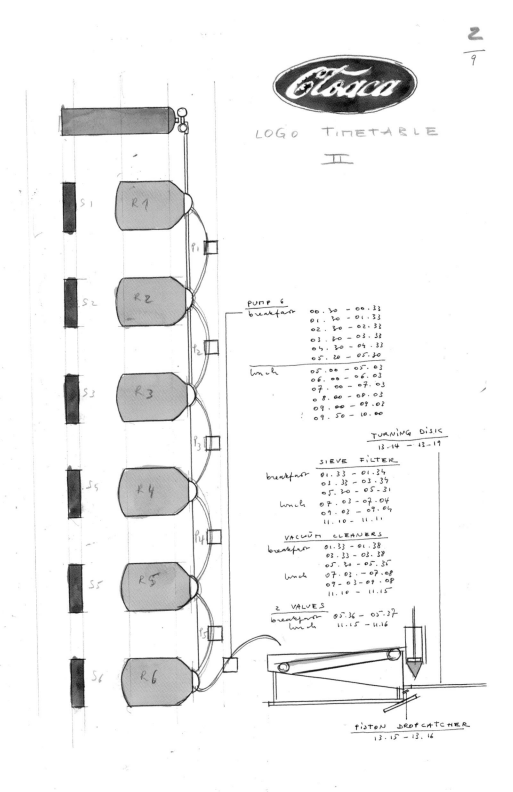

2/9

Cloaca

LOGO TIMETABLE

II

PUMP 6
breakfast 00.30 – 00.33
 01.30 – 01.33
 02.30 – 02.33
 03.30 – 03.33
 04.30 – 04.33
 05.20 – 05.30

lunch 05.00 – 05.03
 06.00 – 06.03
 07.00 – 07.03
 08.00 – 08.03
 09.00 – 09.03
 09.50 – 10.00

TURNING DISK
13.14 – 13.19

SIEVE FILTER
breakfast 01.33 – 01.34
 03.33 – 03.34
 05.30 – 05.31
lunch 07.03 – 07.04
 09.03 – 09.04
 11.10 – 11.11

VACUUM CLEANERS
breakfast 01.33 – 01.38
 03.33 – 03.38
 05.30 – 05.35
lunch 07.03 – 07.08
 09.03 – 09.08
 11.10 – 11.15

2 VALVES
breakfast 05.36 – 05.37
lunch 11.15 – 11.16

PISTON DROPCATCHER
13.15 – 13.16

watercolour

1997 – 2001, 62 X 43 CM (24 3/8 X 16 7/8 INCHES), PENCIL, MARKER & COLLAGE ON PAPER

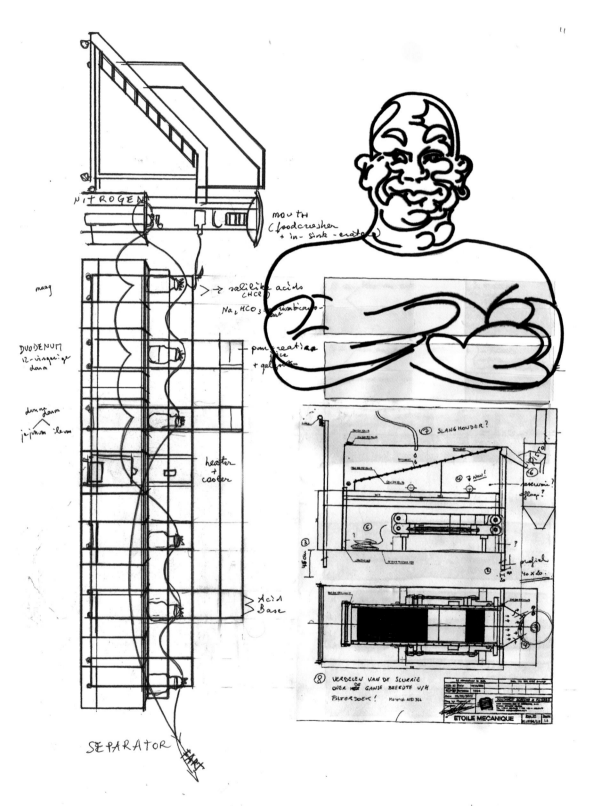

1997 – 2001, 62 X 43 CM (24 3/8 X 16 7/8 INCHES), COLOUR PENCIL & MARKER ON PAPER
(PRIVATE COLLECTION, BELGIUM)

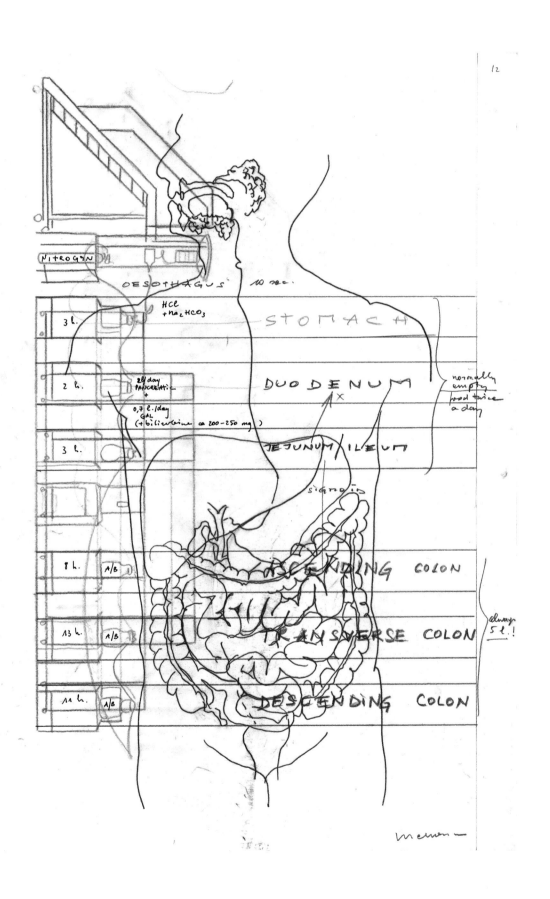

1997 – 2001, 62 X 43 CM (24 3/8 X 16 7/8 INCHES), PENCIL, WATERCOLOUR & MARKER ON PAPER
(COLOUR PENCIL & STAMP INK, 2006) (PRIVATE COLLECTION, BELGIUM)

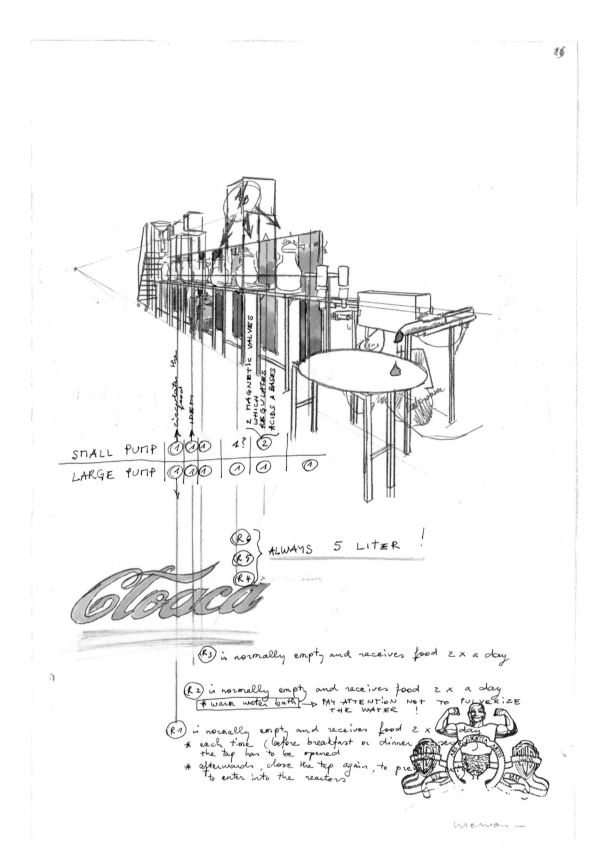

SMALL PUMP | ① ① ① | 1? | ②
LARGE PUMP | ① ① ① | ① | ① | ①

2 MAGNETIC VALVES
WHICH
REGULATES
ACIDS & BASES

R6
R5
ALWAYS 5 LITER !
R4

Cloaca

R3 is normally empty and receives food 2 x a day

R2 is normally empty and receives food 2 x a day
* warm water bath → PAY ATTENTION NOT TO PULVERIZE
THE WATER !

R1 is normally empty and receives food 2 x day
* each time (before breakfast or dinner) the tap has to be opened
* afterwards, close the tap again, to pre to enter into the reactors

1997 – 2001, 62 X 43 CM (24 3/8 X 16 7/8 INCHES), COLOUR PENCIL, MARKER & COLLAGE ON PAPER
(ADDITIONAL COLOUR PENCIL & STAMP INK, 2006) (PRIVATE COLLECTION, BELGIUM)

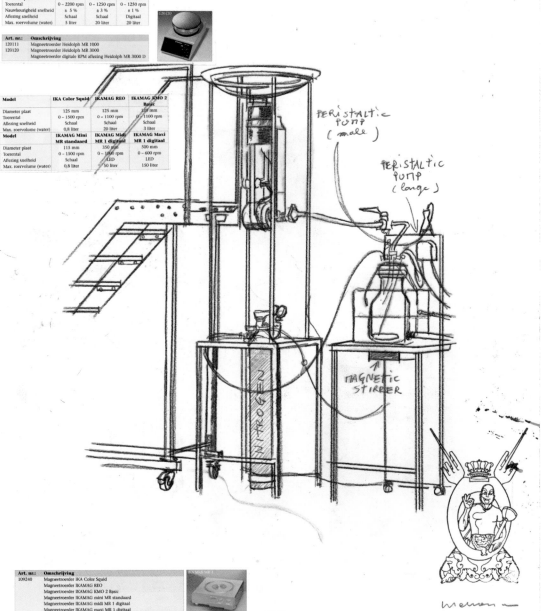

Magneetroerders zonder verwarming

Heidolph

- Electronische snelheidscontrole.
- MR 3000: zeer geringe opwarming van de plaat.

Model	MR 1000	MR 3000	MR 3000 D
Diameter plaat	104 mm	145 mm	145 mm
Toerental	0 – 2200 rpm	0 – 1250 rpm	0 – 1250 rpm
Nauwkeurigheid snelheid	± 5 %	± 3 %	± 1 %
Aflezing snelheid	Schaal	Schaal	Digitaal
Max. roervolume (water)	5 liter	20 liter	20 liter

Art. nr.:	Omschrijving
120111	Magneetroerder Heidolph MR 1000
120120	Magneetroerder Heidolph MR 3000
	Magneetroerder digitale RPM aflezing Heidolph MR 3000 D

Model	IKA Color Squid	IKAMAG REO	IKAMAG KMO 2 Basic
Diameter plaat	125 mm	125 mm	120 mm
Toerental	0 – 1500 rpm	0 – 1100 rpm	0 – 1100 rpm
Aflezing snelheid	Schaal	Schaal	Schaal
Max. roervolume (water)	0,8 liter	20 liter	3 liter
Model	IKAMAG Mini MR standaard	IKAMAG Midi MR 1 digitaal	IKAMAG Maxi MR 1 digitaal
Diameter plaat	115 mm	350 mm	500 mm
Toerental	0 – 1500 rpm	0 – 1000 rpm	0 – 600 rpm
Aflezing snelheid	Schaal	LED	LED
Max. roervolume (water)	0,8 liter	50 liter	150 liter

Art. nr.:	Omschrijving
109240	Magneetroerder IKA Color Squid
	Magneetroerder IKAMAG REO
	Magneetroerder IKAMAG KMO 2 Basic
	Magneetroerder IKAMAG mini MR standaard
	Magneetroerder IKAMAG midi MR 1 digitaal
	Magneetroerder IKAMAG maxi MR 1 digitaal

PERISTALTIC PUMP (male)

PERISTALTIC PUMP (large)

NITROGEN

MAGNETIC STIRRER

1997 – 2001, 62 X 43 CM (24 3/8 X 16 7/8 INCHES), PENCIL, WATERCOLOUR & MARKER ON PAPER
(PRIVATE COLLECTION, BELGIUM)

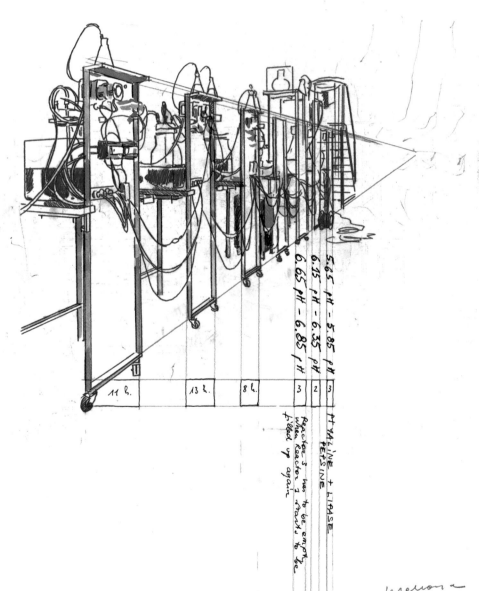

1997 – 2001, 62 X 43 CM (24 3/8 X 16 7/8 INCHES), PENCIL, WATERCOLOUR & MARKER ON PAPER
(COLOUR PENCIL & STAMP INK, 2006) (PRIVATE COLLECTION, BELGIUM)

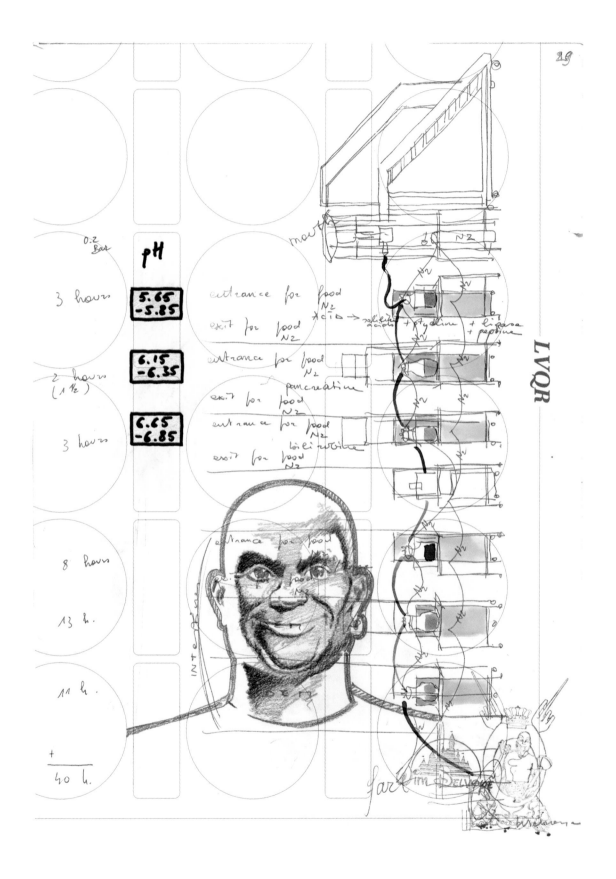

1997 – 2001, 62 X 43 CM (24 3/8 X 16 7/8 INCHES), PENCIL, MARKER & COLLAGE ON PAPER
(COLOUR PENCIL & STAMP INK, 2006) (PRIVATE COLLECTION, BELGIUM)

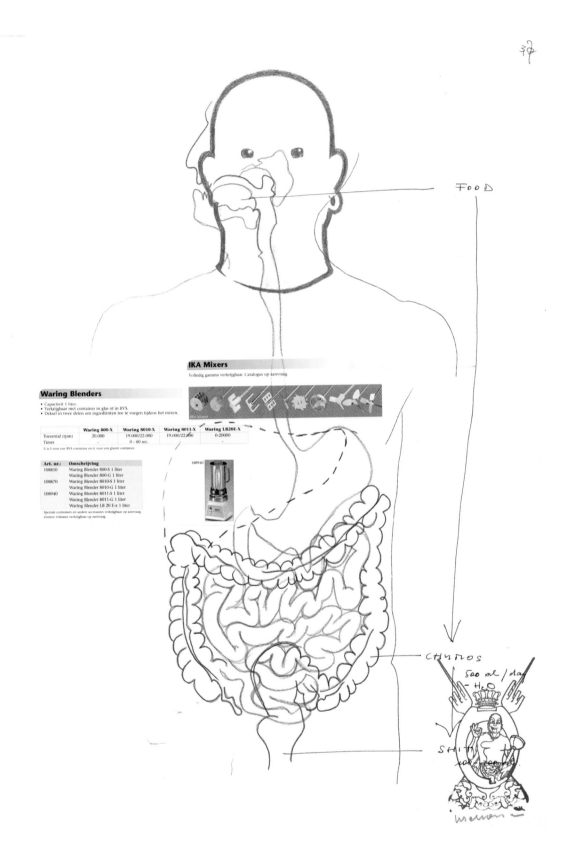

1997 – 2001, 62 X 43 CM (24 3/8 X 16 7/8 INCHES), PENCIL, COLOUR PENCIL, MARKER & COLLAGE ON PAPER
(ADDITIONAL COLOUR PENCIL, 2006) (PRIVATE COLLECTION, BELGIUM)

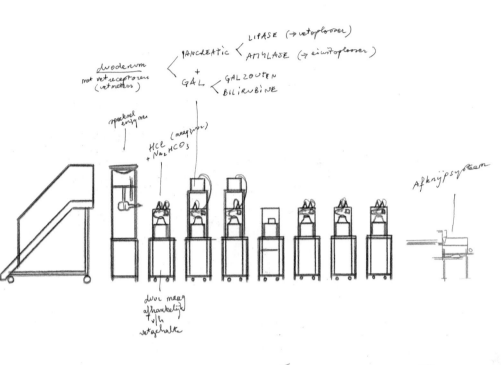

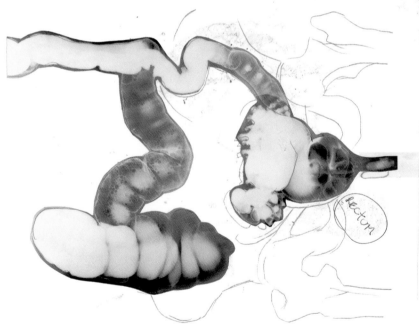

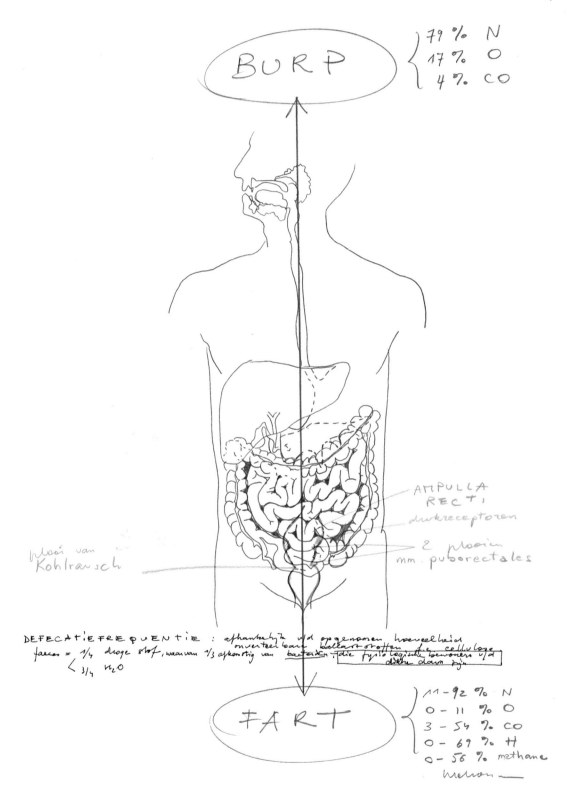

BURP
$\begin{cases} 79\,\%\ N \\ 17\,\%\ O \\ 4\,\%\ CO \end{cases}$

AMPULLA
RECTI
drukreceptoren

2 plooien
mm. puborectales

plooi van
Kohlrausch

DEFECATIEFREQUENTIE : afhankelijk v/d opgenomen hoeveelheid
onverteerbare ballaststoffen zic. cellulose
faeces = 1/4 droge stof, waarvan 1/3 afkomstig van bacteriën die fysiologische bewoners v/d
dikke darm zijn
< 3/4 H₂O

FART
$\begin{cases} 11-92\,\%\ N \\ 0-11\,\%\ O \\ 3-54\,\%\ CO \\ 0-69\,\%\ H \\ 0-56\,\%\ methane \end{cases}$
methaan

1997 – 2001, 62 X 43 CM (24 3/8 X 16 7/8 INCHES), PENCIL, WATERCOLOUR & MARKER ON PAPER
(PRIVATE COLLECTION, BELGIUM)

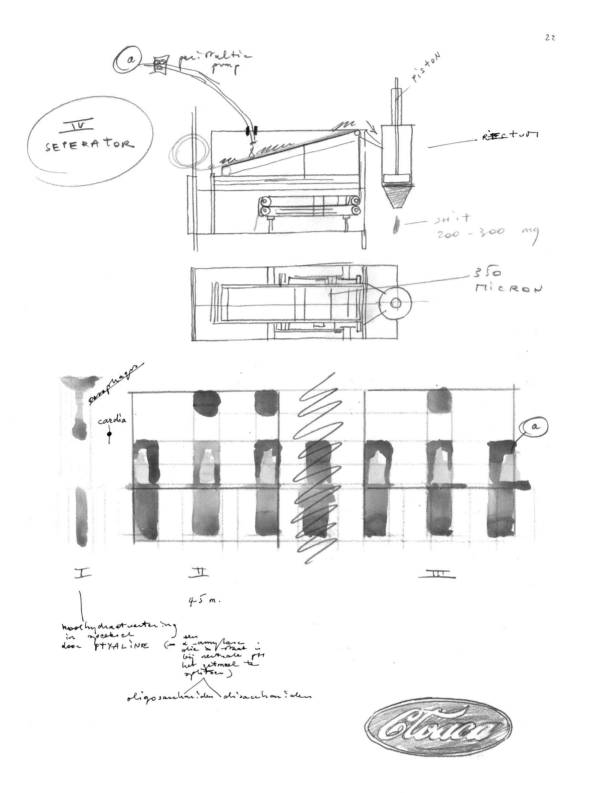

1997 – 2001, 62 X 43 CM (24 3/8 X 16 7/8 INCHES), PENCIL, COLOUR PENCIL & WATERCOLOUR ON PAPER
(PRIVATE COLLECTION, BELGIUM)

TRACTUS DIGESTIVUS

SEPARATOR

23

SIEVE FILTER
01.33 — 01.34 breakfast
03.33 — 03.34
05.30 — 05.31

07.03 — 07.04 lunch
07.03 — 09.04
11.10 — 11.11

350 MICRON

magnetic stirrer
14.45 — 16.55 breakfast
19.15 — 22.05 lunch

stirrer
11.05 — 15.05 breakfast
16.35 — 19.35 lunch

14.40 — 15.05 pumping the breakfast to R2
19.10 — 19.35 pumping the lunch to R2

Cloaca

1997 – 2001, 62 X 43 CM (24 3/8 X 16 7/8 INCHES), PENCIL, WATERCOLOUR & MARKER ON PAPER
(PRIVATE COLLECTION, BELGIUM)

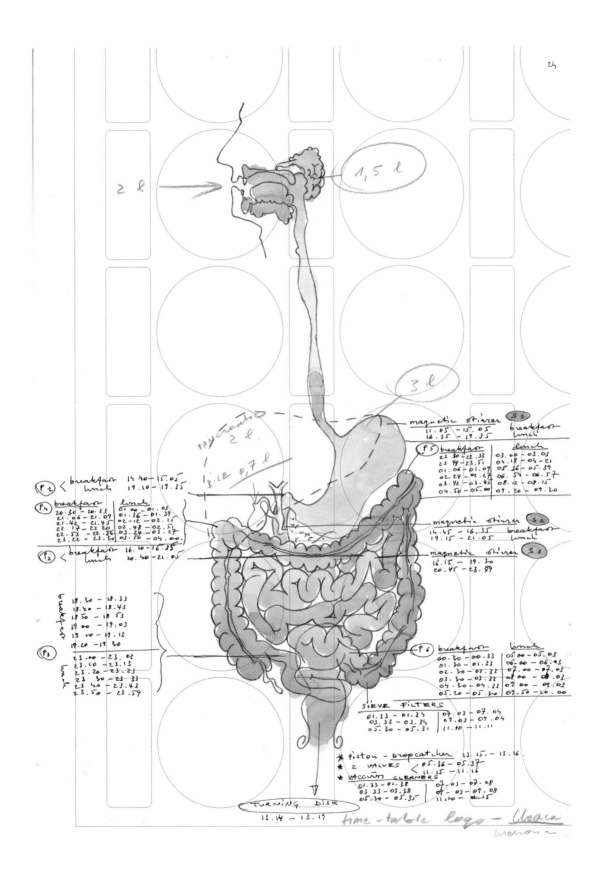

Studies for Cloaca
New & Improved

1997-2001

1999, 65 X 50 CM (29 5/8 X 19 5/8 INCHES), PENCIL & COLOUR PENCIL ON PAPER
(PRIVATE COLLECTION, BELGIUM)

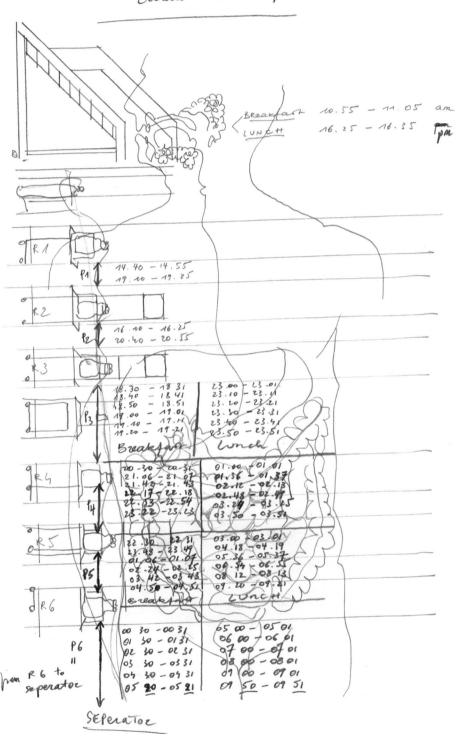

1999, 65 X 50 CM (29 5/8 X 19 5/8 INCHES), PENCIL, COLOUR PENCIL & COLLAGE ON PAPER
(PRIVATE COLLECTION, BELGIUM)

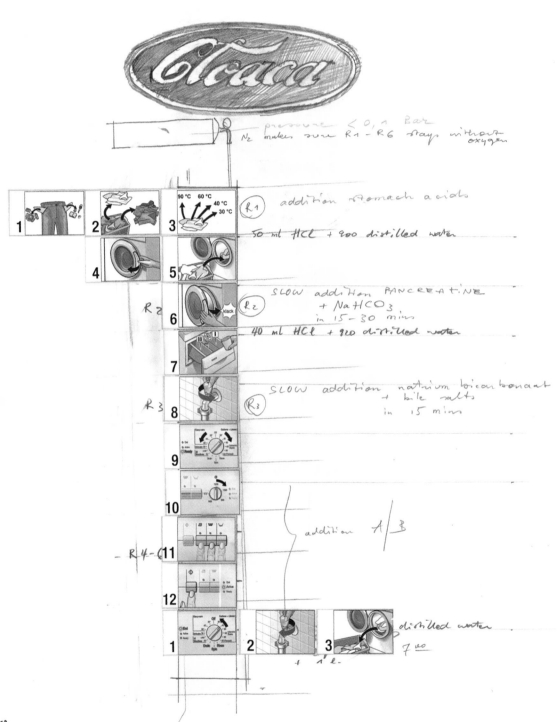

1999

1999 – 2000, 65 X 50 CM (29 5/8 X 19 5/8 INCHES), PENCIL, COLOUR PENCIL AND MARKER ON PAPER

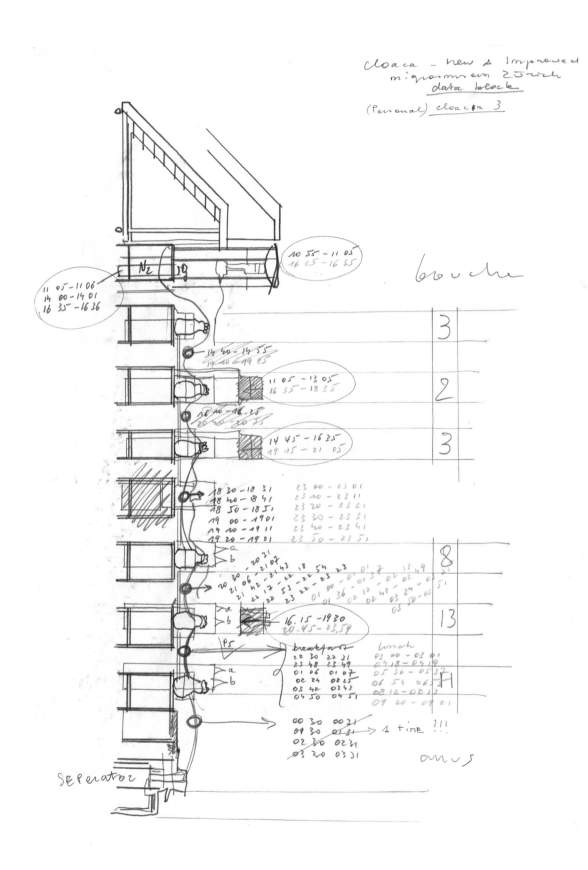

2000, 65 X 50 CM (29 5/8 X 19 5/8 INCHES), PENCIL & COLOUR PENCIL ON PAPER
(PRIVATE COLLECTION, BELGIUM)

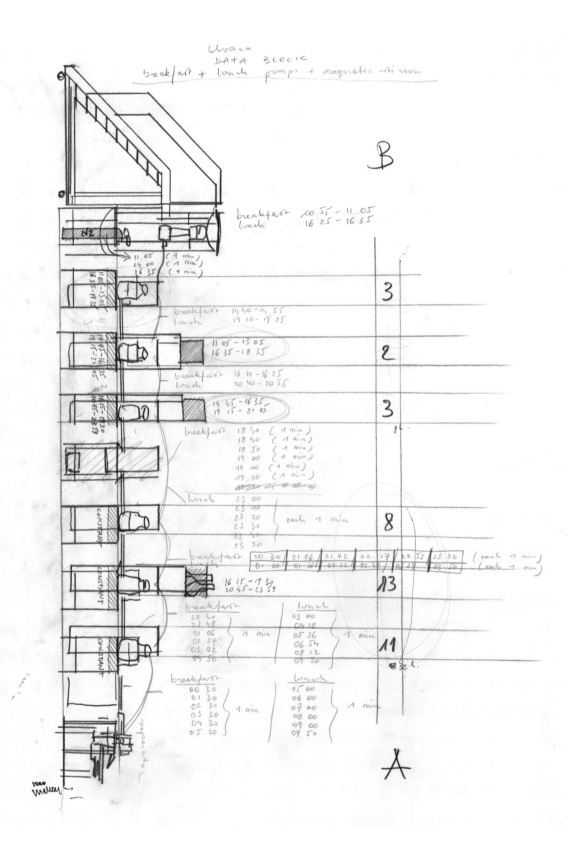

2000, 65 X 50 CM (29 5/8 X 19 5/8 INCHES), PENCIL & COLOUR PENCIL ON PAPER
(PRIVATE COLLECTION, BELGIUM)

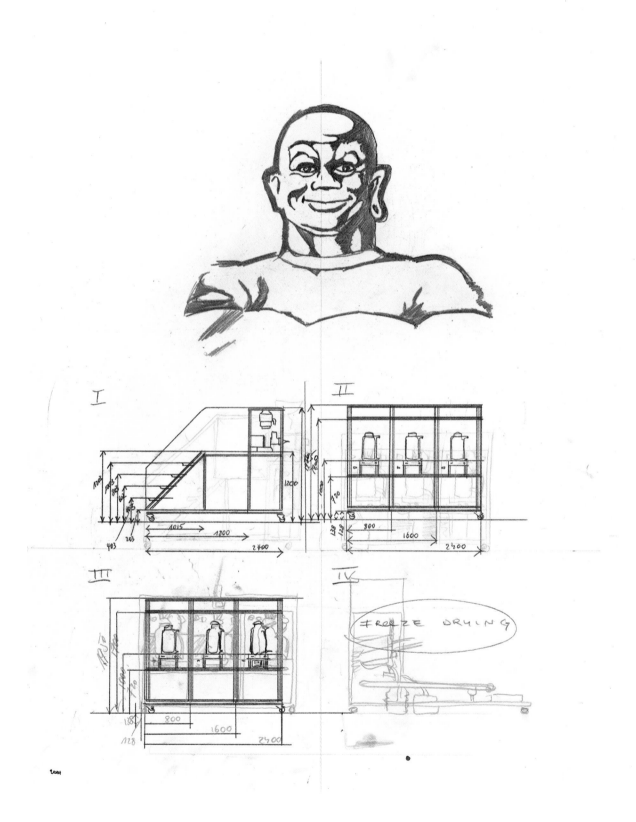

2000, 65 X 50 CM (29 5/8 X 19 5/8 INCHES), PENCIL & COLOUR PENCIL ON PAPER
(PRIVATE COLLECTION, BELGIUM)

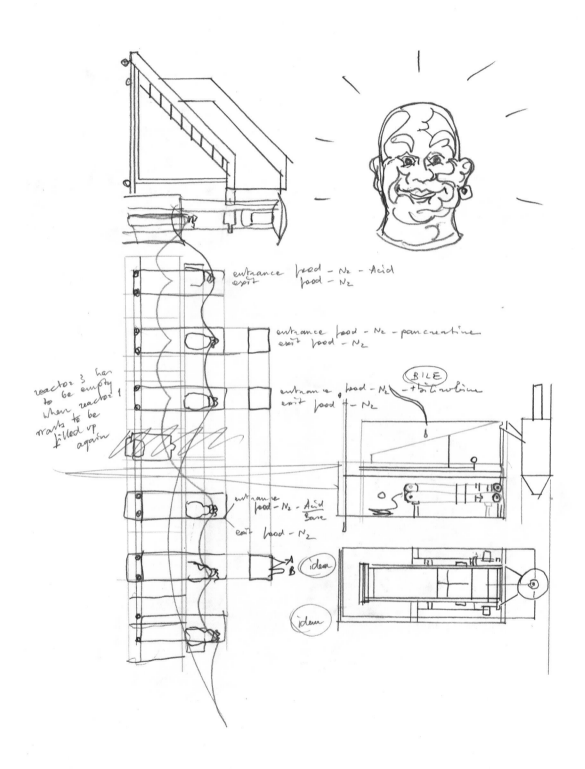

2000, 65 X 50 CM (29 5/8 X 19 5/8 INCHES), PENCIL & COLOUR PENCIL ON PAPER
(PRIVATE COLLECTION, BELGIUM)

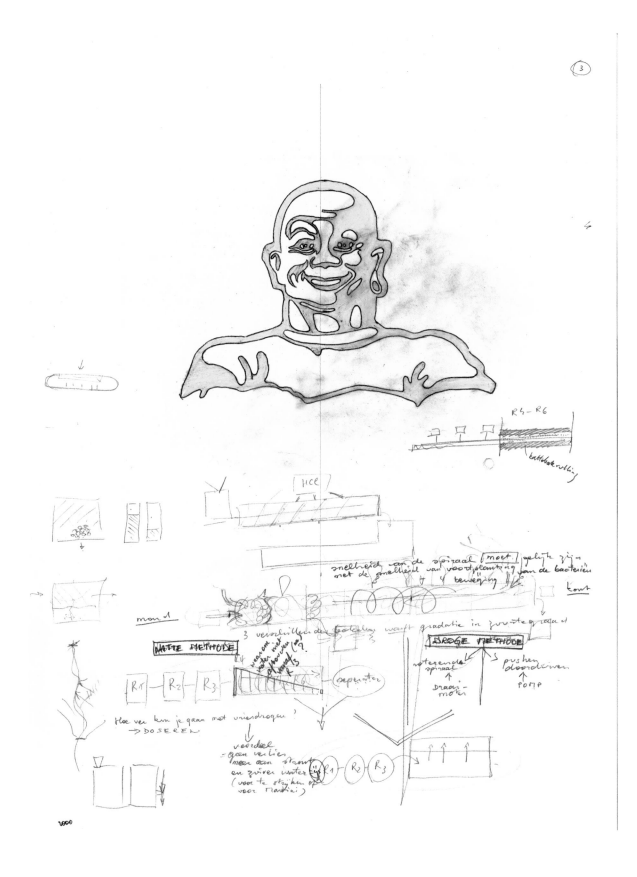

1997 – 2001, 62 X 43 CM (24 3/8 X 16 7/8 INCHES), PENCIL, COLOUR PENCIL & MARKER ON PAPER
(ADDITIONAL COLOUR PENCIL, 2006)

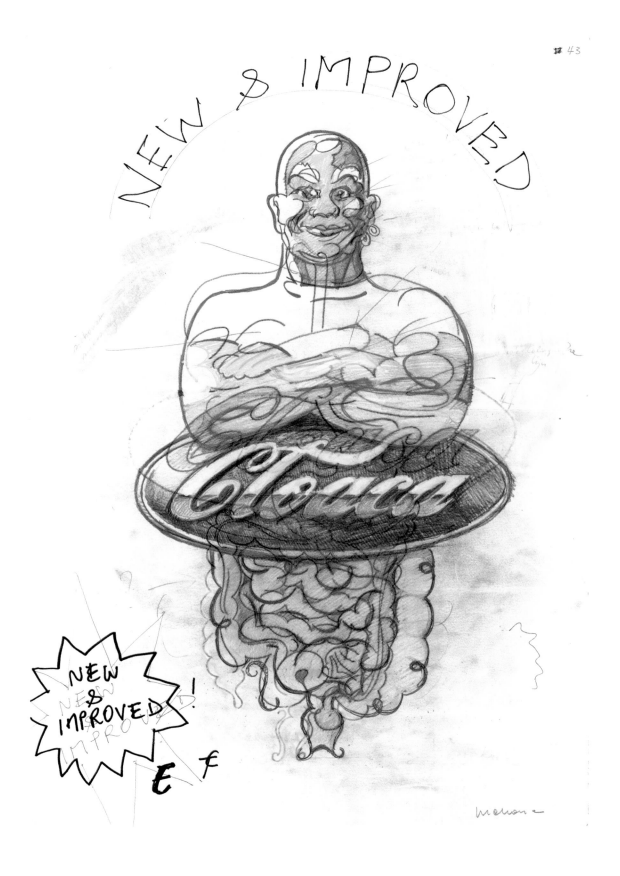

1997 – 2001, 62 X 43 CM (24 3/8 X 16 7/8 INCHES), PENCIL, COLOUR PENCIL & MARKER ON PAPER

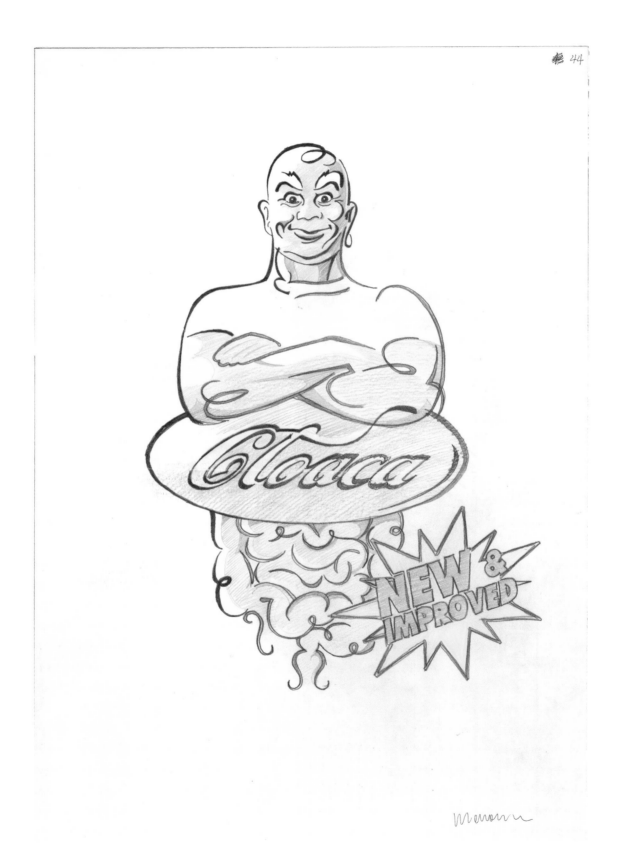

2001, 23.5 X 46 CM (9 1/4 X 18 1/8 INCHES), PENCIL, COLOUR PENCIL & STAMP INK ON PAPER
(PRIVATE COLLECTION, BELGIUM)

2001, 65 X 50 CM (29 5/8 X 19 5/8 INCHES), PENCIL & COLOUR PENCIL ON PAPER
(PRIVATE COLLECTION, BELGIUM)

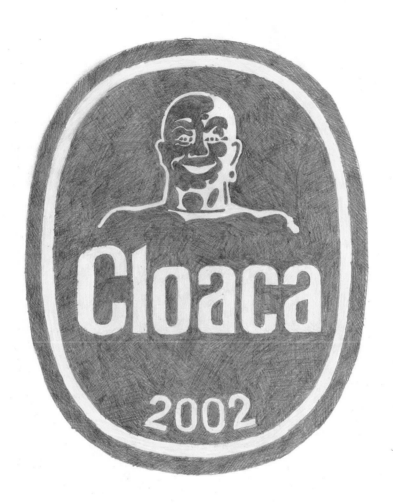

2001, 65 X 50 CM (29 5/8 X 19 5/8 INCHES), PENCIL, MARKER & COLLAGE ON PAPER
(PRIVATE COLLECTION, BELGIUM)

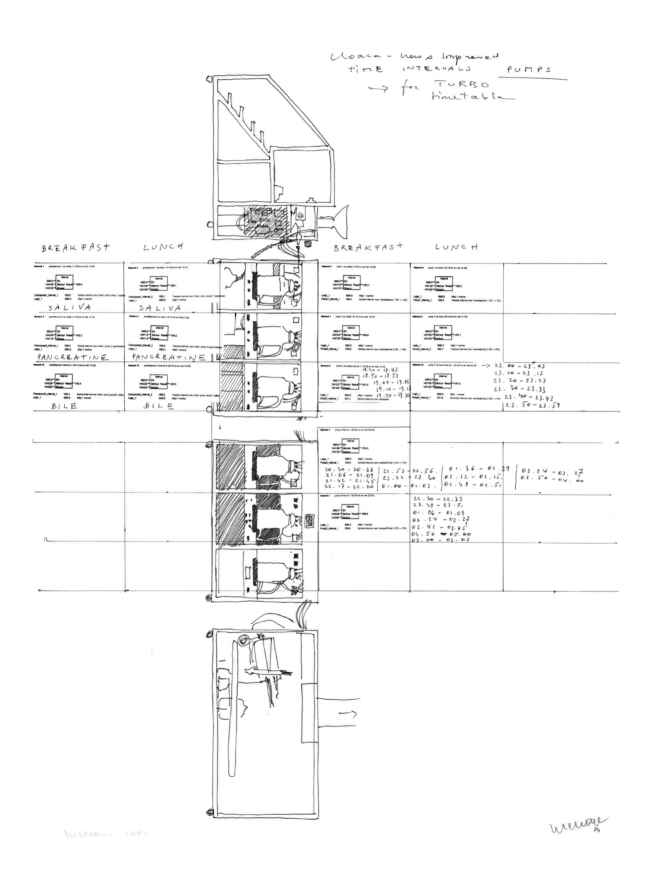

2001, 65 X 50 CM (29 5/8 X 19 5/8 INCHES), COLOUR PENCIL, WATERCOLOUR, MARKER & COLLAGE ON PAPER
(PRIVATE COLLECTION, BELGIUM)

2001, 65 X 50 CM (29 5/8 X 19 5/8 INCHES), PENCIL, COLOUR PENCIL & MARKER ON PAPER
(PRIVATE COLLECTION, BELGIUM)

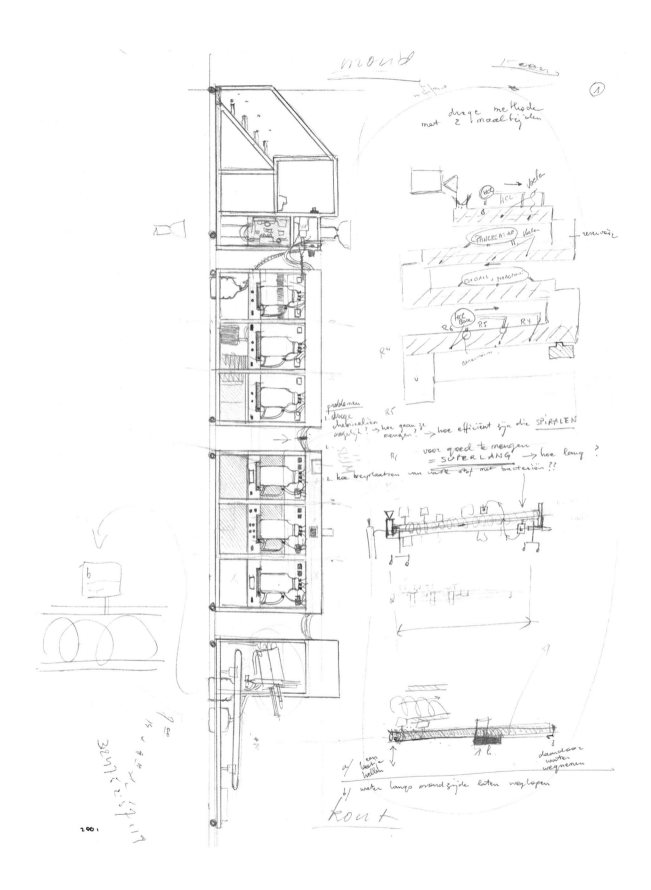

2001, 23.5 X 46 CM (9 1/4 X 18 1/8 INCHES), PENCIL, COLOUR PENCIL, WATERCOLOUR, MARKER & STAMP INK ON PAPER (PRIVATE COLLECTION, BELGIUM)

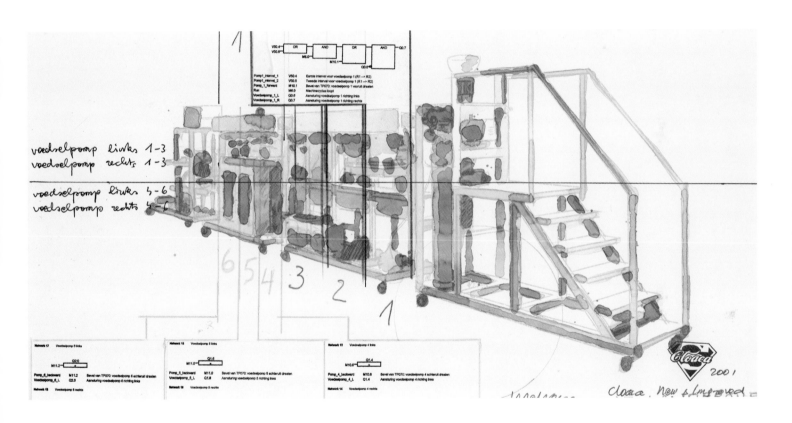

2001, 65 X 50 CM (29 5/8 X 19 5/8 INCHES), PENCIL & COLOUR PENCIL ON PAPER
(PRIVATE COLLECTION, BELGIUM)

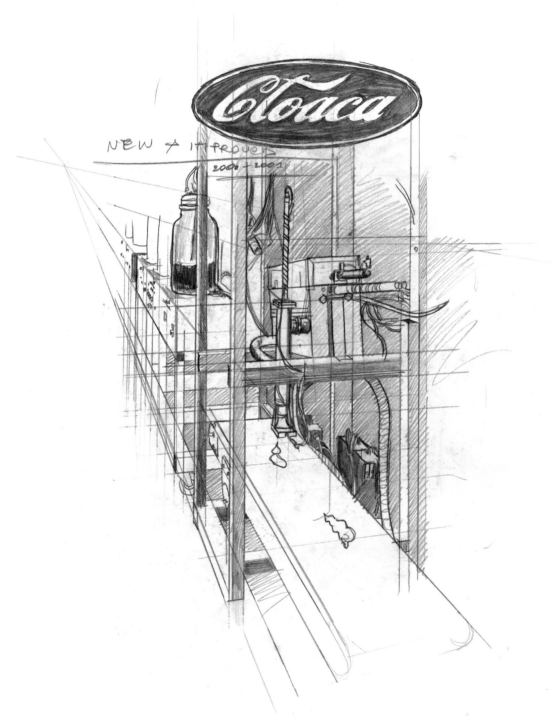

2001, 65 X 50 CM (29 5/8 X 19 5/8 INCHES), PENCIL & COLOUR PENCIL ON PAPER
(PRIVATE COLLECTION, BELGIUM)

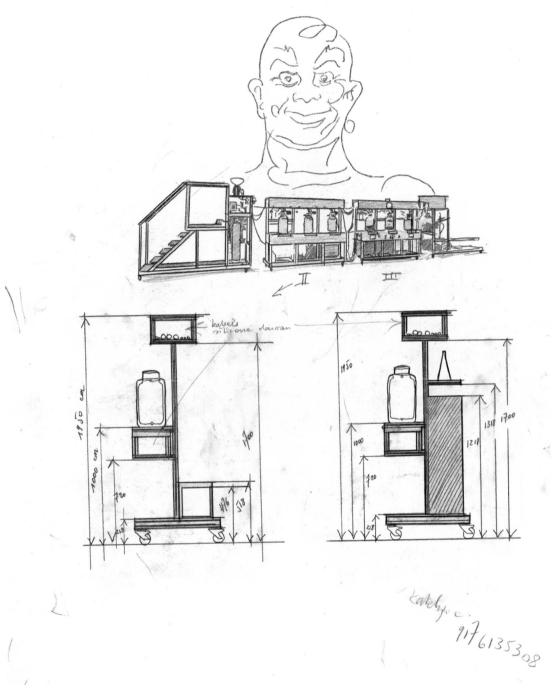

2001, 65 X 50 CM (29 5/8 X 19 5/8 INCHES), PENCIL & COLOUR PENCIL ON PAPER
(PRIVATE COLLECTION, BELGIUM)

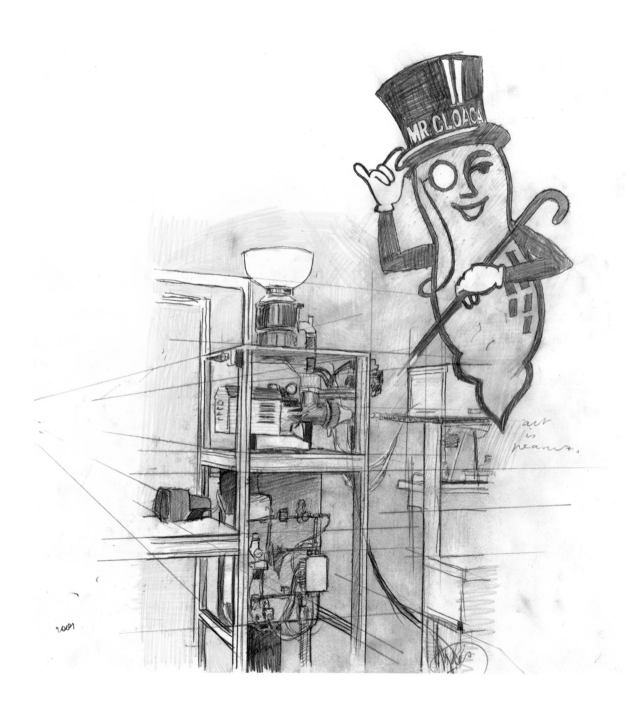

2001, 65 X 50 CM (29 5/8 X 19 5/8 INCHES), PENCIL & COLOUR PENCIL ON PAPER
(PRIVATE COLLECTION, BELGIUM)

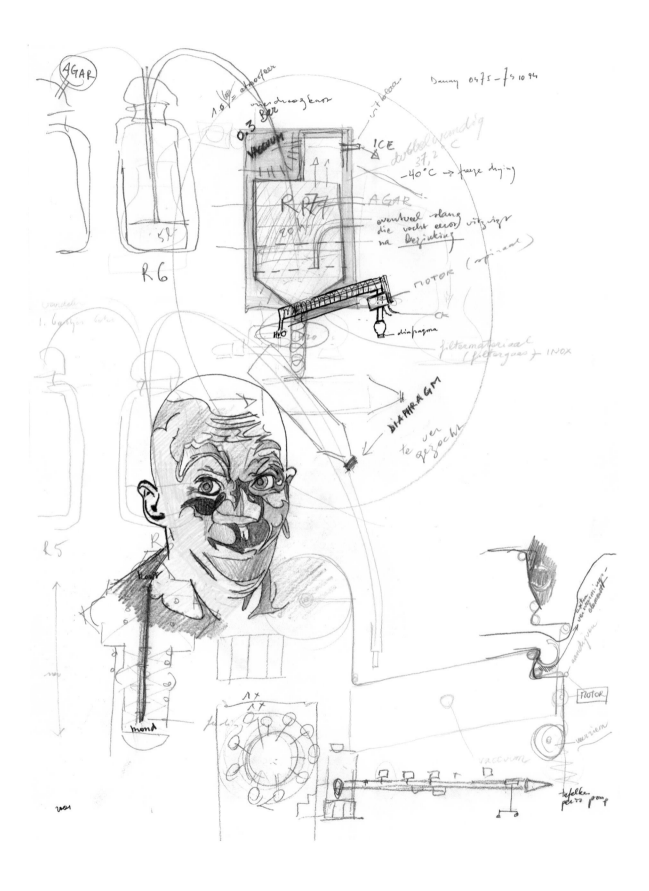

Studies for Cloaca Shares, Convertible Bonds & Certificates

1999-2005

2000, 24.5 X 30 CM (9 5/8 X 11 3/4 INCHES), PENCIL & STAMP INK ON PAPER
(PRIVATE COLLECTION, BELGIUM)

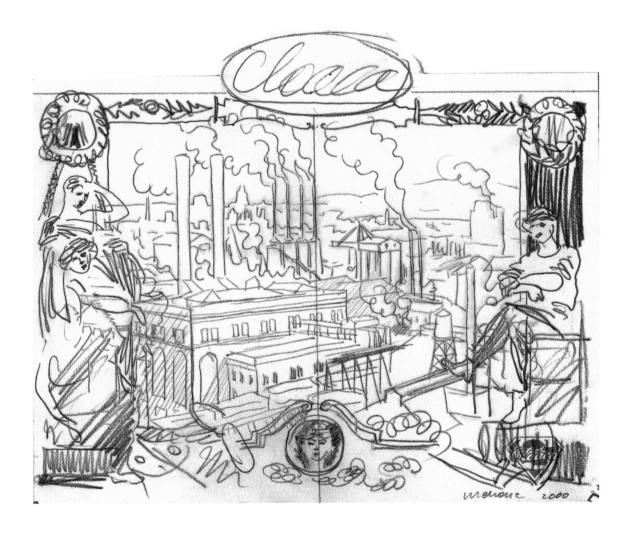

2001, 42.5 X 31.5 CM (16 3/4 X 12 3/8 INCHES), COLOUR PENCIL & COLLAGE ON PAPER
(PRIVATE COLLECTION, BELGIUM)

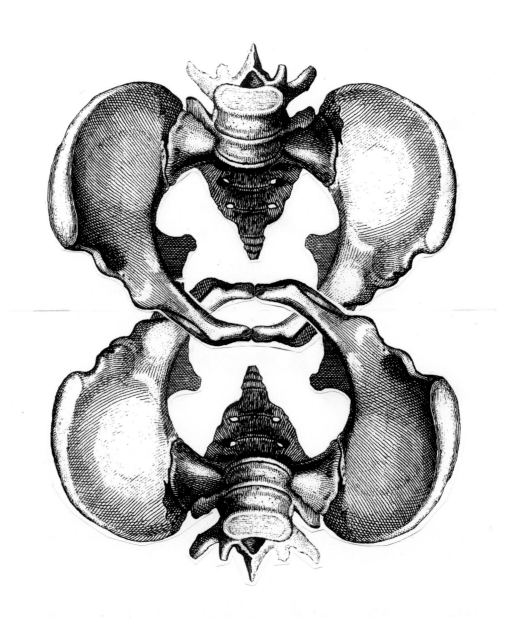

2000, 24.5 X 30 CM (9 5/8 X 11 3/4 INCHES), PENCIL & STAMP INK ON PAPER
(PRIVATE COLLECTION, BELGIUM)

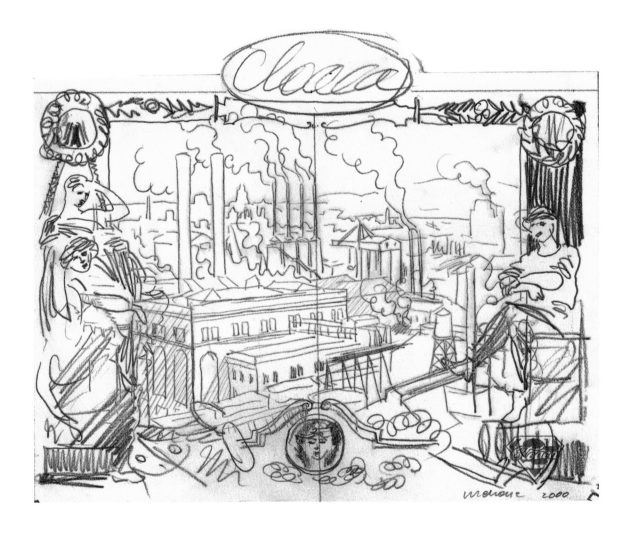

2001, 75.5 X 55.5 CM (29 3/4 X 21 7/8 INCHES), PENCIL & COLOUR PENCIL ON PAPER
(PRIVATE COLLECTION, SWITZERLAND)

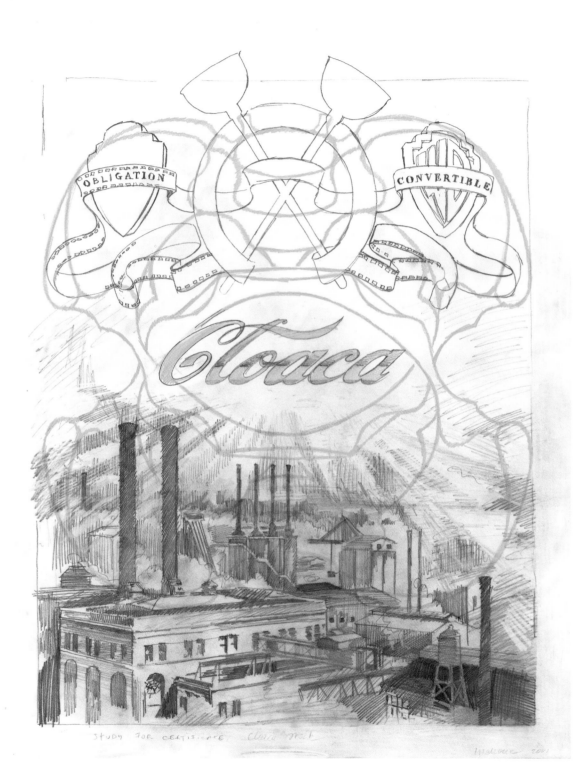

2001, 65 X 49.7 CM (29 5/8 X 19 1/2 INCHES), PENCIL, MARKER & COLLAGE ON PAPER
(PRIVATE COLLECTION, BELGIUM)

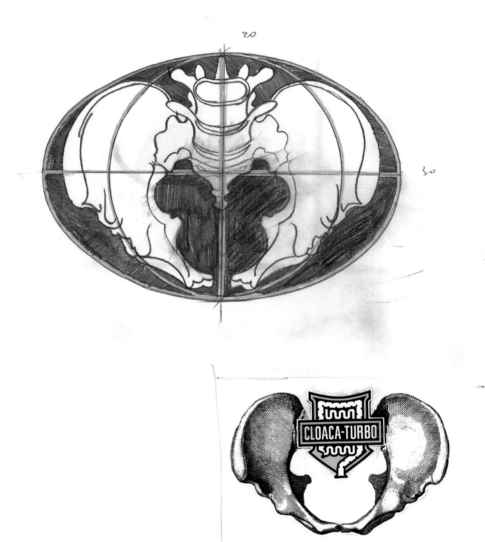

2001, 42.5 X 31.5 CM (16 3/4 X 12 3/8 INCHES), COLOUR PENCIL & COLLAGE ON PAPER
(PRIVATE COLLECTION, BELGIUM)

2001, 65 X 49.8 CM (29 5/8 X 19 5/8 INCHES), PENCIL, WATERCOLOUR, MARKER & COLLAGE ON PAPER
(PRIVATE COLLECTION, BELGIUM)

2001, 65 X 50 CM (29 5/8 X 19 5/8 INCHES), PENCIL, COLOUR PENCIL & MARKER ON PAPER
(PRIVATE COLLECTION, BELGIUM)

2001, 65 X 50 CM (29 5/8 X 19 5/8 INCHES), PENCIL & COLOUR PENCIL ON PAPER
(PRIVATE COLLECTION, BELGIUM)

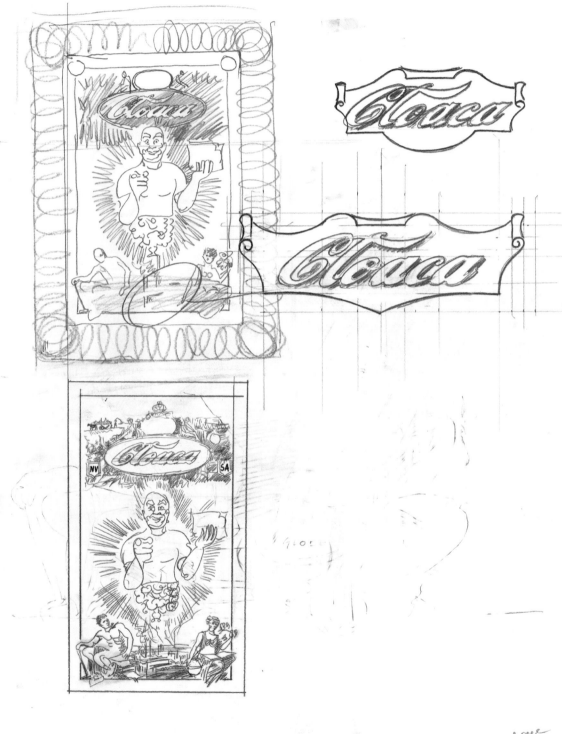

2001, 65 X 50 CM (29 5/8 X 19 5/8 INCHES), PENCIL & MARKER ON PAPER
(PRIVATE COLLECTION, BELGIUM)

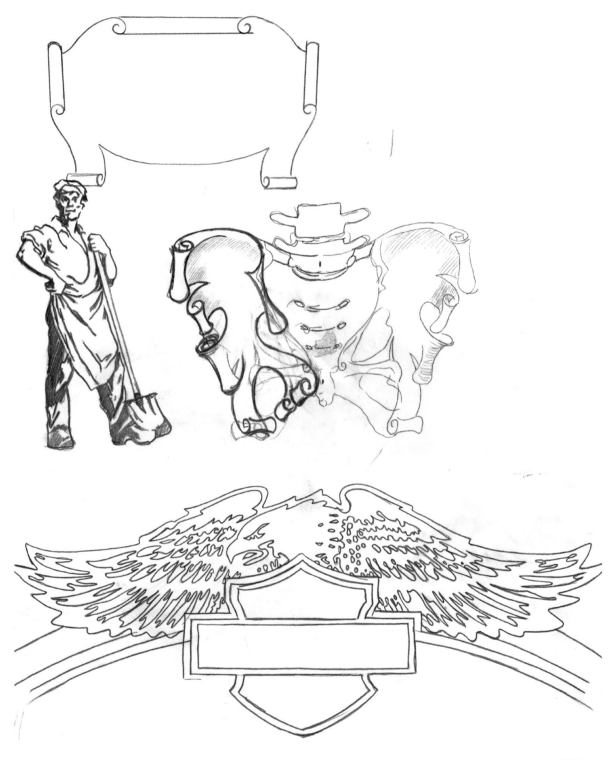

2001, 65 X 50 CM (29 5/8 X 19 5/8 INCHES), PENCIL & MARKER ON PAPER
(PRIVATE COLLECTION, BELGIUM)

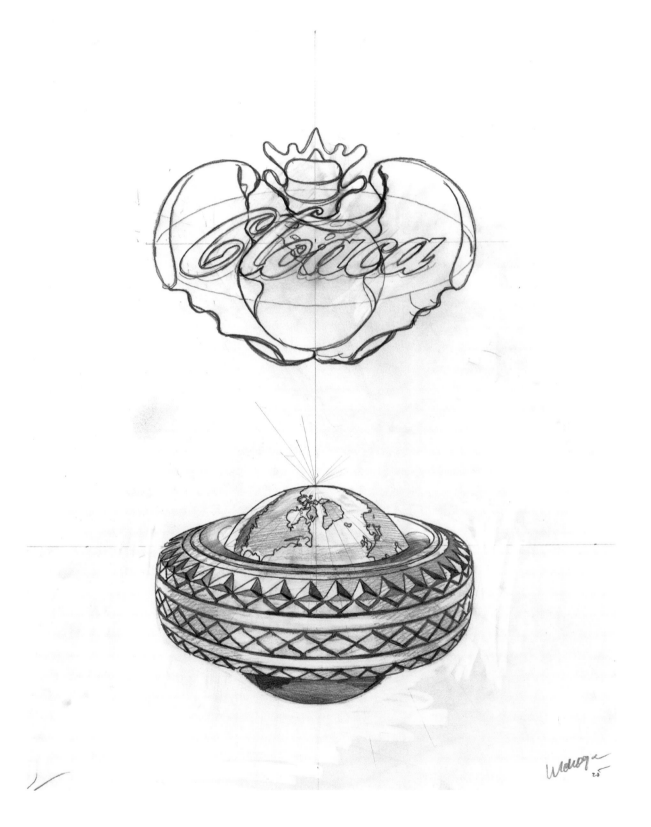

2001, 65 X 50 CM (29 5/8 X 19 5/8 INCHES), PENCIL, MARKER & STAMP INK ON PAPER

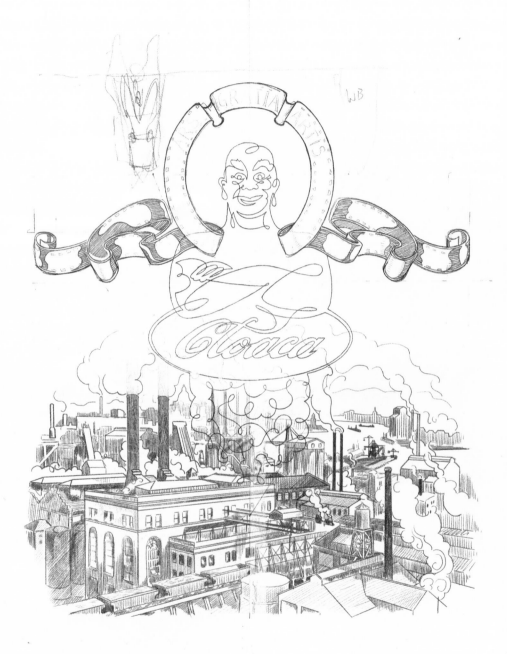

2002, 75.5 X 55.5 CM (29 3/4 X 21 7/8 INCHES), PENCIL, WATERCOLOUR & MARKER ON PAPER
(PRIVATE COLLECTION, SWITZERLAND)

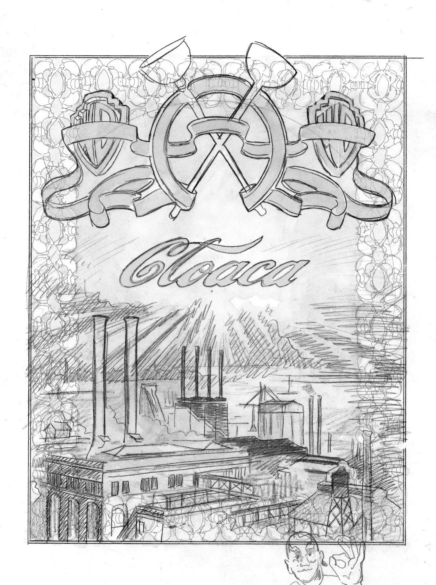

1999 – 2003, 65 X 50 CM (29 5/8 X 19 5/8 INCHES), PENCIL, COLOUR PENCIL & BALLPOINT ON PAPER
(PRIVATE COLLECTION, BELGIUM)

2002 – 2003, 75.5 X 55.5 CM (29 3/4 X 21 7/8 INCHES), PENCIL, COLOUR PENCIL, MARKER & STAMP INK ON PAPER

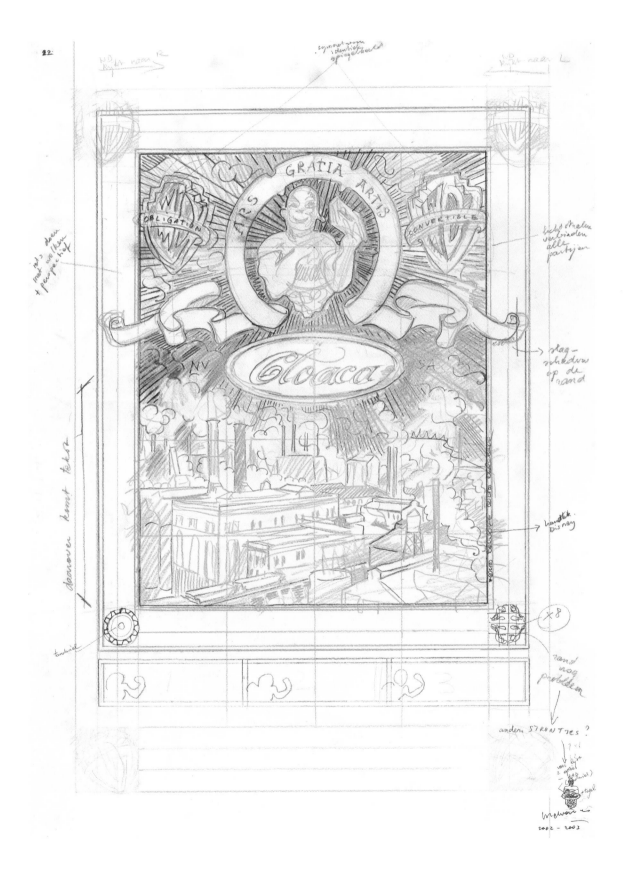

2003, 73.5 X 109.7 CM (28 7/8 X 43 1/8 INCHES), PENCIL, COLOUR PENCIL & STAMP INK ON PAPER
(PRIVATE COLLECTION, USA)

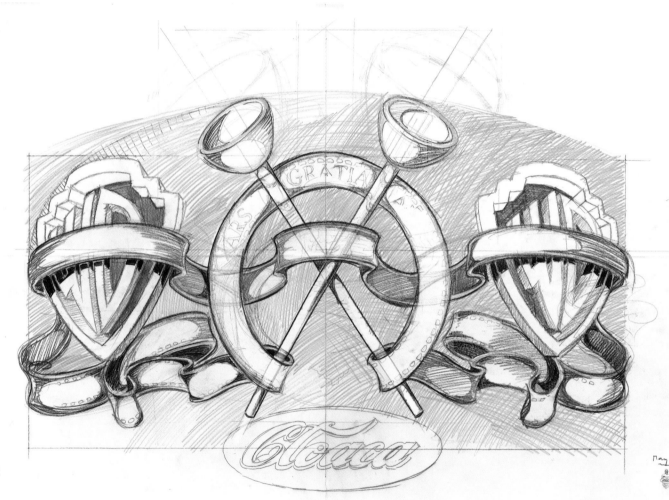

2003, 109.7 X 73.5 CM (43 1/8 X 28 7/8 INCHES), PENCIL, COLOUR PENCIL, MARKER & STAMP INK ON PAPER
(PRIVATE COLLECTION, USA)

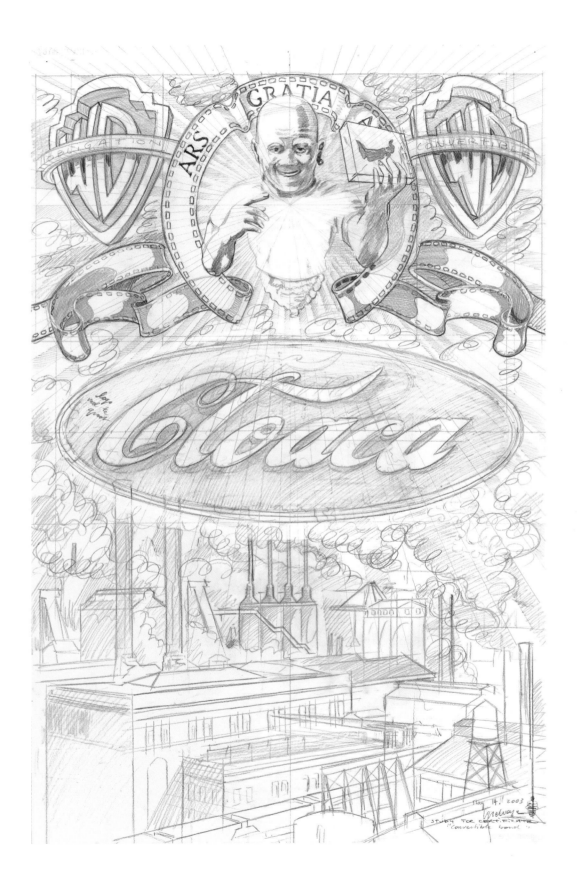

2003, 109.7 X 73.5 CM (43 1/8 X 28 7/8 INCHES), PENCIL, COLOUR PENCIL & MARKER ON PAPER

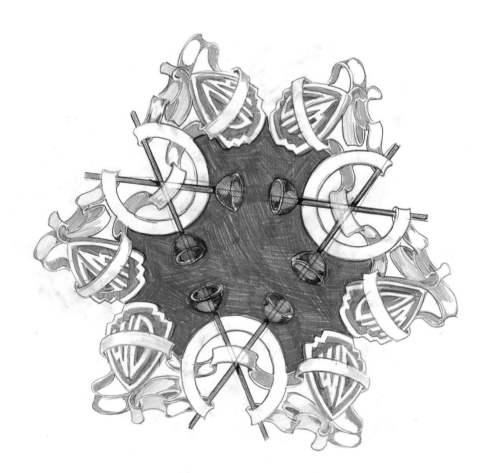

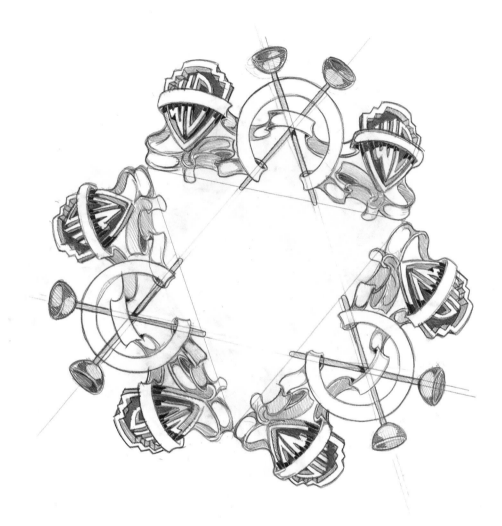

2003, 109.7 X 73.5 CM (43 1/8 X 28 7/8 INCHES), PENCIL, COLOUR PENCIL & MARKER ON PAPER

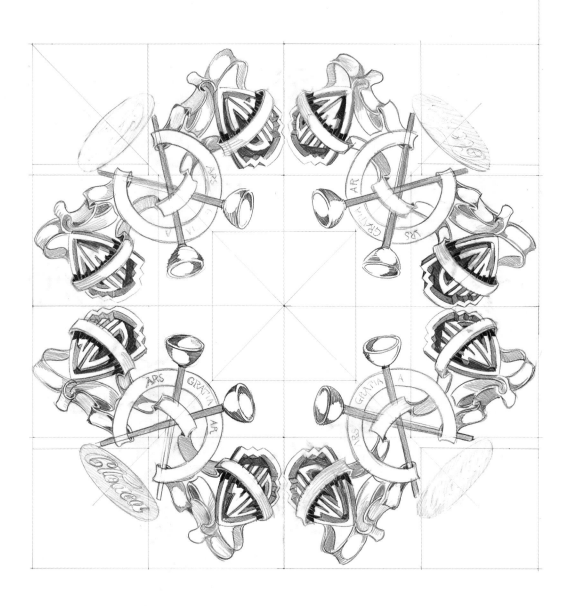

2003, 65 X 50 CM (29 5/8 X 19 5/8 INCHES), PENCIL, MARKER, BALLPOINT & COLLAGE ON PAPER
(PRIVATE COLLECTION, BELGIUM)

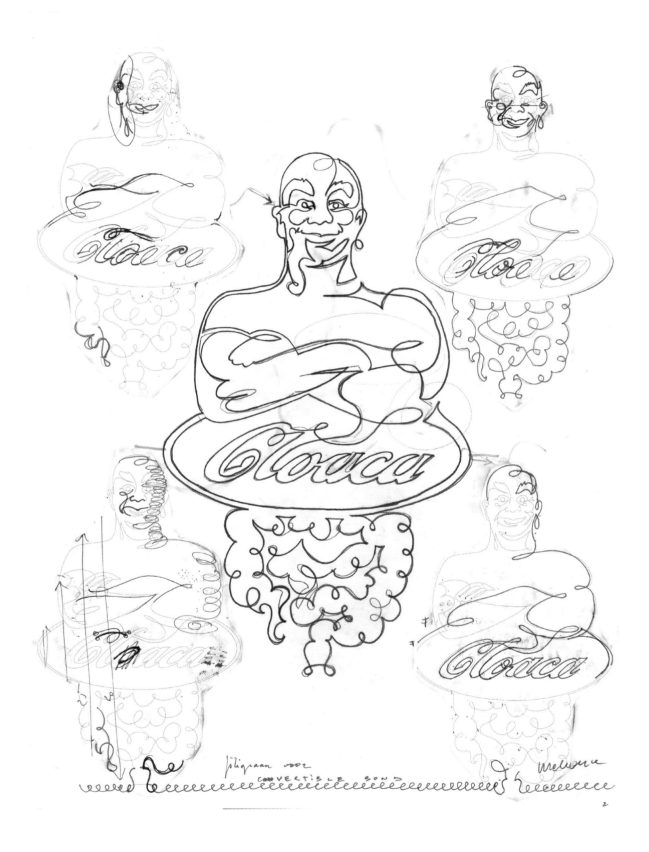

2003, 75.5 X 55.5 CM (29 3/4 X 21 7/8 INCHES), PENCIL, COLOUR PENCIL & MARKER ON PAPER

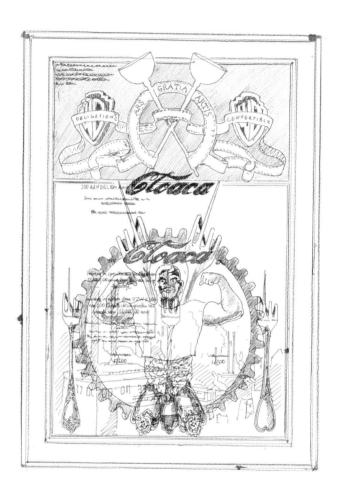

2004, 75.5 X 55.5 CM (29 3/4 X 21 7/8 INCHES), PENCIL, COLOUR PENCIL & MARKER ON PAPER
(PRIVATE COLLECTION, SWITZERLAND)

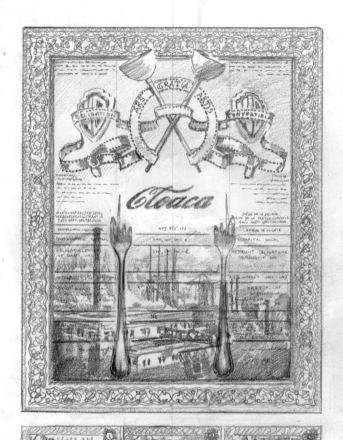

2004, 75.5 X 55.5 CM (29 3/4 X 21 7/8 INCHES), PENCIL & COLOUR PENCIL ON PAPER
(PRIVATE COLLECTION, BELGIUM)

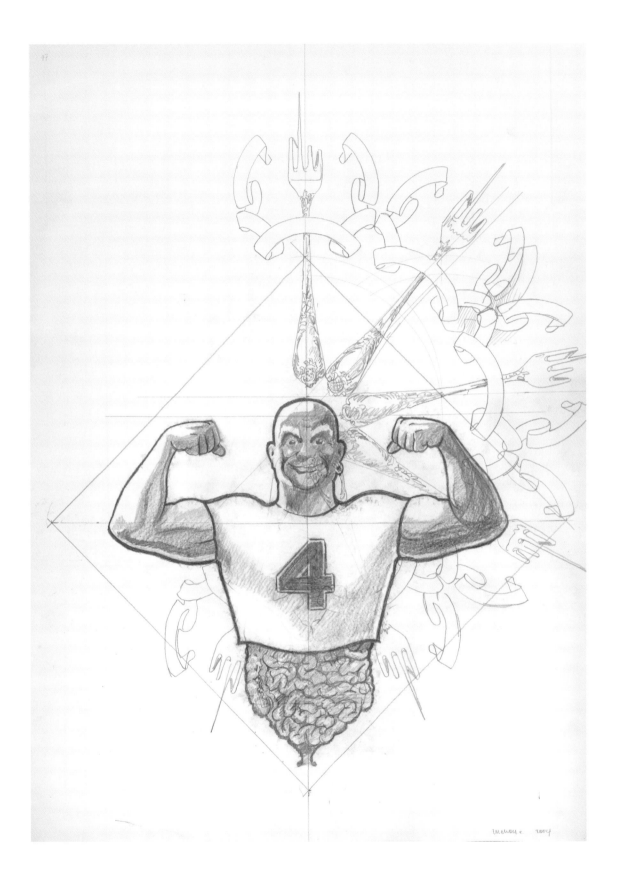

2004, 62 X 45 CM (24 3/8 X 17 3/4 INCHES), COLOUR PENCIL & STAMP INK ON PAPER

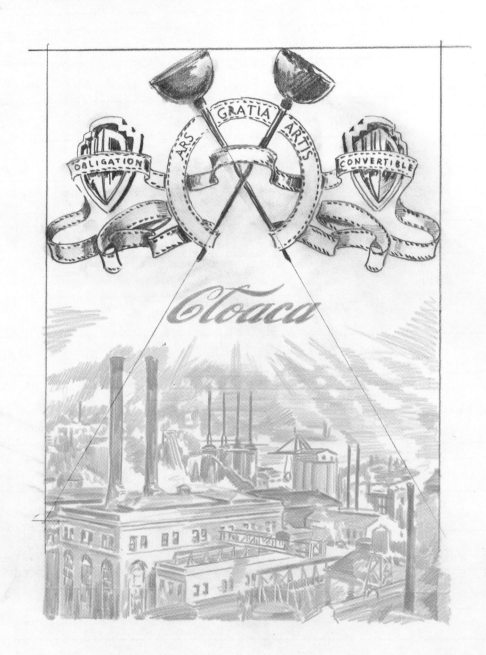

2004, 76.5 X 56.5 CM (30 1/8 X 22 1/4 INCHES), COLOUR PENCIL & STAMP INK ON PAPER

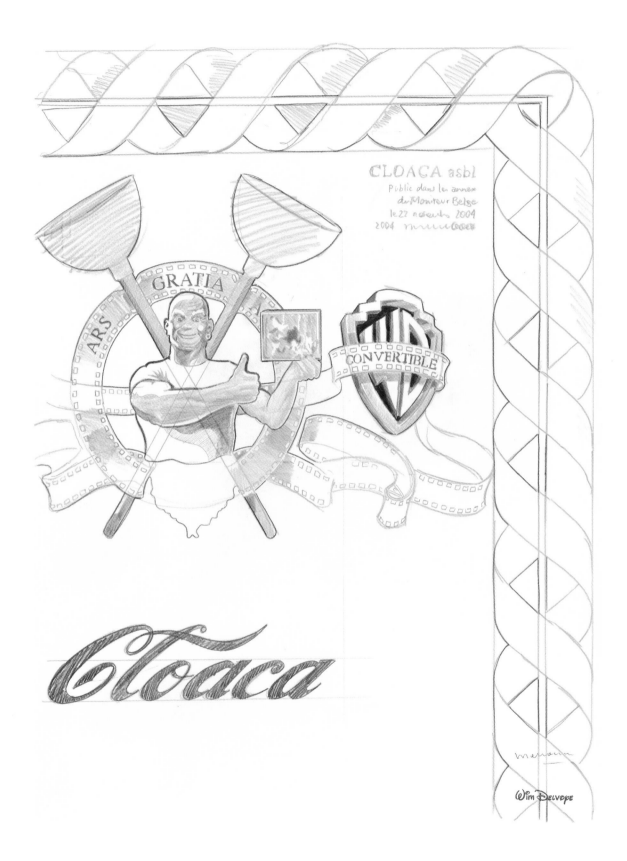

2004, 75.5 X 55.5 CM (29 3/4 X 21 7/8 INCHES), PENCIL, COLOUR PENCIL & MARKER ON PAPER

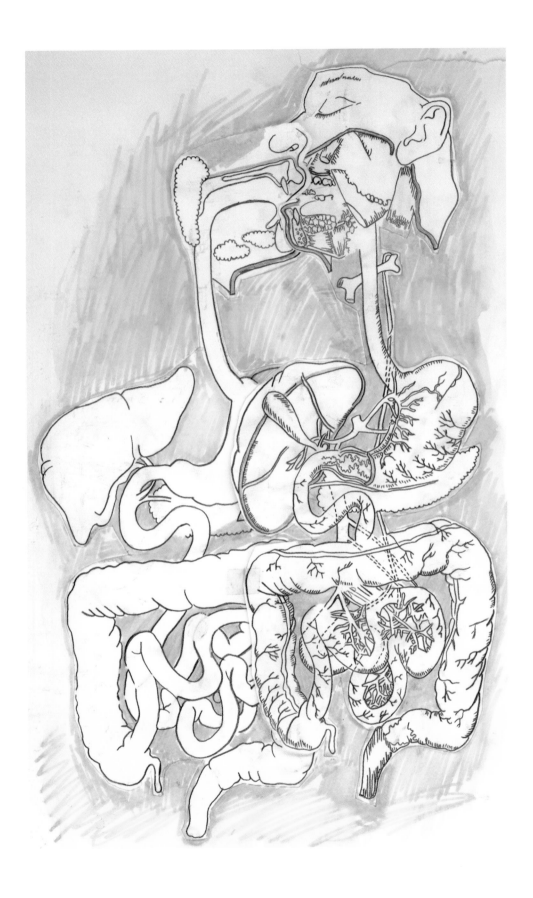

2004 – 2005, 62 X 45 CM (24 3/8 X 17 3/4 INCHES), PENCIL, COLOUR PENCIL & STAMP INK ON PAPER
(PRIVATE COLLECTION, BELGIUM)

N° 5
CLOACA

2005, 45 X 62 CM (17 3/4 X 24 3/8 INCHES), PENCIL & STAMP INK ON PAPER

Certificate No.:

CLOACA INVEST LIMITED

Number of Shares: 001 / 100

Incorporated under the International Business Companies Act (CAP. 291) of the Territory of the British Virgin Islands

Authorised Capital:

US$_____ divided into 100 shares with a par value of US$_____ each

This is to Certify that:_____ is entitled

to_____ share(s) of US$ _____ each in the above named Company, subject to the Memorandum and Articles of Association of the said Company

IN WITNESS WHEREOF the Company has authorised this certificate to be issued this_____ day_____, _____.

Director

Director

2005, 45 X 62 CM (17 3/4 X 24 3/8 INCHES), PENCIL & COLOUR PENCIL ON PAPER

Certificate No.:

Number of shares: 001 / 100

CLOACA INVEST LIMITED

Incorporated under the International Business Companies Act (CAP. 291) of the Territory of the British Virgin Islands

Authorised Capital:

US$ _____ divided into 100 shares with a par value of US$ _____ each

This is to Certify that: _____

_____ _____

2005, 62 X 45 CM (24 3/8 X 17 3/4 INCHES), COLOUR PENCIL ON PAPER
(PRIVATE COLLECTION, BELGIUM)

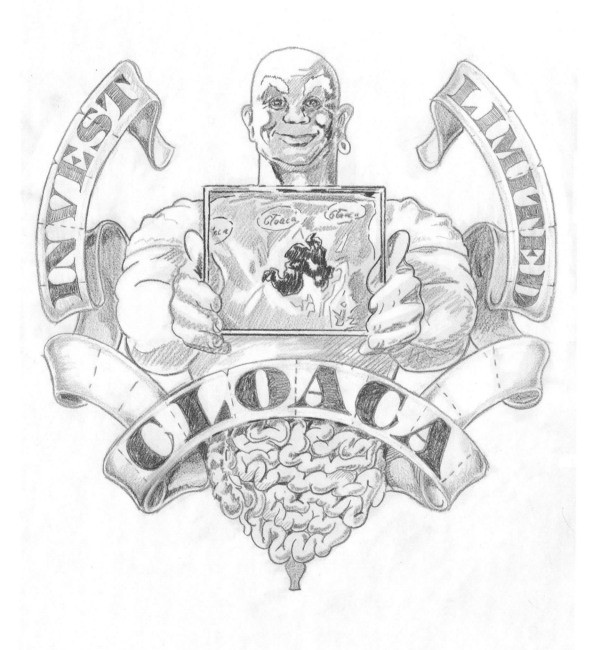

2005, 62 X 45 CM (24 3/8 X 17 3/4 INCHES), COLOUR PENCIL ON PAPER

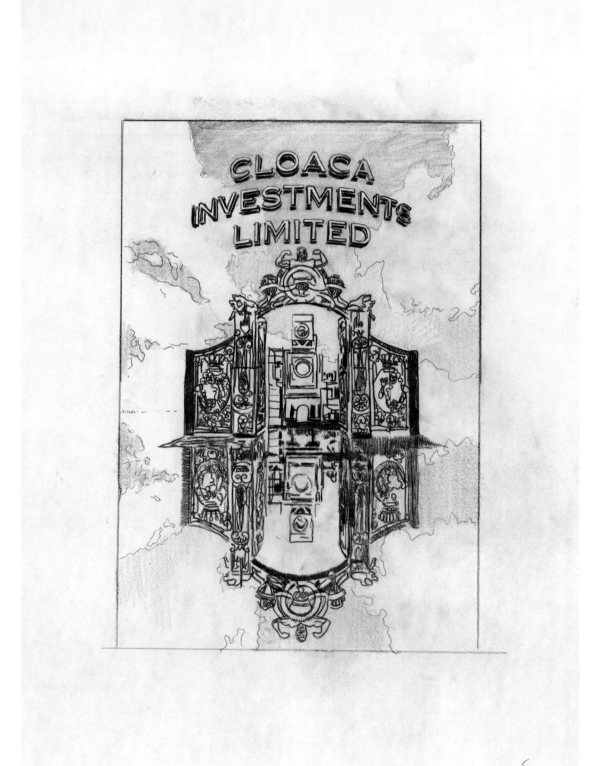

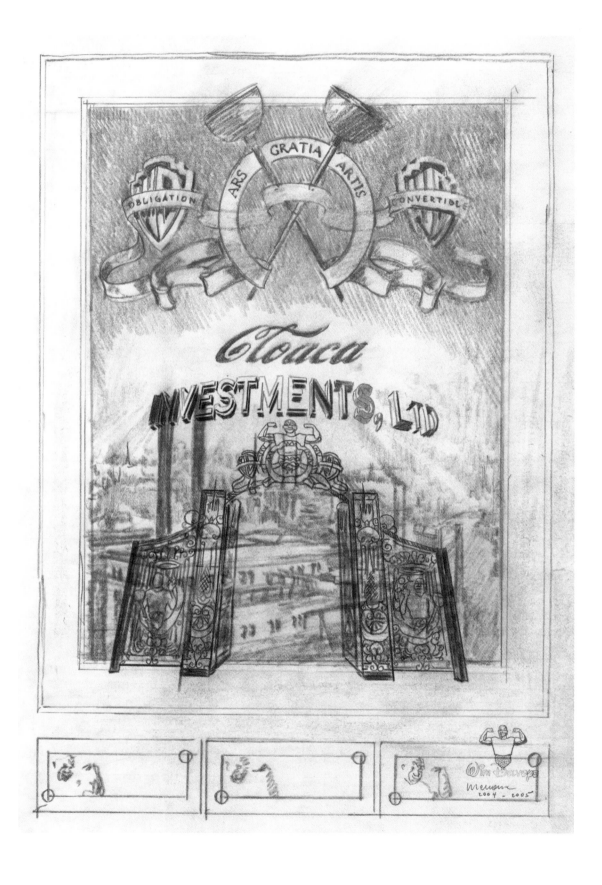

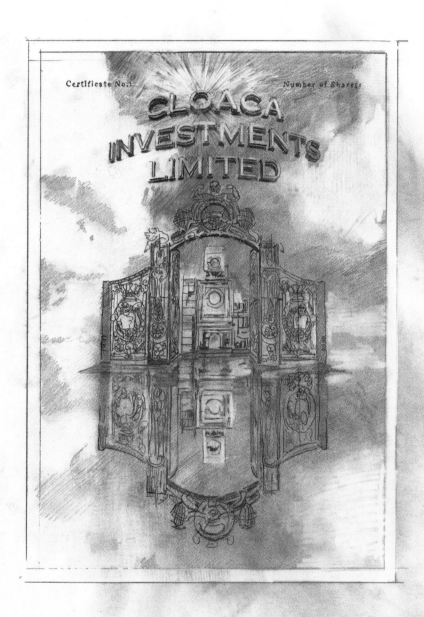

2005, 76.5 X 56.5 CM (30 1/8 X 22 1/4 INCHES), PENCIL, COLOUR PENCIL & STAMP INK ON PAPER

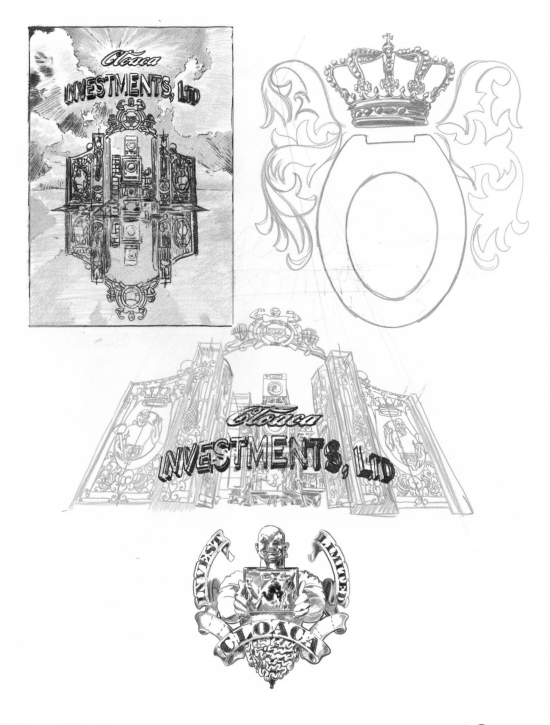

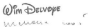

2005, 76.5 X 56.5 CM (30 1/8 X 22 1/4 INCHES), PENCIL, COLOUR PENCIL & STAMP INK ON PAPER

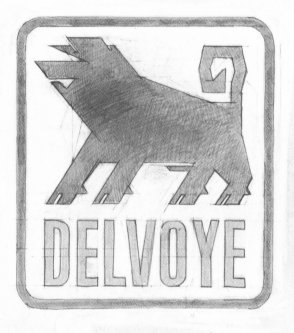

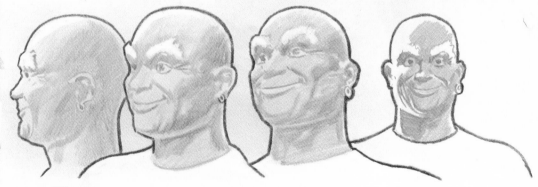

Studies for Convertible Cloaca, Personal Cloaca & Cloaca Travel Kit

2000-2004

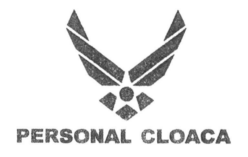

PERSONAL CLOACA

2000, 65 X 50 CM (29 5/8 X 19 5/8 INCHES), PENCIL, COLOUR PENCIL & MARKER ON PAPER
(PRIVATE COLLECTION, BELGIUM)

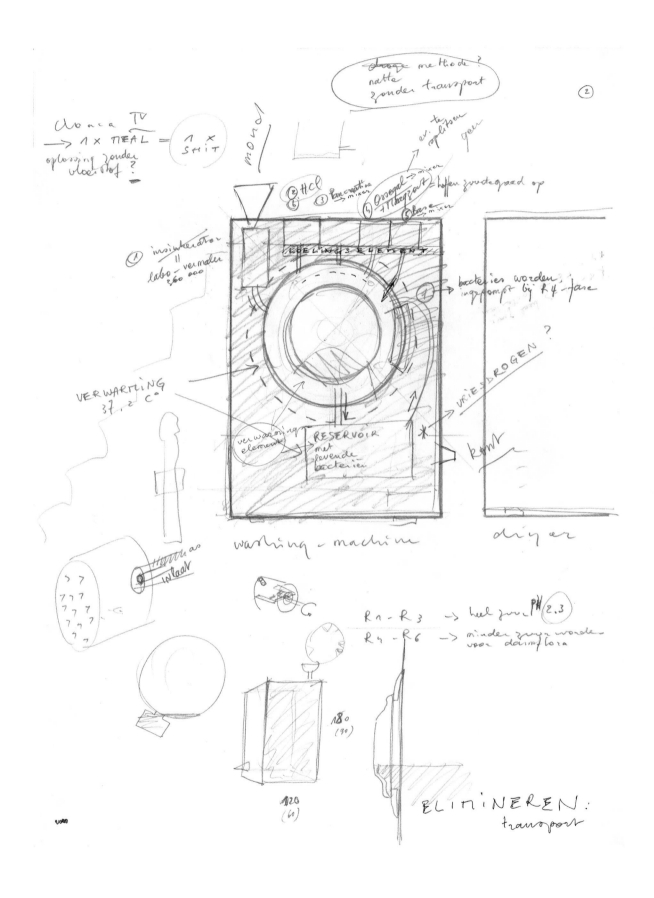

2001, 65 X 50 CM (29 5/8 X 19 5/8 INCHES), PENCIL & MARKER ON PAPER
(PRIVATE COLLECTION, BELGIUM)

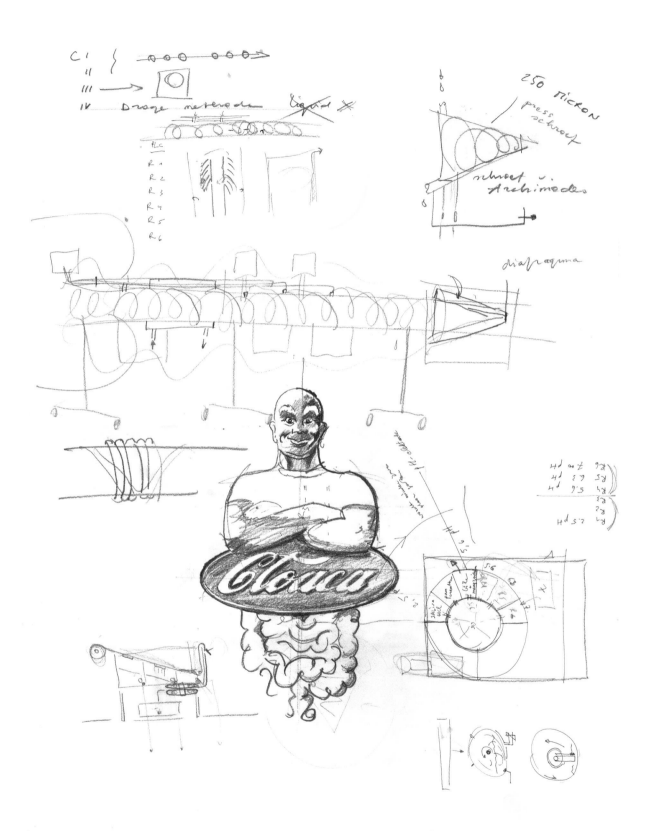

2001, 55 X 75 CM (21 5/8 X 29 1/2 INCHES), PENCIL, COLOUR PENCIL, MARKER & COLLAGE ON PAPER

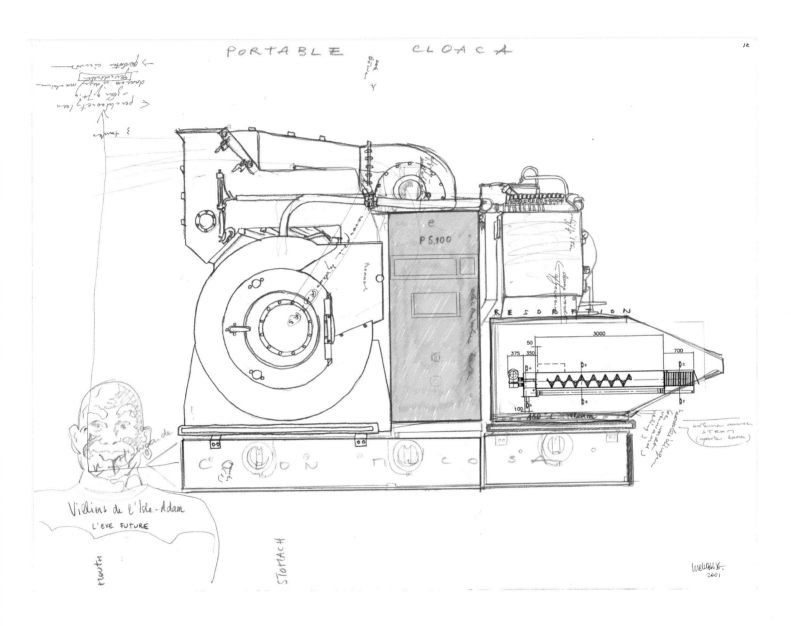

PORTABLE CLOACA

12

RESORPTION

P 5.100

Villiers de l'Isle-Adam

L'EVE FUTURE

mouth

STOMACH

2002, 75 X 55 CM (29 1/2 X 21 5/8 INCHES), PENCIL, COLOUR PENCIL, MARKER & STAMP INK ON PAPER

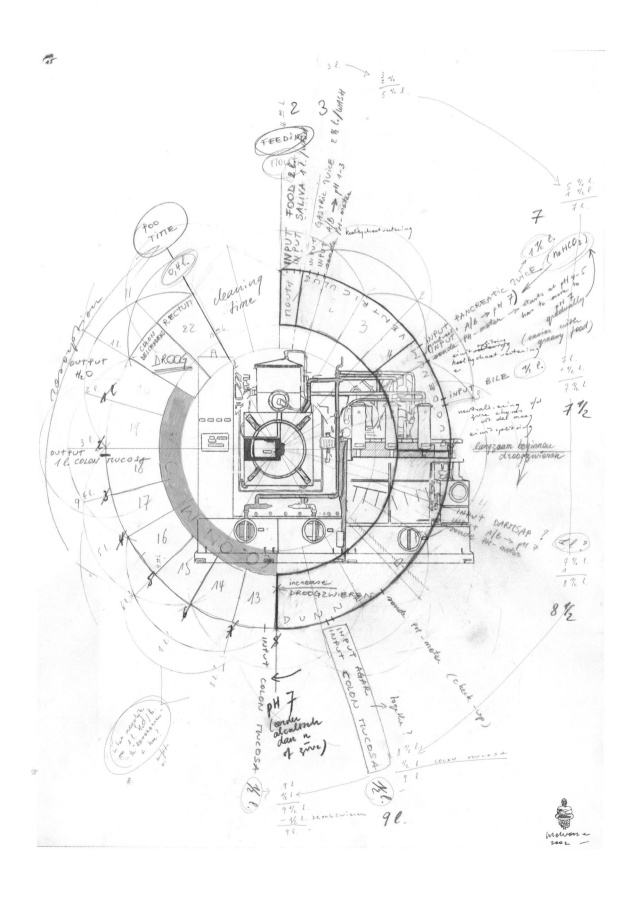

2002, 65 X 50 CM (29 5/8 X 19 5/8 INCHES), PENCIL, COLOUR PENCIL, MARKER & STAMP INK ON PAPER

GASPILLA — BACKSIDE

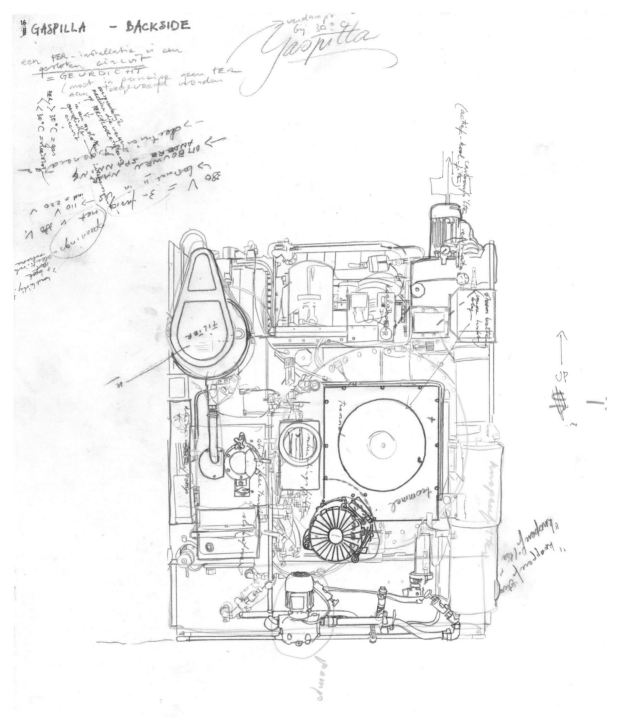

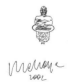

2002, 65 X 50 CM (29 5/8 X 19 5/8 INCHES), PENCIL, MARKER & STAMP INK ON PAPER
(PRIVATE COLLECTION, BELGIUM)

2002, 65 X 50 CM (29 5/8 X 19 5/8 INCHES), PENCIL, MARKER & STAMP INK ON PAPER
(PRIVATE COLLECTION, BELGIUM)

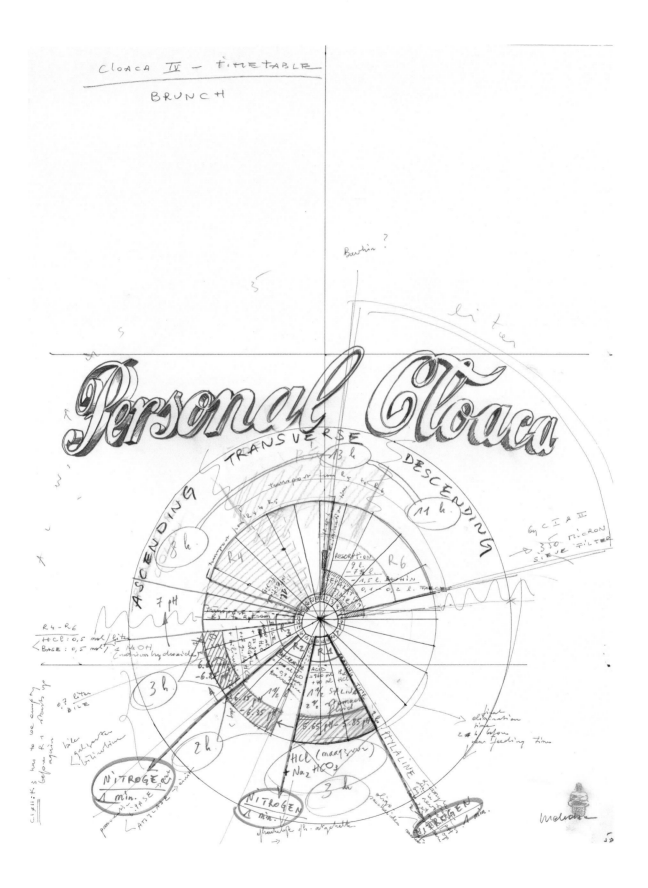

2002, 65 X 50 CM (29 5/8 X 19 5/8 INCHES), PENCIL, WATERCOLOUR, MARKER & STAMP INK ON PAPER
(PRIVATE COLLECTION, BELGIUM)

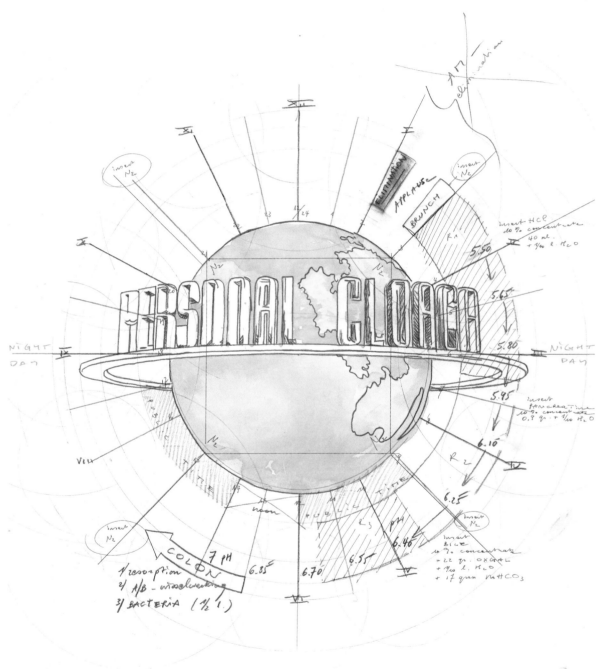

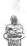

2002, 65 X 50 CM (29 5/8 X 19 5/8 INCHES), PENCIL, COLOUR PENCIL & STAMP INK ON PAPER
(PRIVATE COLLECTION, BELGIUM)

CLOACA — AT HOME

2002, 65 X 50 CM (29 5/8 X 19 5/8 INCHES), PENCIL, COLOUR PENCIL, MARKER & STAMP INK ON PAPER
(PRIVATE COLLECTION, BELGIUM)

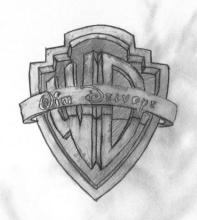

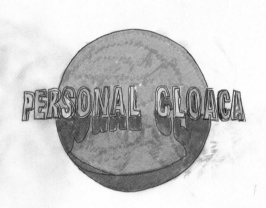

4

BE AT HOME WITH

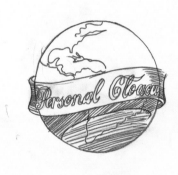

5

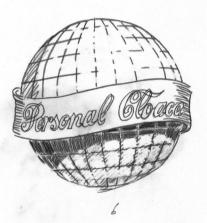

6

wherever home is ...

63

2000 – 2002, 55 X 75 CM (21 5/8 X 29 1/2 INCHES), PENCIL, COLOUR PENCIL, MARKER & STAMP INK ON PAPER

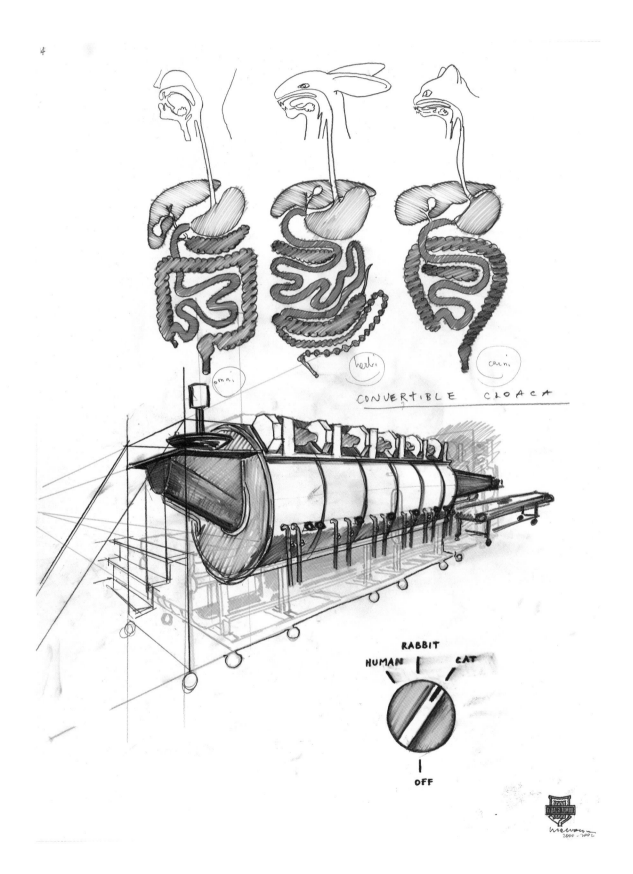

CONVERTIBLE CLOACA

2000 – 2002, 62 X 45 CM (24 3/8 X 17 3/4 INCHES), PENCIL, COLOUR PENCIL & MARKER ON PAPER

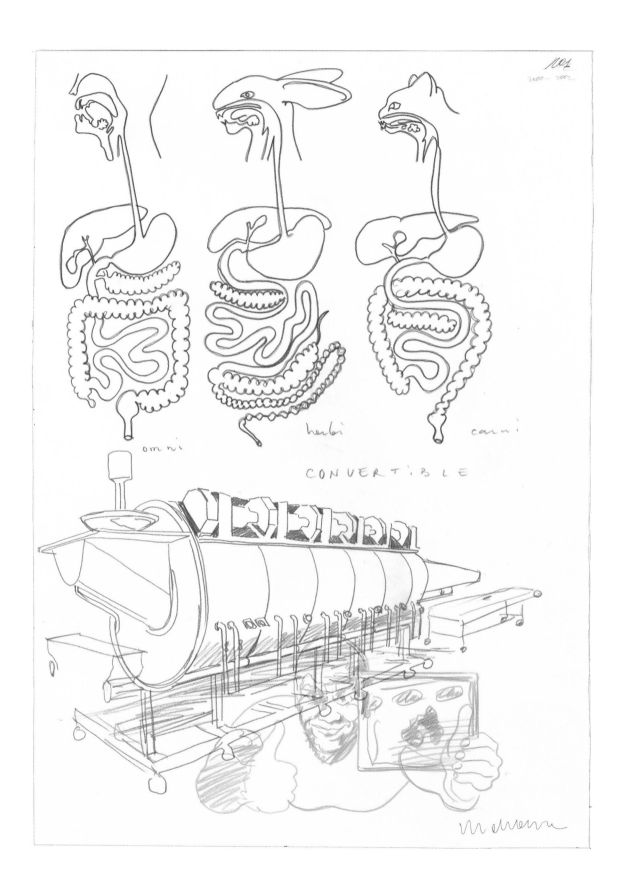

omni

herbi

carni

CONVERTIBLE

2000 – 2002, 62.5 X 46 CM (24 5/8 X 18 1/8 INCHES), PENCIL, COLOUR PENCIL, MARKER & COLLAGE ON PAPER

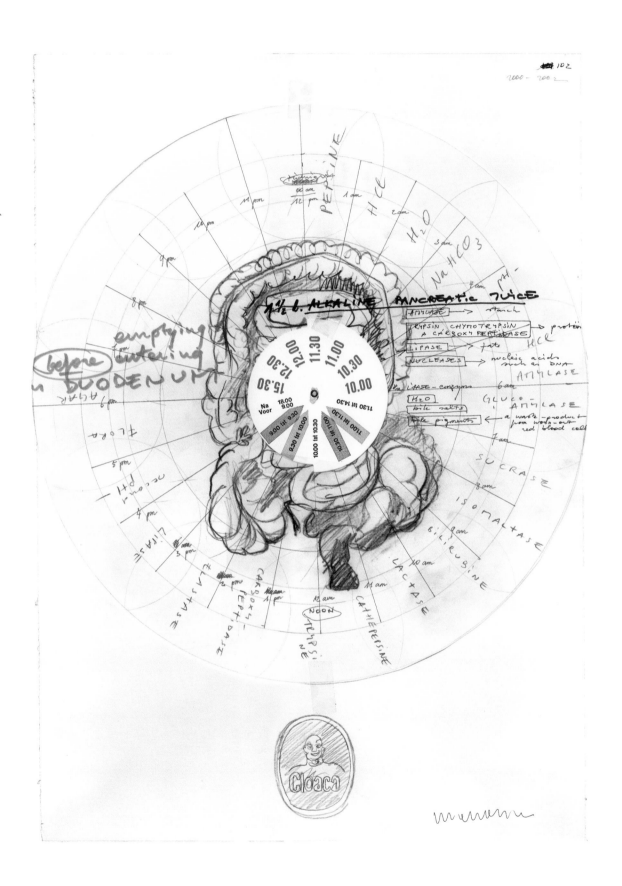

2003, 65 X 50 CM (29 5/8 X 19 5/8 INCHES), PENCIL & MARKER ON PAPER

Warner Bros - logo

Personal Cloaca — letters van coca-cola

1

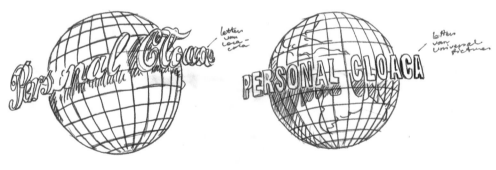

Personal Cloaca — letters van coca-cola

2

PERSONAL CLOACA — letters van Universal Pictures

3

2003, 65 X 50 CM (29 5/8 X 19 5/8 INCHES), PENCIL ON PAPER

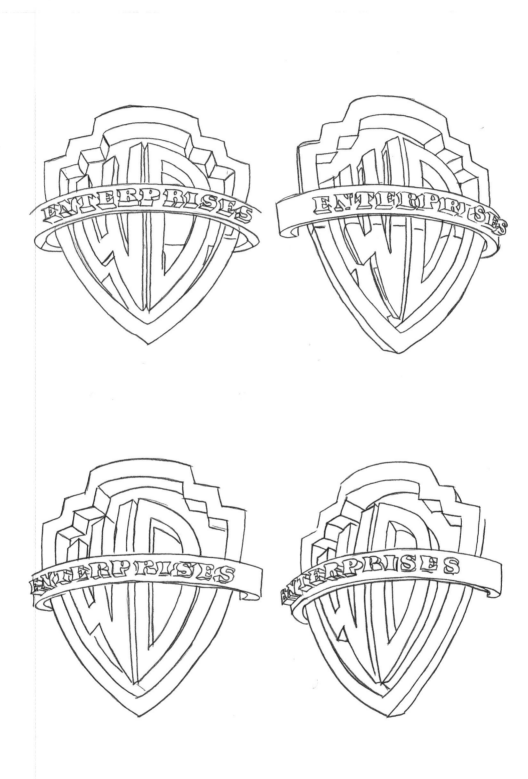

2004, 75.5 X 55.5 CM (29 3/4 X 21 7/8 INCHES), PENCIL & MARKER ON PAPER

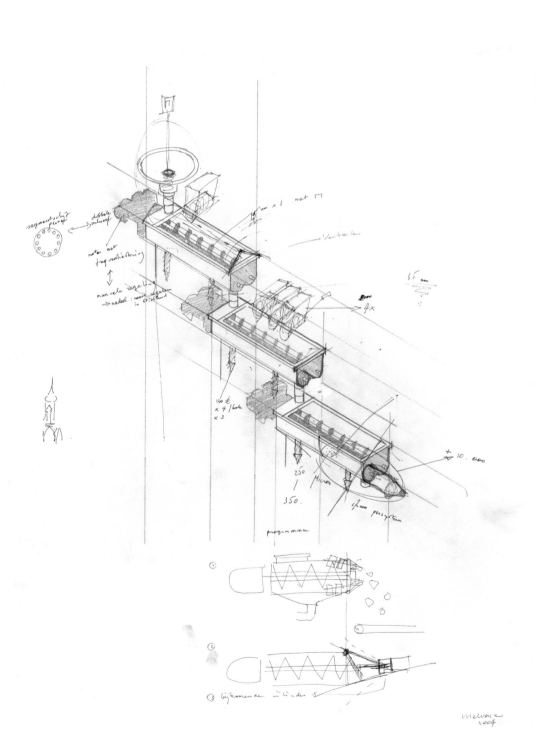

2004, 75.5 X 55.5 CM (29 3/4 X 21 7/8 INCHES), PENCIL, COLOUR PENCIL & MARKER ON PAPER

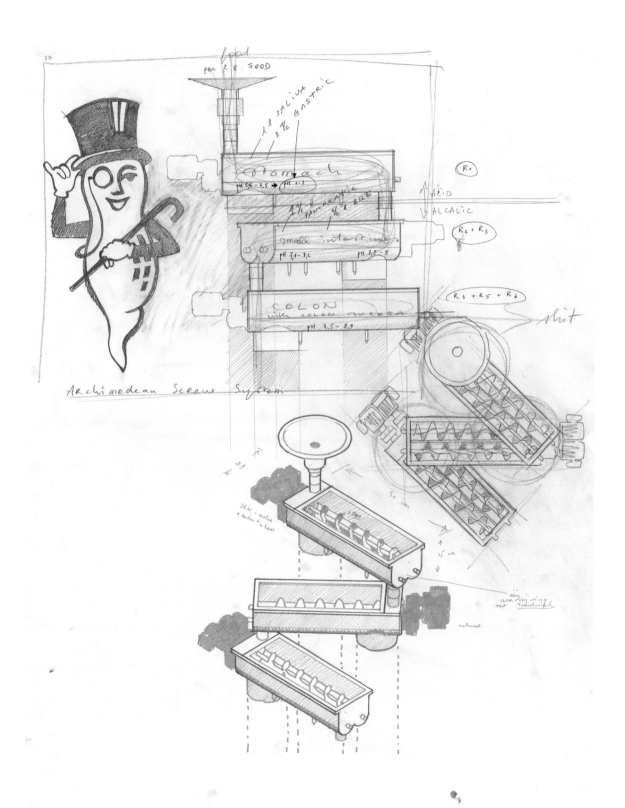

Studies for Super Cloaca

1998 – 2005

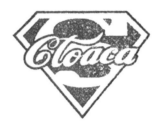

2000, 65.5 X 50 CM (25 3/4 X 19 5/8 INCHES), PENCIL, COLOUR PENCIL, MARKER & STAMP INK ON PAPER
(PRIVATE COLLECTION, FRANCE)

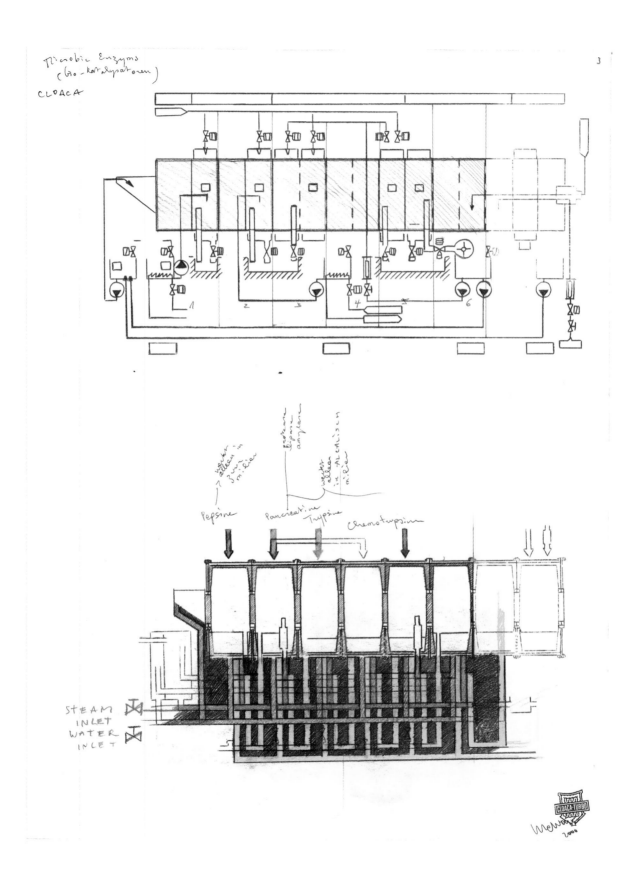

2000 – 2002, 75.5 X 55.5 CM (29 3/4 X 21 7/8 INCHES), PENCIL, COLOUR PENCIL,
WATERCOLOUR & STAMP INK ON PAPER (IGAL AHOUVI COLLECTION, ISRAËL)

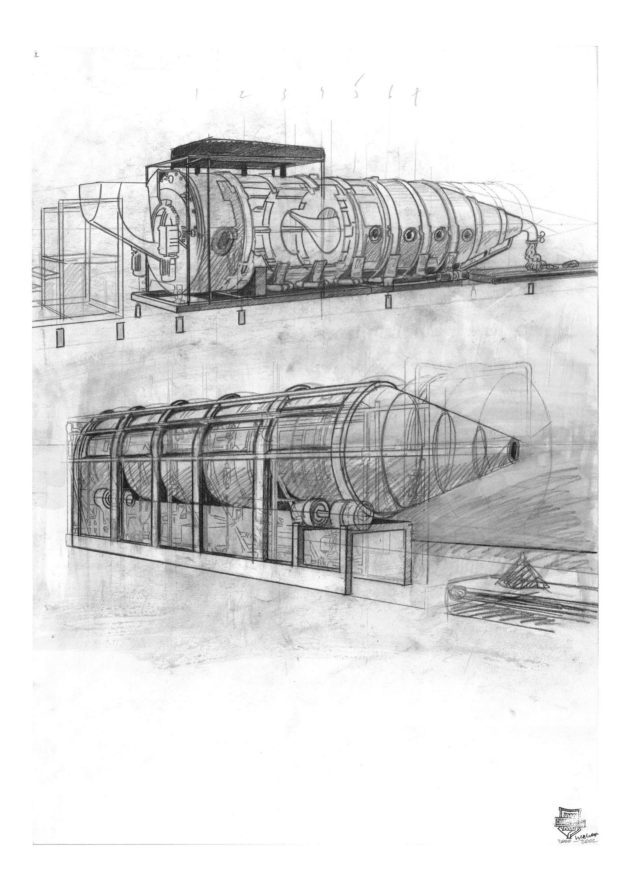

2001, 65 X 50 CM (29 5/8 X 19 5/8 INCHES), PENCIL, COLOUR PENCIL, WATERCOLOUR,
MARKER & STAMP INK ON PAPER (PRIVATE COLLECTION, BELGIUM)

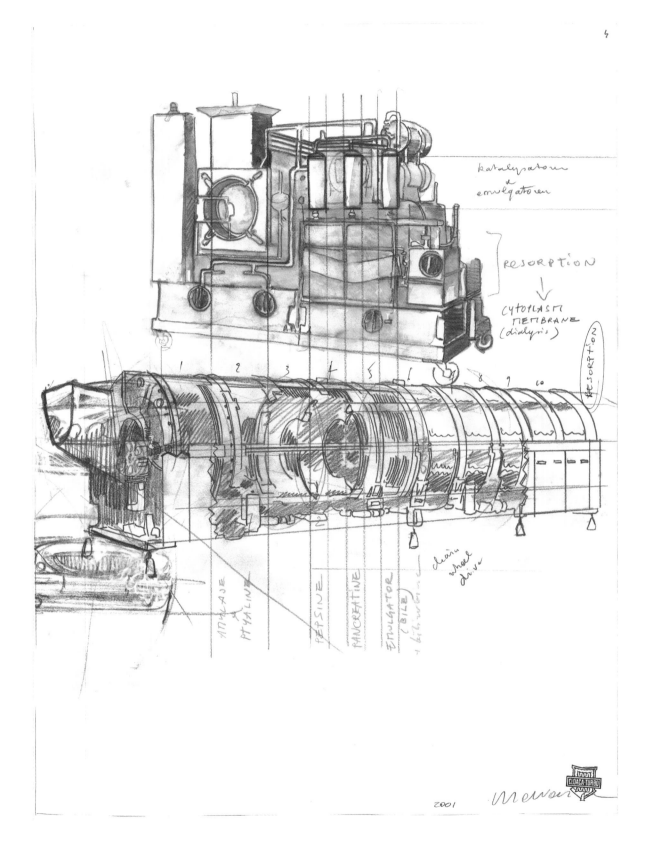

2001, 23.5 X 46 CM (9 1/4 X 18 1/8 INCHES), COLOUR PENCIL, WATERCOLOUR & STAMP INK ON PAPER
(PRIVATE COLLECTION, BELGIUM)

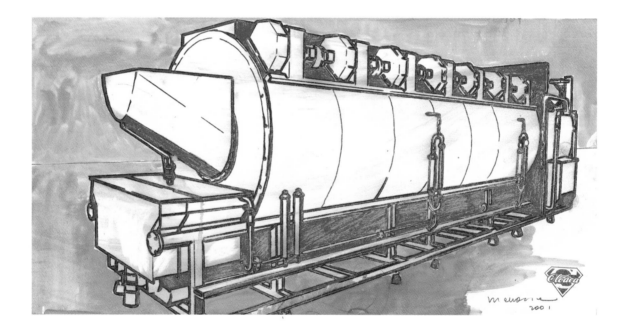

2000 – 2002, 75 X 55 CM (29 1/2 X 21 5/8 INCHES), PENCIL, COLOUR PENCIL, WATERCOLOUR, MARKER & STAMP INK ON PAPER (PRIVATE COLLECTION, BELGIUM)

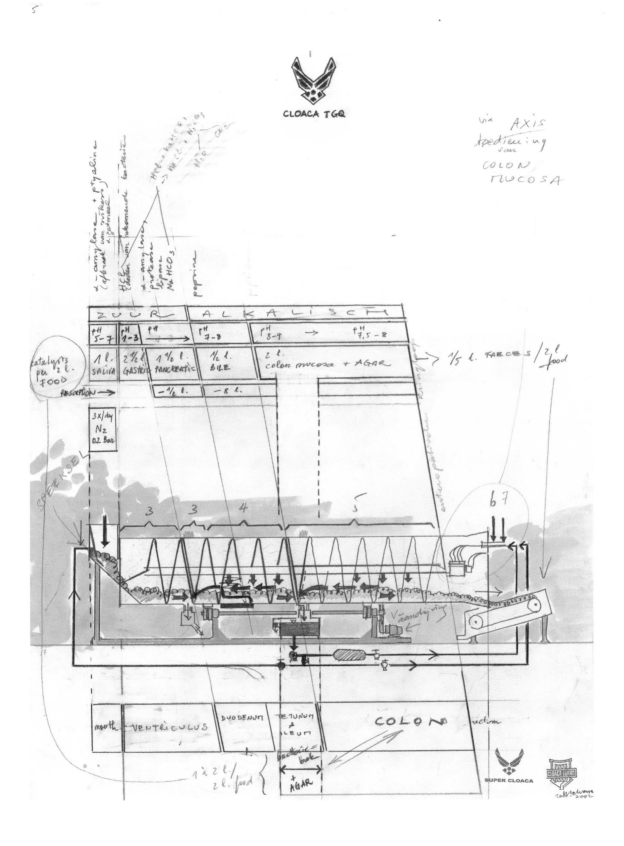

2000 – 2002, 75 X 55 CM (29 1/2 X 21 5/8 INCHES), PENCIL, WATERCOLOUR, MARKER & STAMP INK ON PAPER
(PRIVATE COLLECTION, BELGIUM)

connections
+ Bar

Jenking Continuous Batch Washer
Universal
Fratelli Rosa SRL Washing Tunnel LVE 50-10
6200 - 26400 kg net weight

" operating weight

WATER
EXTRACTION
PRESS SEP

2730
mm
H

+1/+2/+3

solenoid valves for air control stainless steel pneumatic valves for steam control
6 - 10 Bar 4 - 6 Bar
(AIR) (STEAM)

6112 mm - 18612 mm

(ELECTRICITY) membrane solenoid valves for water control
 HOT + COLD
external protection WATER
in Ampere at 380-420 V 2-5 - 6 Bar
 seals 1-4 Bar
 "
 E PDM - caoutchouc

load capacity Kg. 50
production Kg./hour = 750 -1200
water in compartment ratio = 1:33
tunnel rotation 270°
rotation motors N.2 × 7,5 KW.

CLOACA-TURBO

2000 – 2002, 75 X 55 CM (29 1/2 X 21 5/8 INCHES), PENCIL, WATERCOLOUR, MARKER & STAMP INK ON PAPER
(IGAL AHOUVI COLLECTION, ISRAËL)

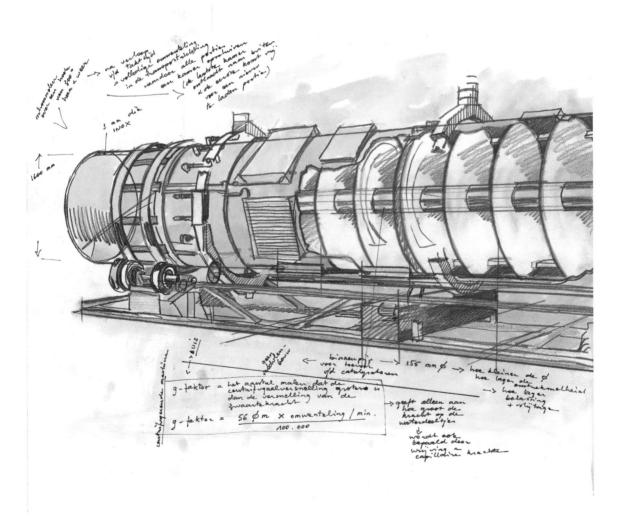

2000 – 2002, 75 X 55 CM (29 1/2 X 21 5/8 INCHES), PENCIL, COLOUR PENCIL & STAMP INK ON PAPER

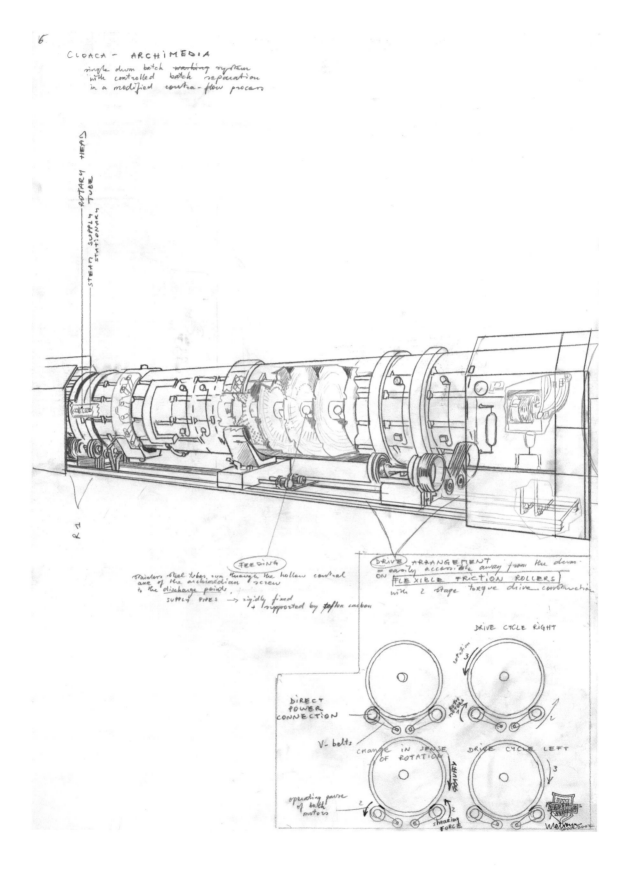

2000 – 2002, 75 X 55 CM (29 1/2 X 21 5/8 INCHES), PENCIL, COLOUR PENCIL, MARKER & STAMP INK ON PAPER
(IGAL AHOUVI COLLECTION, ISRAËL)

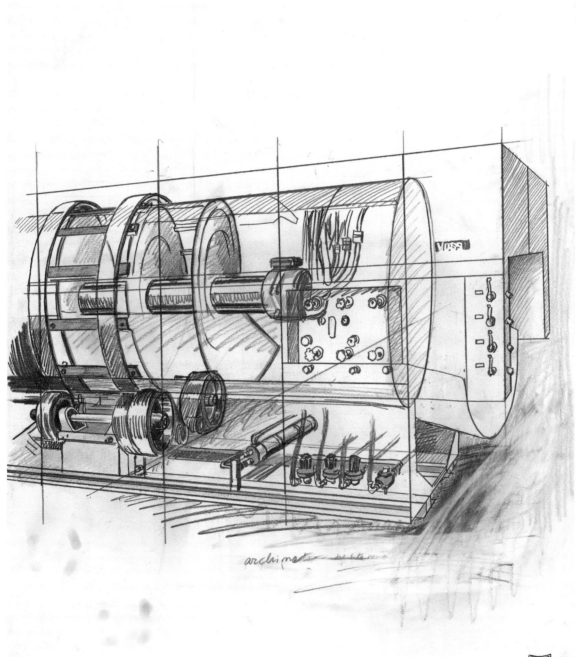

2000 – 2002, 75 X 55 CM (29 1/2 X 21 5/8 INCHES), PENCIL, COLOUR PENCIL, MARKER & STAMP INK ON PAPER
(PRIVATE COLLECTION, BELGIUM)

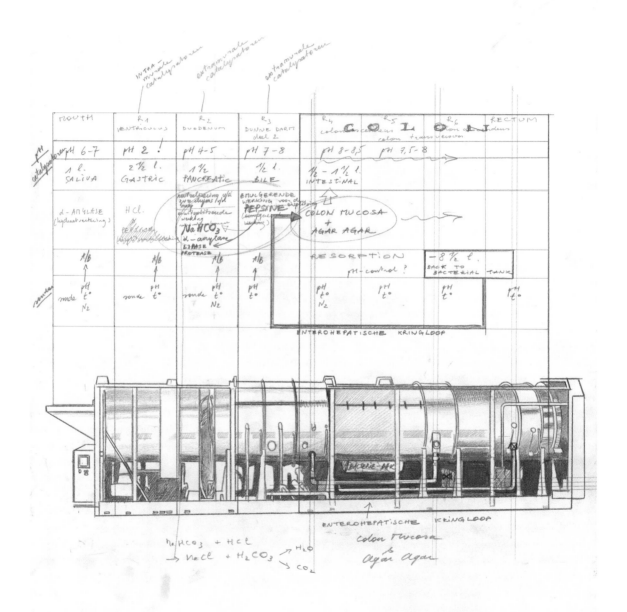

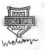

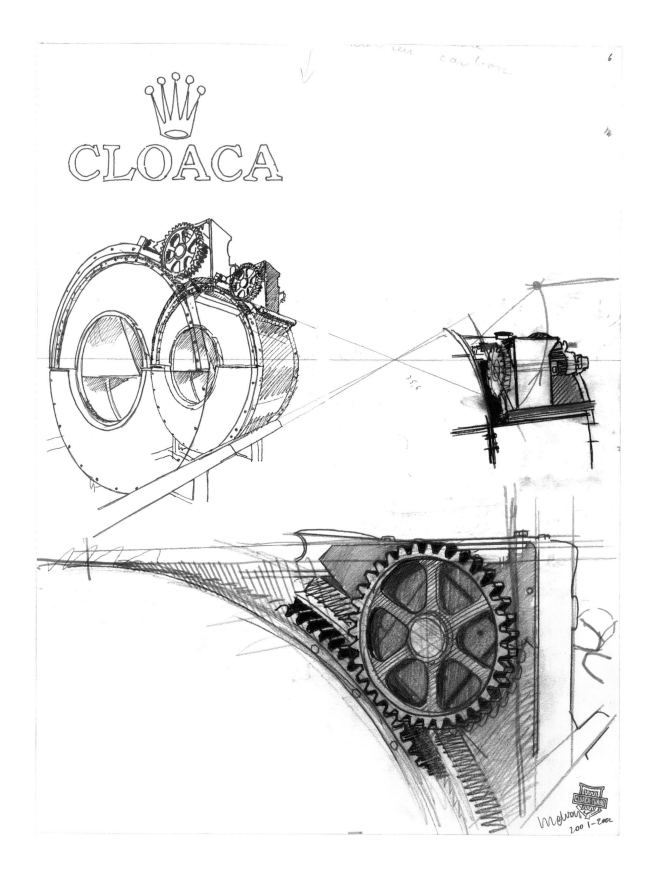

2002, 62 X 53 CM (24 3/8 X 20 7/8 INCHES), PENCIL, COLOUR PENCIL, TAPE & STAMP INK ON PAPER
(PRIVATE COLLECTION, BELGIUM)

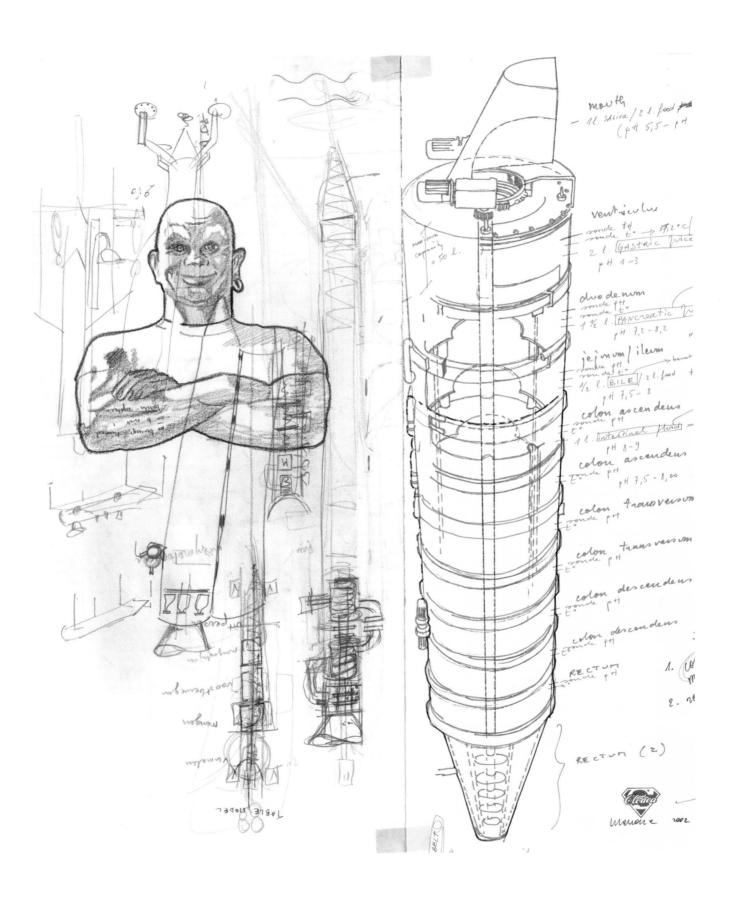

2002, 37.5 X 55 CM (14 3/4 X 21 5/8 INCHES), PENCIL, COLOUR PENCIL, MARKER & STAMP INK ON PAPER
(PRIVATE COLLECTION, BELGIUM)

2003, 75 X 55 CM (29 1/2 X 21 5/8 INCHES), PENCIL, WATERCOLOUR, MARKER & STAMP INK ON PAPER

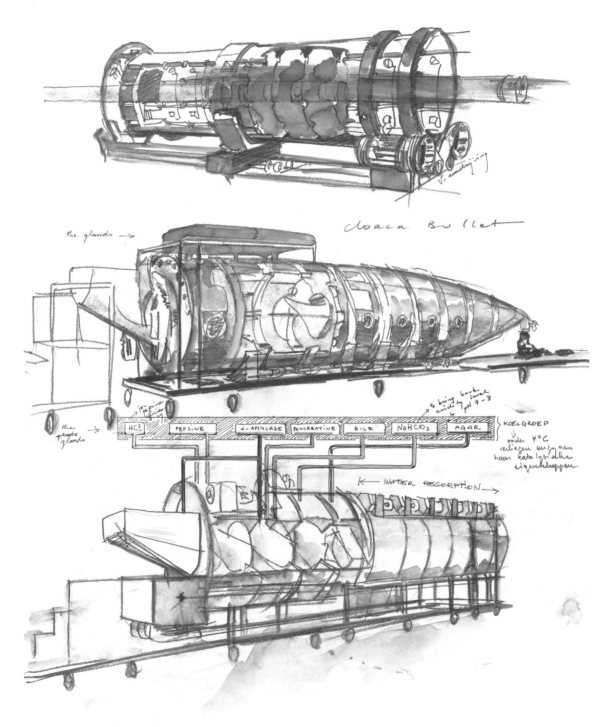

Cloaca Bullet

the glands →

the plants glands →

| HCl | PEPSINE | d-AMYLASE | PANCREATINE | BILE | NaHCO₃ | AGAR | KOELGROEP |

← WATER RESORPTION →

2002, 36.6 X 55.5 CM (14 3/8 X 21 7/8 INCHES), PENCIL, COLOUR PENCIL, MARKER & STAMP INK ON PAPER
(PRIVATE COLLECTION, BELGIUM)

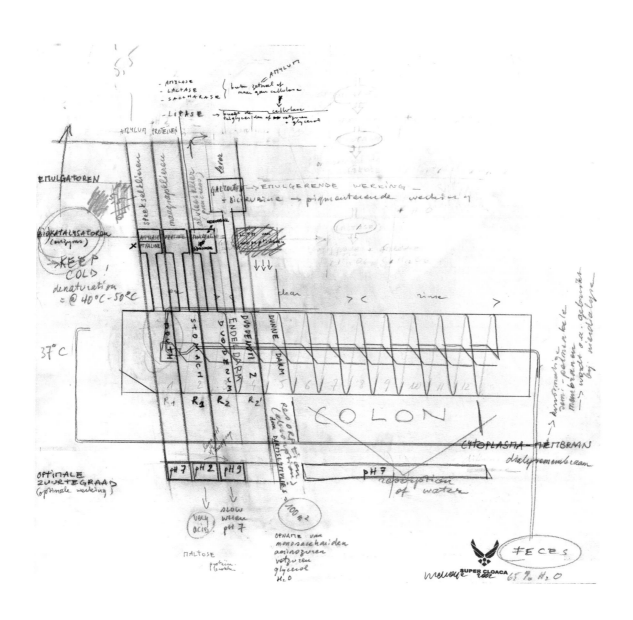

2002, 36.6 X 55.5 CM (14 3/8 X 21 7/8 INCHES), PENCIL, COLOUR PENCIL, WATERCOLOUR, MARKER & STAMP INK ON PAPER (PRIVATE COLLECTION, BELGIUM)

Cloaca

6 – BATCH – system

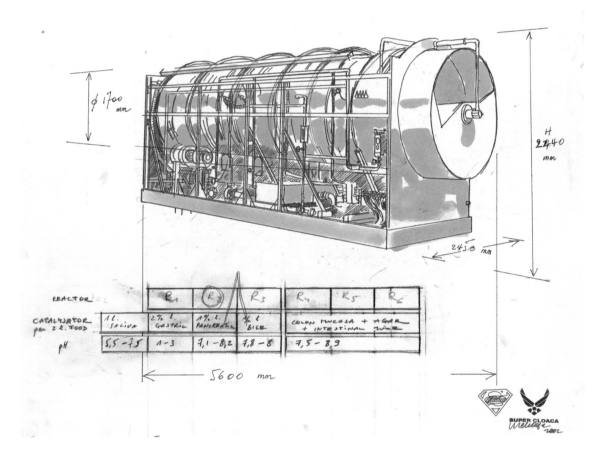

REACTOR 02	R_1	R_2	R_3		R_4	R_5	R_6
CATALYSATOR per 2 l. FOOD	1 l. SALIVA	2½ l. GASTRIC	1% l. PANCREATIC	½ l. BILE	COLON MUCOSA + AGAR + INTESTINAL juice		
pH	5,5 – 7,5	1 – 3	7,1 – 8,2	7,8 – 8	7,5 – 8,9		

SUPER CLOACA
Wim Delvoye 2002

2002, 36.6 X 55.5 CM (14 3/8 X 21 7/8 INCHES), PENCIL, COLOUR PENCIL, MARKER & STAMP INK ON PAPER
(PRIVATE COLLECTION, BELGIUM)

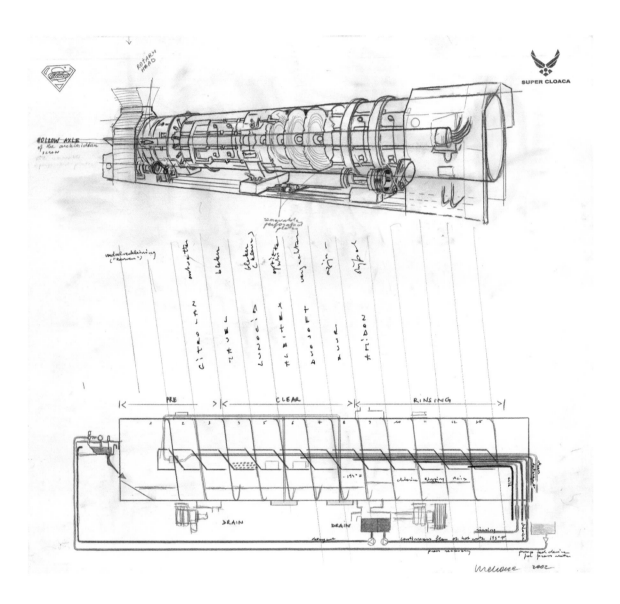

2002, 36.6 X 55.5 CM (14 3/8 X 21 7/8 INCHES), PENCIL, COLOUR PENCIL, WATERCOLOUR,
MARKER & STAMP INK ON PAPER (PRIVATE COLLECTION, BELGIUM)

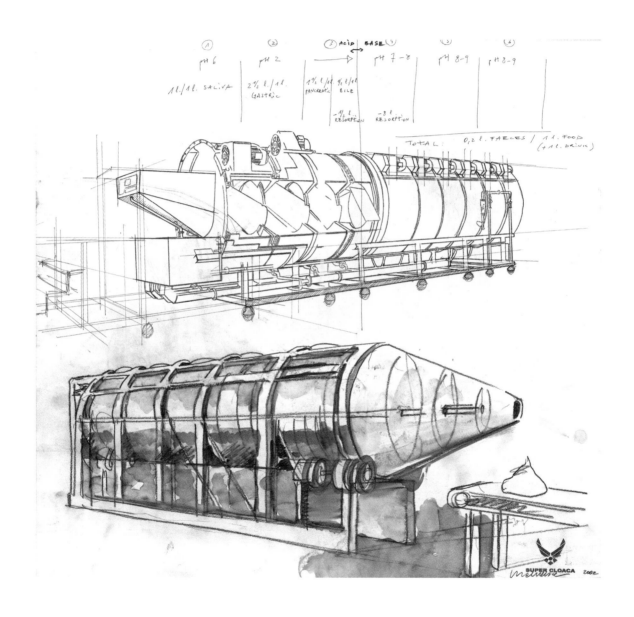

2002, 36.6 X 55.5 CM (14 3/8 X 21 7/8 INCHES), PENCIL, COLOUR PENCIL, WATERCOLOUR, MARKER & STAMP INK ON PAPER (PRIVATE COLLECTION, BELGIUM)

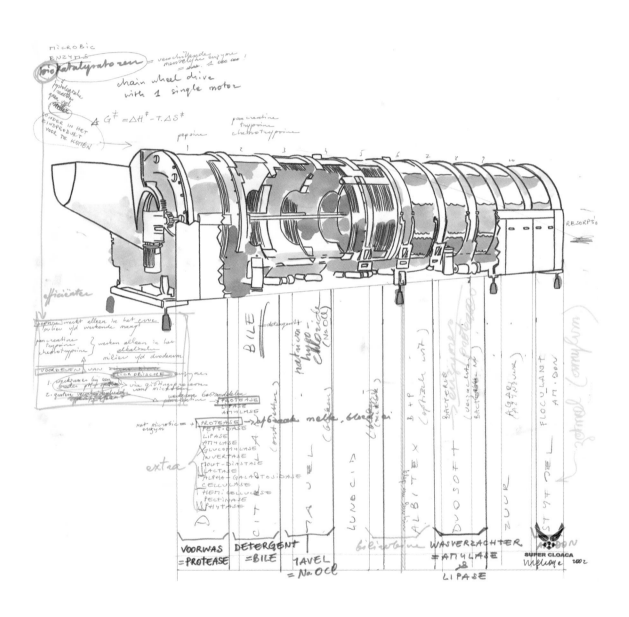

2002, 36.6 X 55.5 CM (14 3/8 X 21 7/8 INCHES), PENCIL, MARKER & STAMP INK ON PAPER
(PRIVATE COLLECTION, BELGIUM)

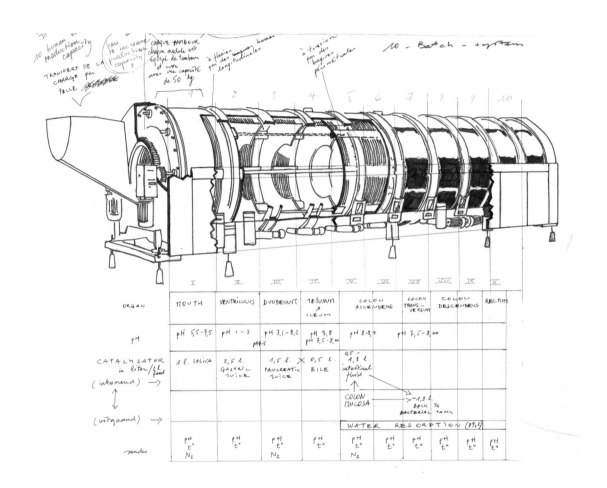

ORGAN	MOUTH	VENTRICULUS	DUODENUM	JEJUNUM à ILEUM	COLON ASCENDENS	COLON TRANS-VERSUM	COLON DESCENDENS	RECTUM		
	I	II	III	IV	V	VI	VII	VIII	IX	X
pH	pH 5,5-7,5	pH 1-3	pH 7,1-8,2 pH 4-5	pH 7,8 pH 7,5-8,00	pH 8-8,4	pH 7,5-8,00				
CATALYSATOR in liter/g l. food (inkomend) →	1 l. SALIVA	2,5 l. GASTRIC JUICE	1,5 l. PANCREATIC JUICE ✕ 0,5 l. BILE		0,5-1,8 l. intestinal fluid					
↑ ↓ (utgaand) →					COLON MUCOSA	~1,8 l. BACK TO BACTERIAL TANK				
					WATER	RESORPTION	(89,4)			
sondes	pH t° N₂	pH t°	pH t° N₂	pH t°	pH t° N₂	pH t°	pH t°	pH t°	pH t°	pH t°

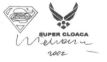

SUPER CLOACA
2002

2002, 36.6 X 55.5 CM (14 3/8 X 21 7/8 INCHES), PENCIL, COLOUR PENCIL, TAPE, MARKER & STAMP INK ON PAPER
(PRIVATE COLLECTION, BELGIUM)

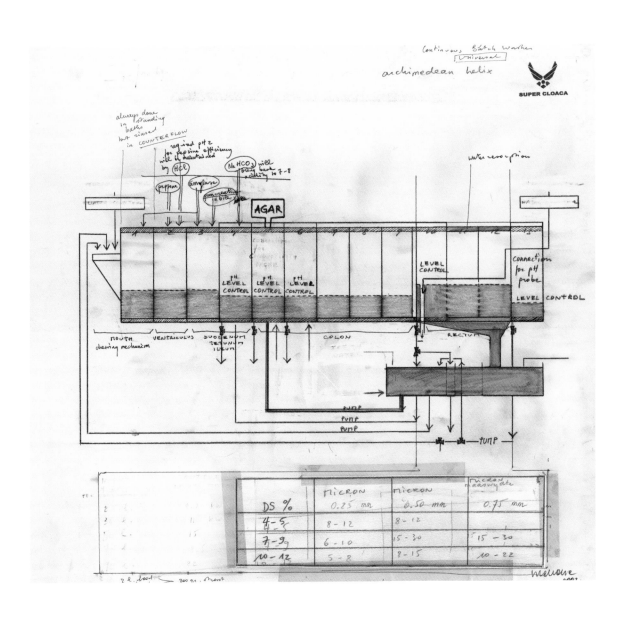

2002, 36.6 X 55.5 CM (14 3/8 X 21 7/8 INCHES), PENCIL, COLOUR PENCIL, WATERCOLOUR, MARKER & STAMP INK ON PAPER (PRIVATE COLLECTION, BELGIUM)

2002, 23.5 X 46 CM (9 1/4 X 18 1/8 INCHES), PENCIL, COLOUR PENCIL, BALLPOINT, MARKER & STAMP INK ON PAPER
(PRIVATE COLLECTION, BELGIUM)

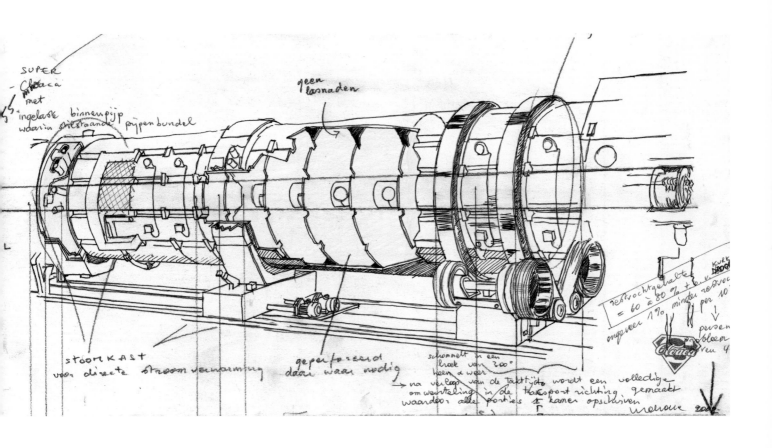

2002, 24 X 46 CM (9 1/2 X 18 1/8 INCHES), PENCIL, MARKER & STAMP INK ON PAPER
(PRIVATE COLLECTION, BELGIUM)

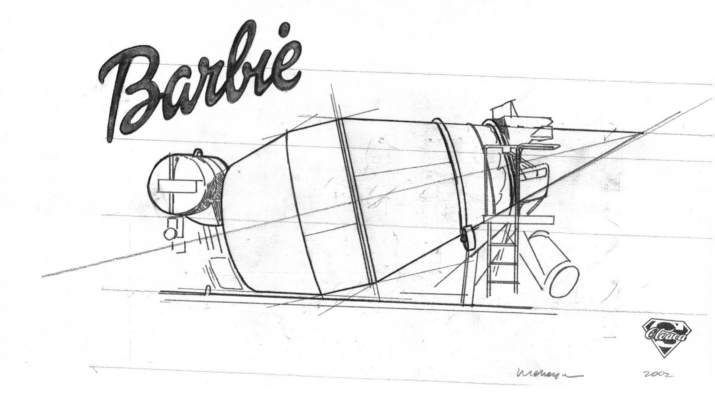

2003, 75.5 X 55.5 CM (29 3/4 X 21 7/8 INCHES), PENCIL, COLOUR PENCIL, WATERCOLOUR
MARKER & STAMP INK ON PAPER (PRIVATE COLLECTION, BELGIUM)

RECTUM & MOUTH (1)

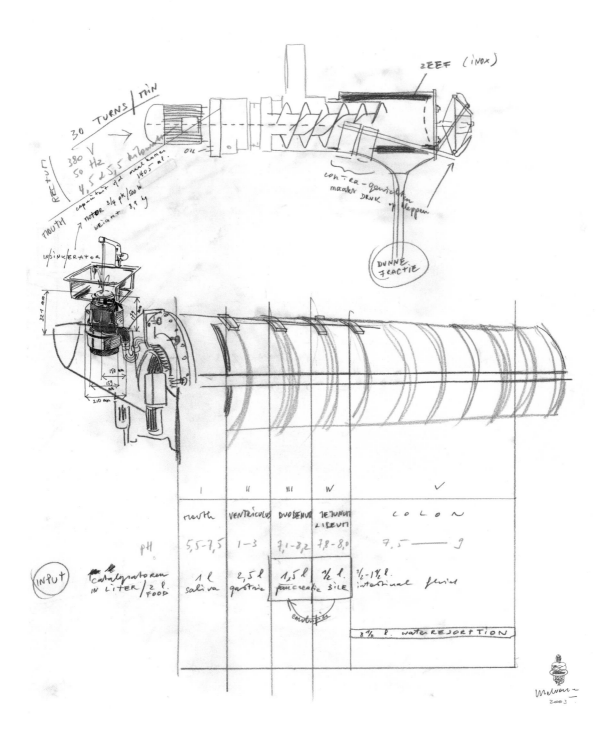

	I	II	III	IV	V
	mouth	VENTRICULUS	DUODENUM	JEJUNUM & ILEUM	COLON
pH	5,5-7,5	1-3	7,1-8,2	7,8-8,0	7,5 —— 9
catalysatoren IN LITER / 2 l. FOOD	1 l saliva	2,5 l gastric	1,5 l pancreatic	1/2 l. bile	1/2-1 1/2 l. intestinal fluid
					8 1/2 l. water RESORPTION

INPUT

2003, 45 X 62 CM (17 3/4 X 24 3/8 INCHES), PENCIL, COLOUR PENCIL & STAMP INK ON PAPER
(PRIVATE COLLECTION, BELGIUM)

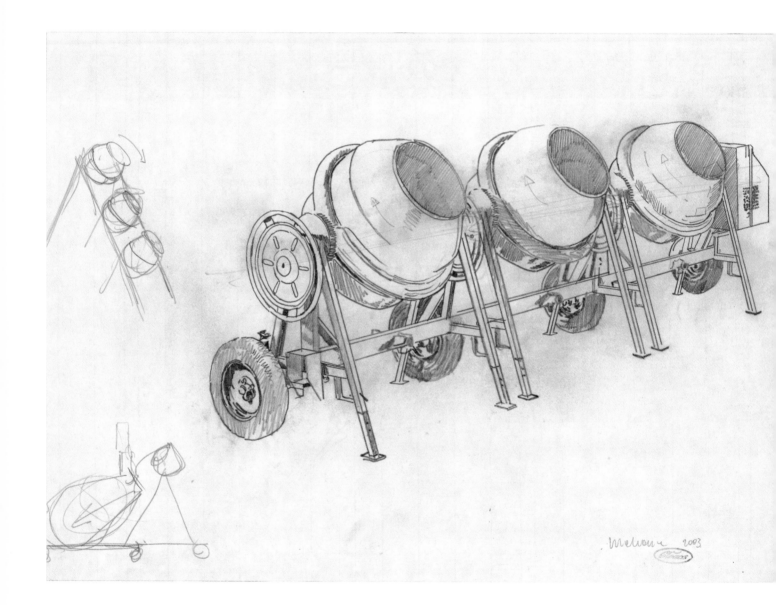

2000 - 2003, 72.5 X 106.5 CM (28 1/2 X 41 7/8 INCHES), PENCIL, COLOUR PENCIL & STAMP INK ON PAPER
(PRIVATE COLLECTION, FRANCE)

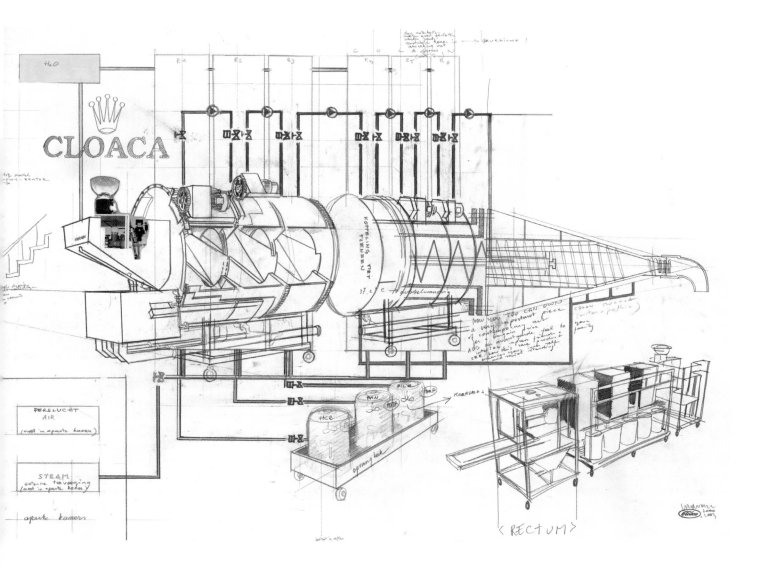

2001 - 2003, 72.5 X 106.5 CM (28 1/2 X 41 7/8 INCHES), PENCIL, COLOUR PENCIL & STAMP INK ON PAPER
(PRIVATE COLLECTION, FRANCE)

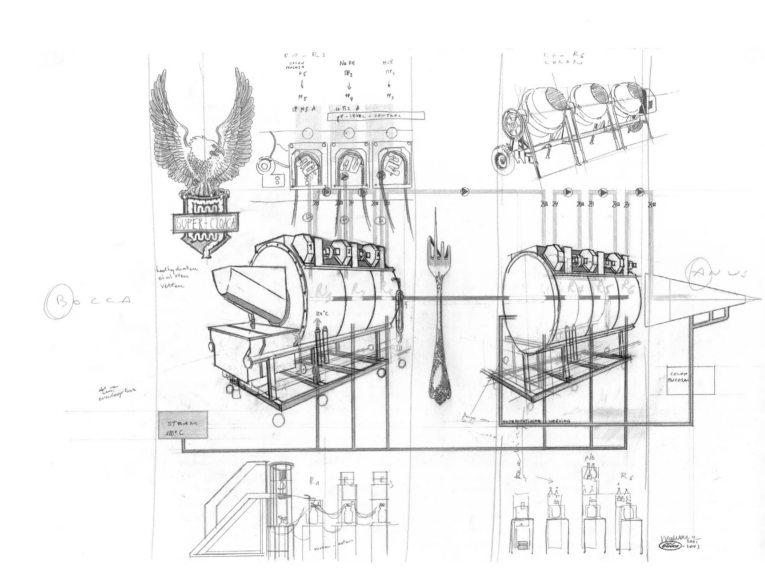

1998 – 2004, 87 X 70 CM (34 1/4 X 27 1/2 INCHES), PENCIL, COLOUR PENCIL, WATERCOLOUR, MARKER & STAMP INK ON PAPER (PRIVATE COLLECTION, FRANCE)

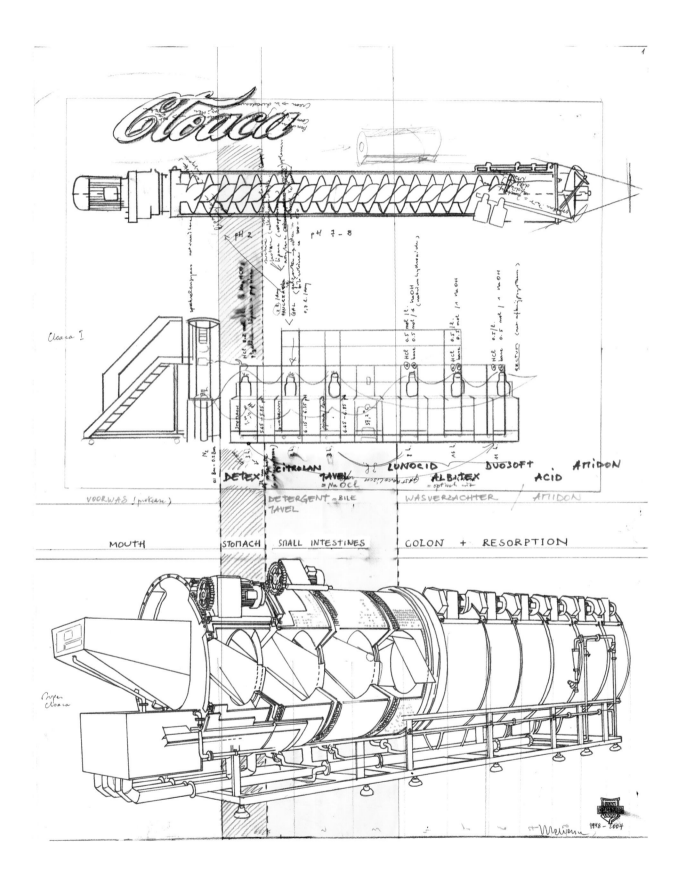

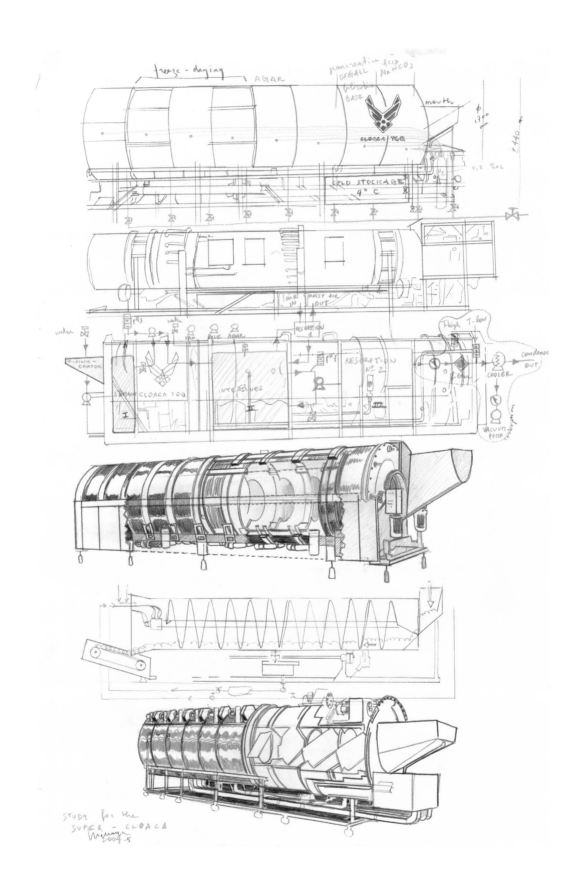

2004 – 2005, 96 X 64 CM (37 7/8 X 25 1/4 INCHES), PENCIL & COLOUR PENCIL ON PAPER

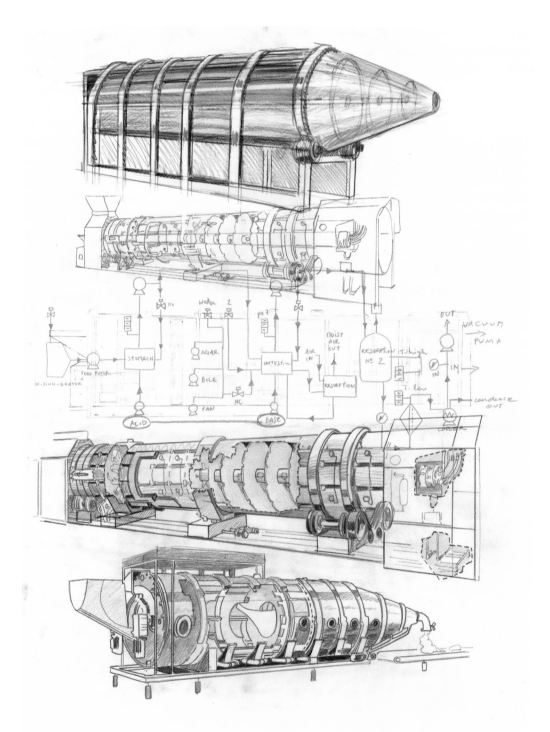

Studies for Cloaca Quattro

2000 – 2005

2000 – 2001, 75 X 55 CM (29 1/2 X 21 5/8 INCHES), PENCIL, COLOUR PENCIL, MARKER & STAMP INK ON PAPER
(PRIVATE COLLECTION, USA)

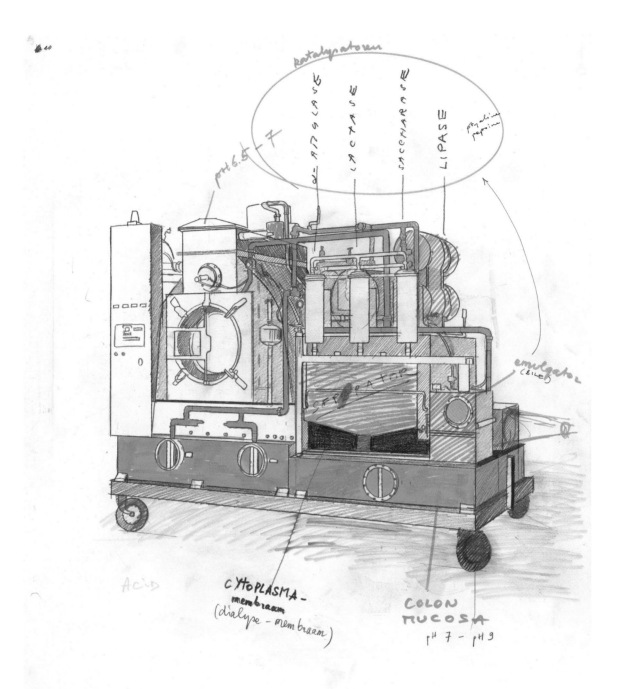

2000 – 2002, 75 X 55 CM (29 1/2 X 21 5/8 INCHES), PENCIL, COLOUR PENCIL, MARKER & STAMP INK ON PAPER

2001, 55 X 75 CM (21 5/8 X 29 1/2 INCHES), PENCIL, COLOUR PENCIL & MARKER ON PAPER
(PRIVATE COLLECTION, FRANCE)

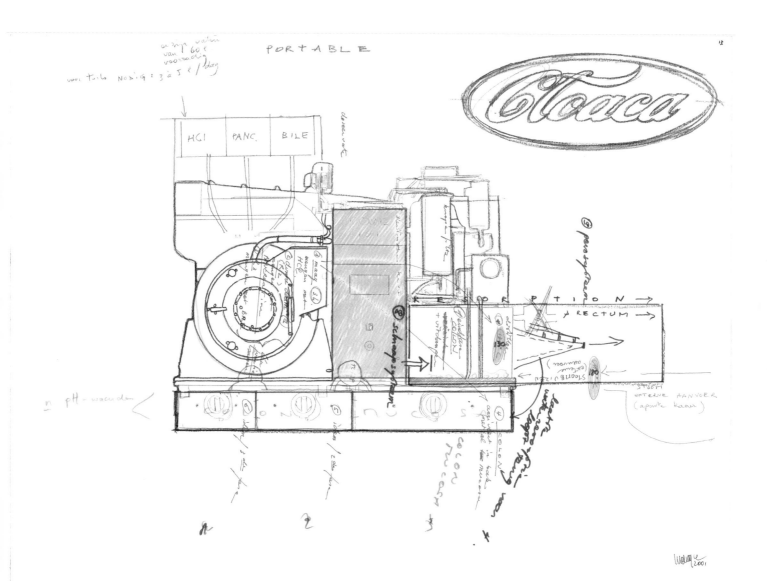

2003, 50 X 75 CM (19 5/8 X 29 1/2 INCHES), PENCIL & COLOUR PENCIL ON PAPER
(PRIVATE COLLECTION, FRANCE)

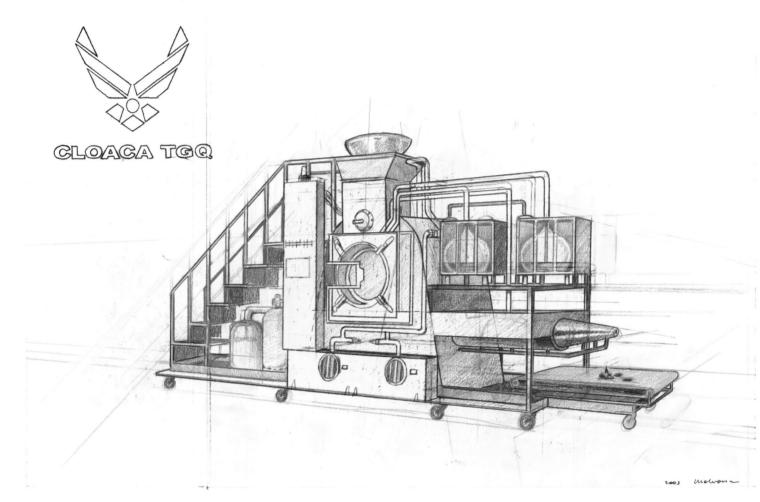

CLOACA TGQ

2003, 75 X 55 CM (29 1/2 X 21 5/8 INCHES), PENCIL, COLOUR PENCIL, WATERCOLOUR & STAMP INK ON PAPER

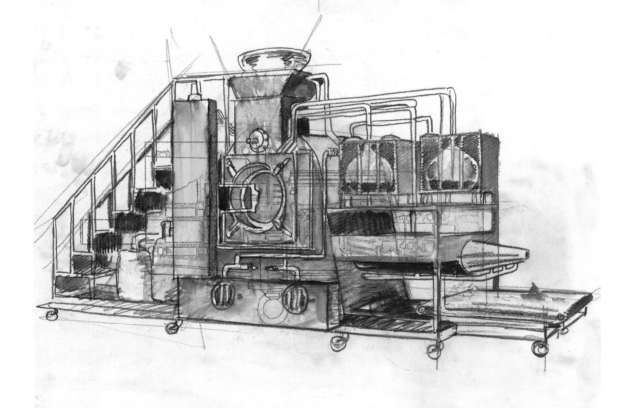

2004, 75 X 55 CM (29 1/2 X 21 5/8 INCHES), PENCIL, COLOUR PENCIL & MARKER ON PAPER

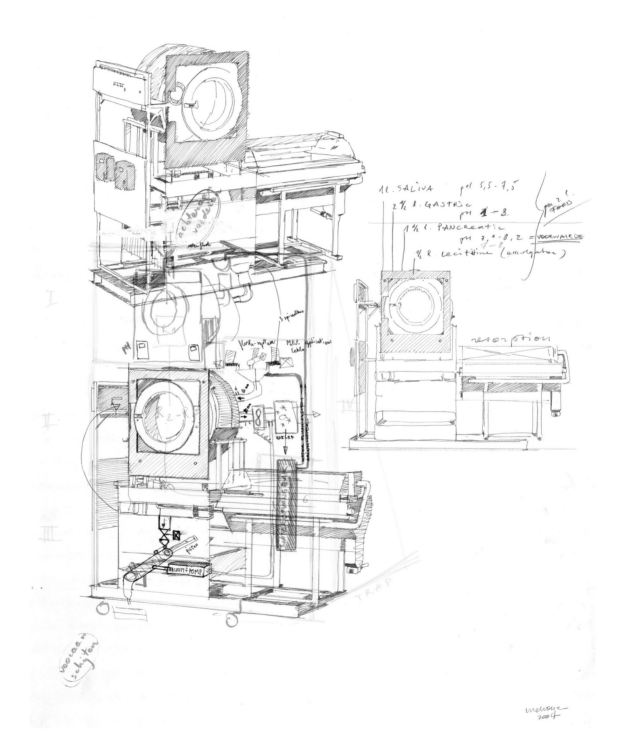

1 l. SALIVA pH 5,5 - 7,5

2½ l. GASTRIC pH 1 - 3

1½ l. PANCREATIC pH 7,1 - 8,2 = VOORWAARDE

½ l lecittine (emulgator)

2004, 75 X 55 CM (29 1/2 X 21 5/8 INCHES), PENCIL, COLOUR PENCIL & MARKER ON PAPER
(PRIVATE COLLECTION, SWITZERLAND)

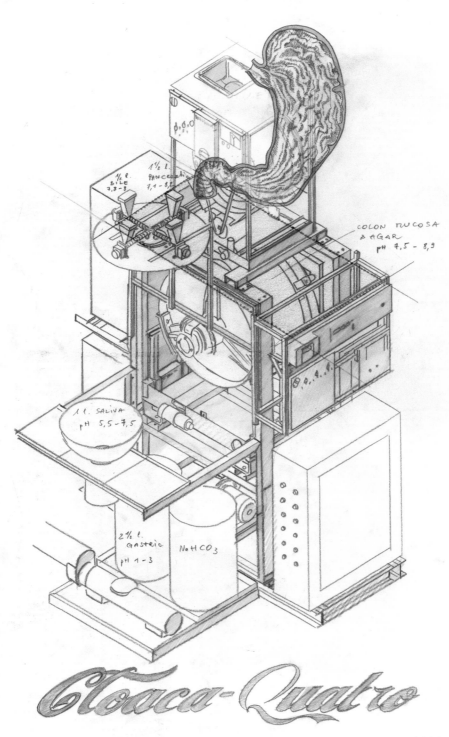

2004, 75 X 55 CM (29 1/2 X 21 5/8 INCHES), PENCIL, COLOUR PENCIL & MARKER ON PAPER
(PRIVATE COLLECTION, SWITZERLAND)

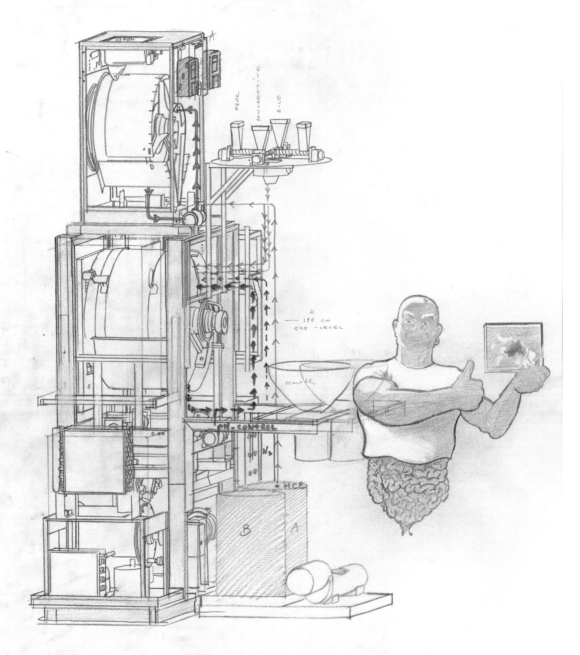

2004, 56.5 X 88.5 CM (22 1/4 X 34 7/8 INCHES), PENCIL, COLOUR PENCIL & MARKER ON PAPER
(PRIVATE COLLECTION, BELGIUM)

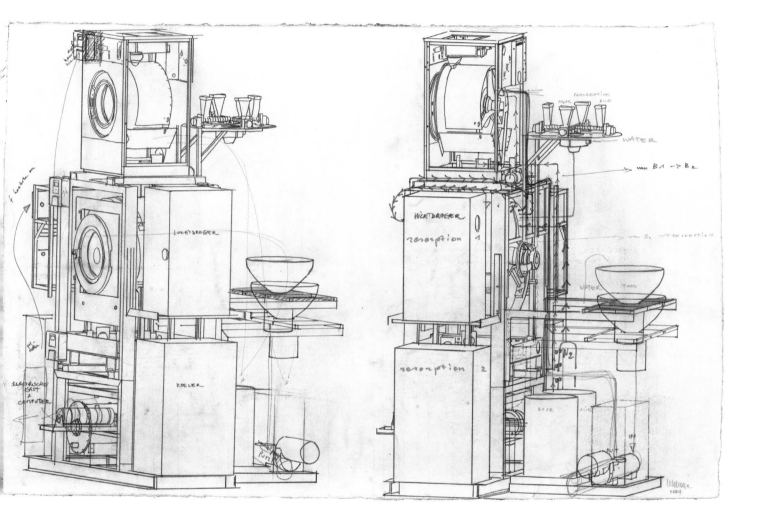

2004, 77 X 112 CM (30 3/8 X 44 INCHES), PENCIL, COLOUR PENCIL, COLLAGE, MARKER & STAMP INK ON PAPER
(PRIVATE COLLECTION, BELGIUM)

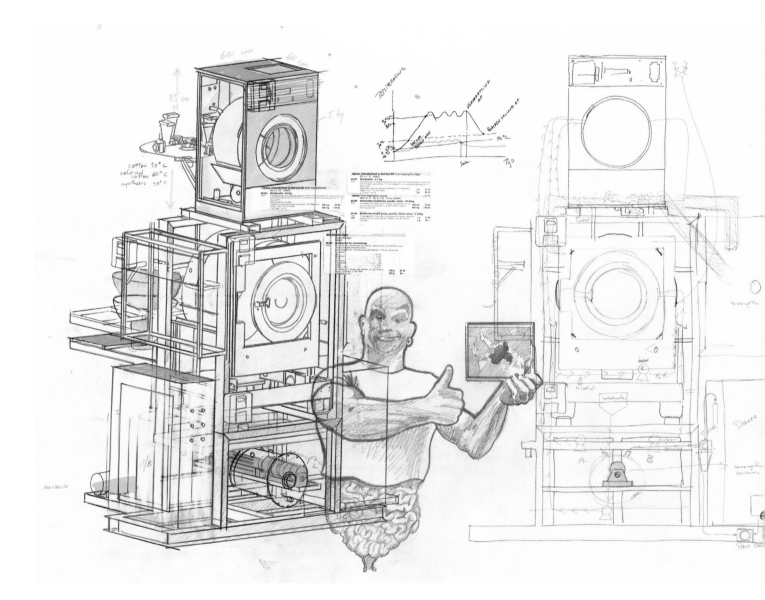

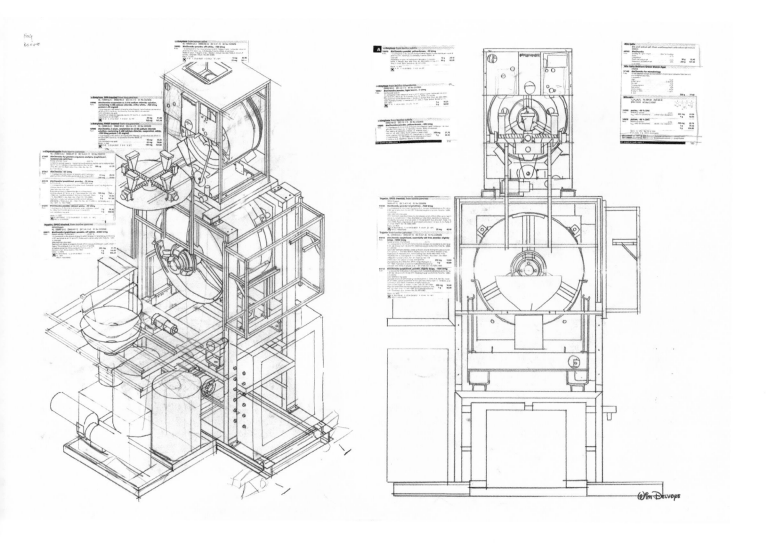

2004, 77 X 112 CM (30 3/8 X 44 INCHES), PENCIL, COLOUR PENCIL, MARKER, COLLAGE & STAMP INK ON PAPER

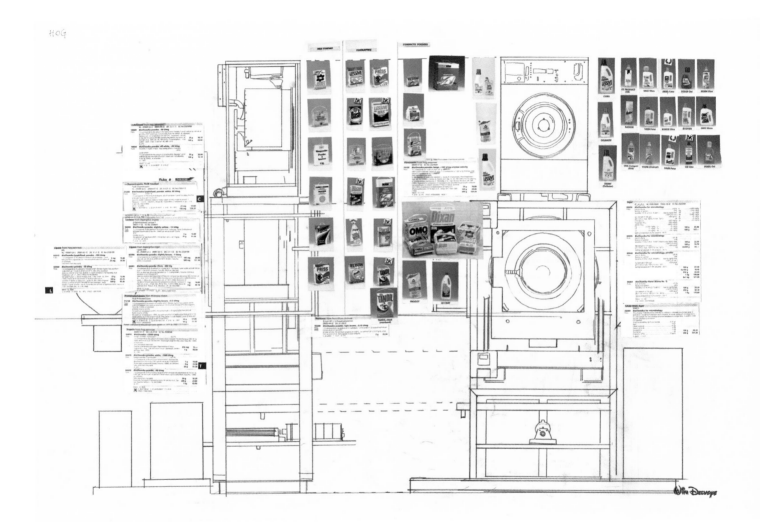

2004, 62 X 45 CM (24 3/8 X 17 3/4 INCHES), PENCIL, COLOUR PENCIL & WATERCOLOUR ON PAPER
(PRIVATE COLLECTION, BELGIUM)

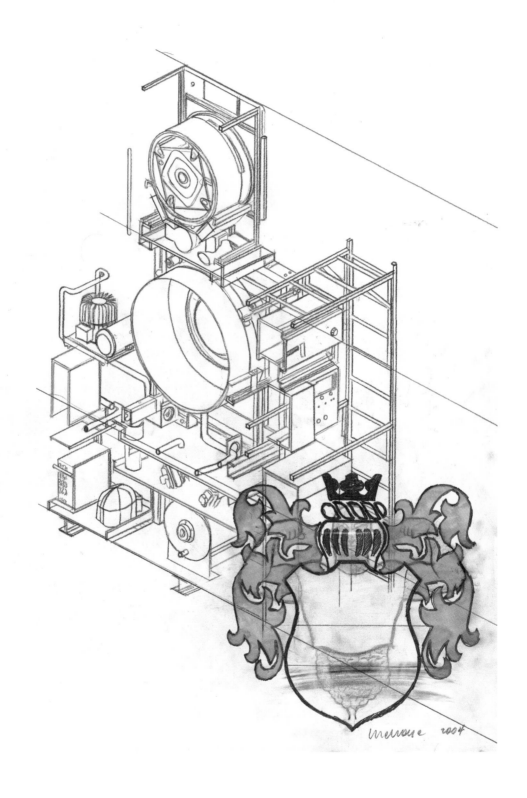

2004, 62 X 45 CM (24 3/8 X 17 3/4 INCHES), PENCIL & COLOUR PENCIL ON PAPER
(PRIVATE COLLECTION, BELGIUM)

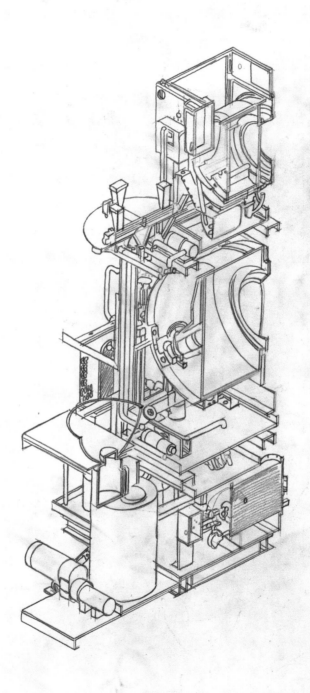

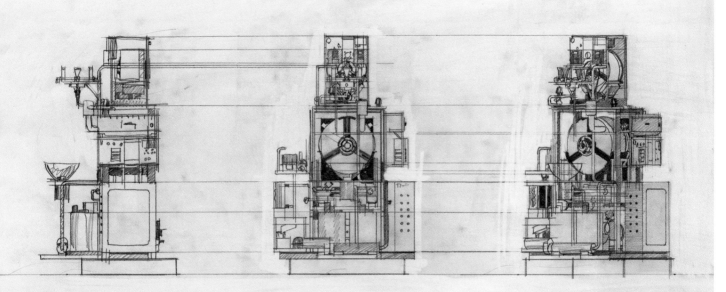

2004, 51 X 73 CM (20 X 28 3/4 INCHES), PENCIL ON PAPER

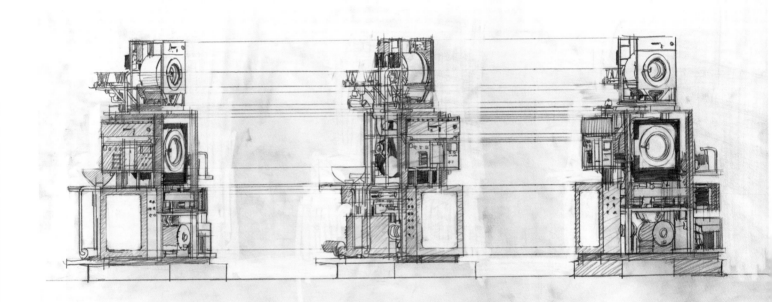

Cloaca Quatro Wim Delvoye 2004

2004, 51 X 73 CM (20 X 28 3/4 INCHES), PENCIL ON PAPER

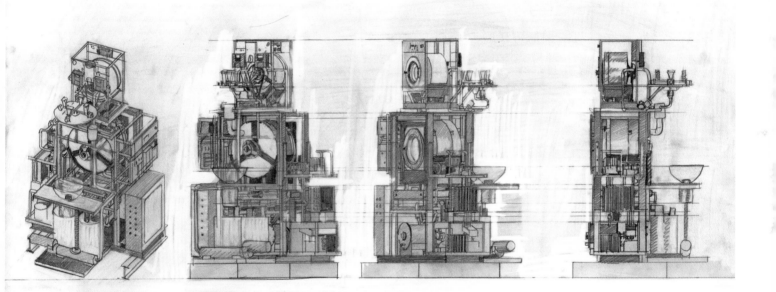

Cloaca Qvatro

Delvoye 2004

2004, 62 X 45 CM (24 3/8 X 17 3/4 INCHES), PENCIL & COLOUR PENCIL ON PAPER
(PRIVATE COLLECTION, BELGIUM)

Cloaca IV - LEFT HALF

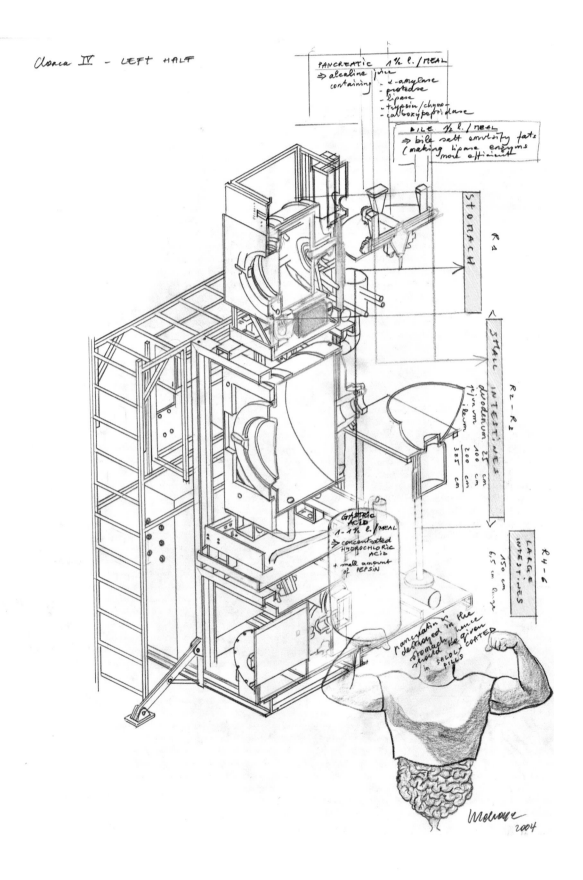

PANCREATIC 1½ l./MEAL
⇒ alkaline juice
containing - d-amylase
- protease
- lipase
- trypsin/chymo-
- carboxypeptidase

BILE ½ l./MEAL
⇒ bile salt emulsify fats
(making lipase enzyms
more efficient)

STOMACH

R 1

SMALL INTESTINES

duodenum 25 cm
jejunum 100 cm
ileum 200 cm
325 cm

R2-R3

GASTRIC ACID
1-1½ l./MEAL
⇒ concentrated
HYDROCHLORIC
ACID
+ small amount
of PEPSIN

LARGE INTESTINES

150 cm
6,5 cm Ø av.

R4-6

pancreatin is the
destroyed in the
stomach juice
should be given
in SALOL, COATED
PILLS

Moroye
2004

2005, 76.5 X 56.5 CM (30 1/8 X 22 1/4 INCHES), COLOUR PENCIL & STAMP INK ON PAPER

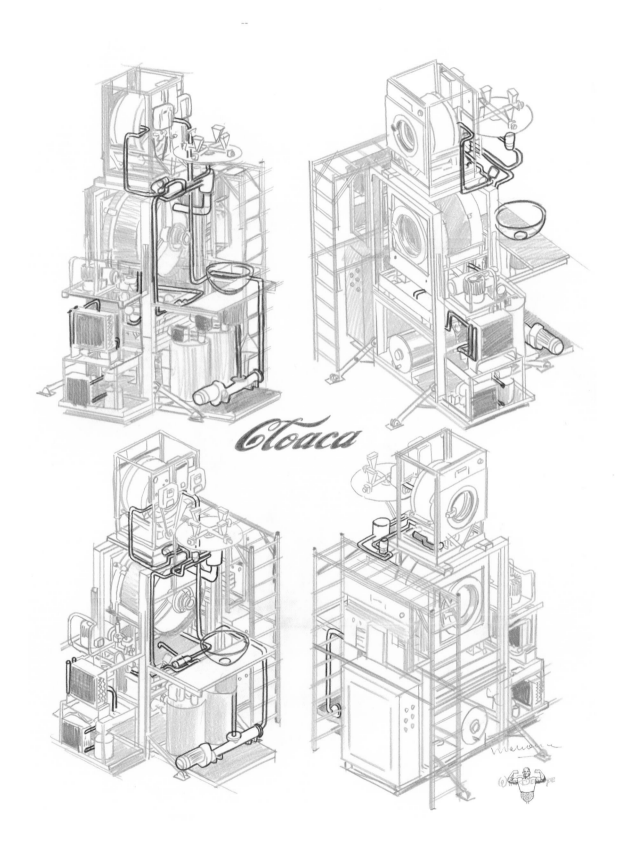

Cloaca

2005, 76.5 X 56.5 CM (30 1/8 X 22 1/4 INCHES), PENCIL, COLOUR PENCIL & STAMP INK ON PAPER

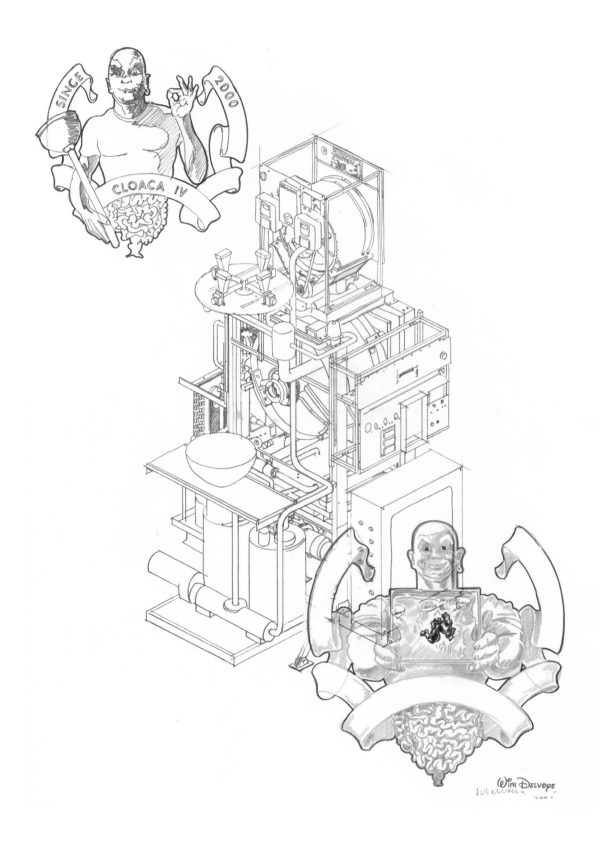

2005, 62 X 45 CM (24 3/8 X 17 3/4 INCHES), COLOUR PENCIL & STAMP INK ON PAPER
(PRIVATE COLLECTION, BELGIUM)

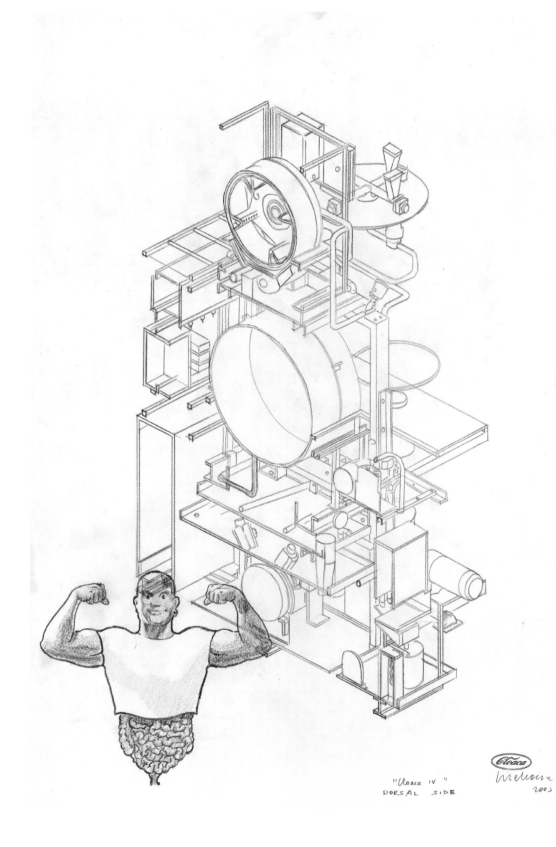

"Cloaca IV"
DORSAL SIDE

Studies for Cloaca N° 5

2000-2006

N° 5
CLOACA

2000, 75.5 X 55.5 CM (29 3/4 X 21 7/8 INCHES), PENCIL, COLOUR PENCIL & MARKER ON PAPER
(PRIVATE COLLECTION, BELGIUM)

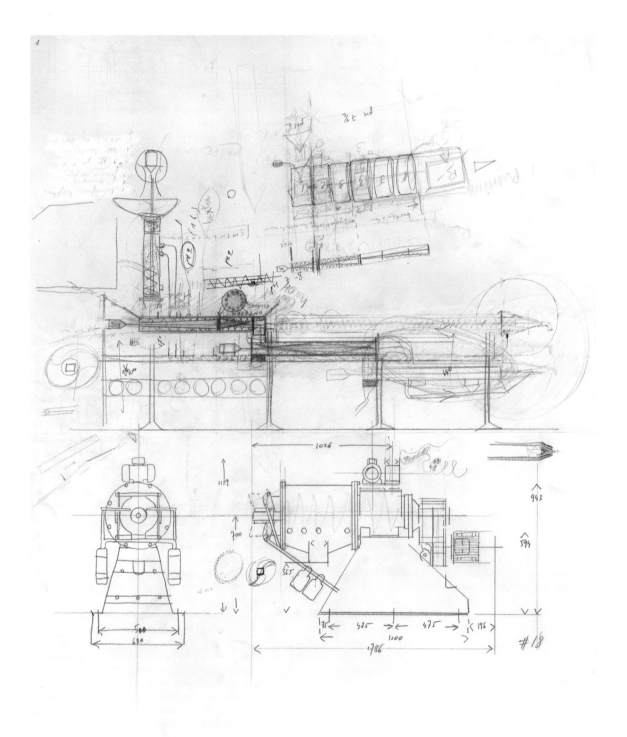

2001, 24 X 46 CM (9 1/2 X 18 1/8 INCHES), PENCIL, COLOUR PENCIL, MARKER & STAMP INK ON PAPER
(PRIVATE COLLECTION, BELGIUM)

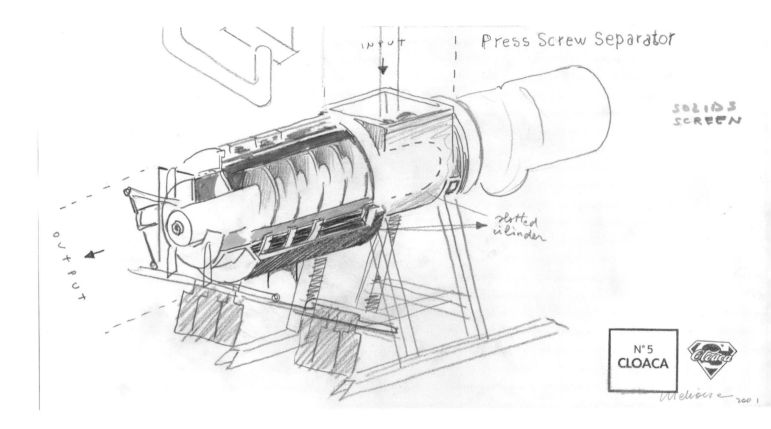

Press Screw Separator

INPUT

SOLIDS
SCREEN

slotted
cilinder

OUTPUT

N° 5
CLOACA

Cloaca

2001, 24 X 46 CM (9 1/2 X 18 1/8 INCHES), PENCIL, COLOUR PENCIL, MARKER & STAMP INK ON PAPER
(PRIVATE COLLECTION, BELGIUM)

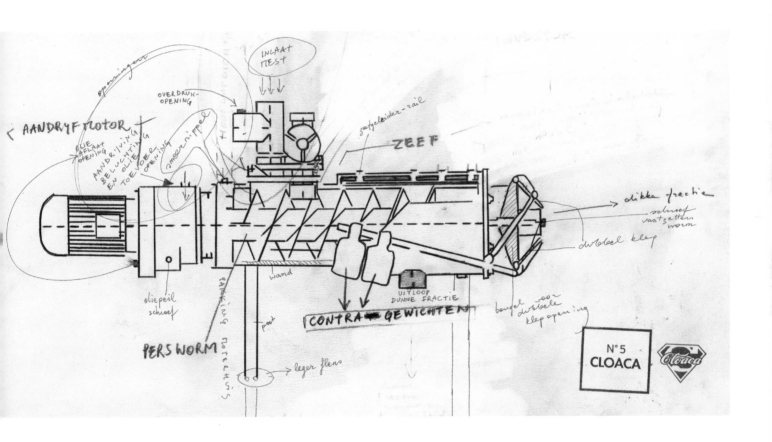

2001, 65.5 X 50.5 CM (25 3/4 X 19 7/8 CM), PENCIL, COLOUR PENCIL, BALLPOINT & STAMP INK ON PAPER

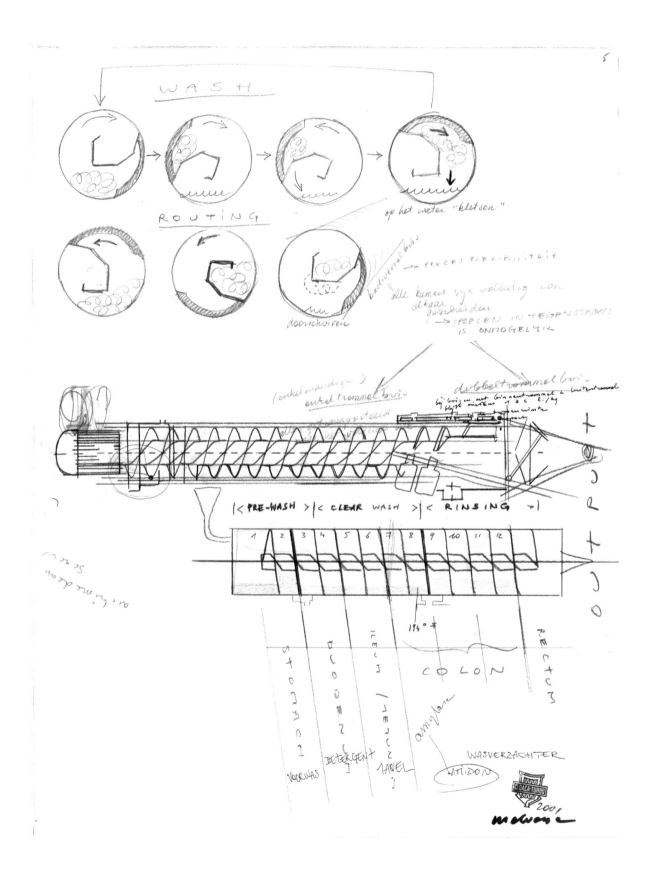

2001, 24 X 46 CM (9 1/2 X 18 1/8 INCHES), PENCIL, COLOUR PENCIL & STAMP INK ON PAPER
(PRIVATE COLLECTION, BELGIUM)

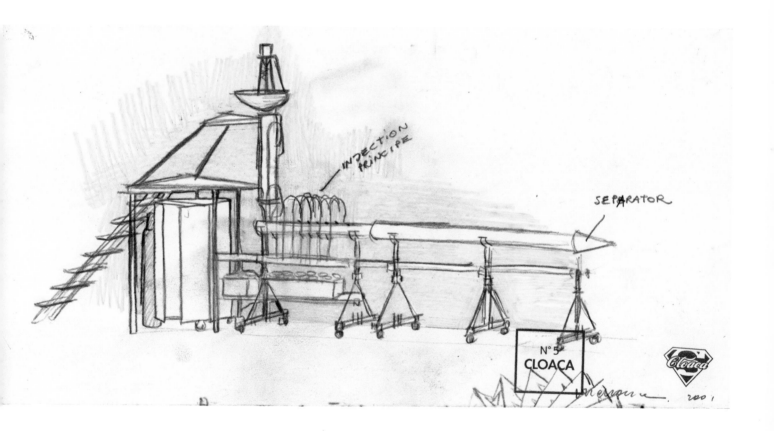

2001 – 2002, 65 X 50 CM (29 5/8 X 19 5/8 INCHES), PENCIL, COLOUR PENCIL, COLLAGE & MARKER ON PAPER

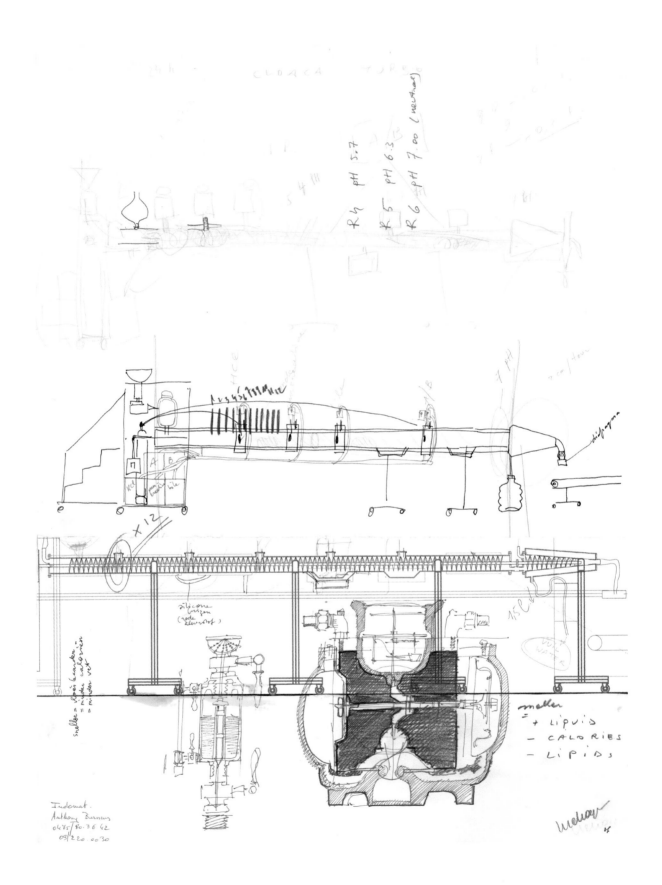

2001 – 2002, 75 X 55 CM (29 1/2 X 21 5/8 INCHES), PENCIL, MARKER & STAMP INK ON PAPER

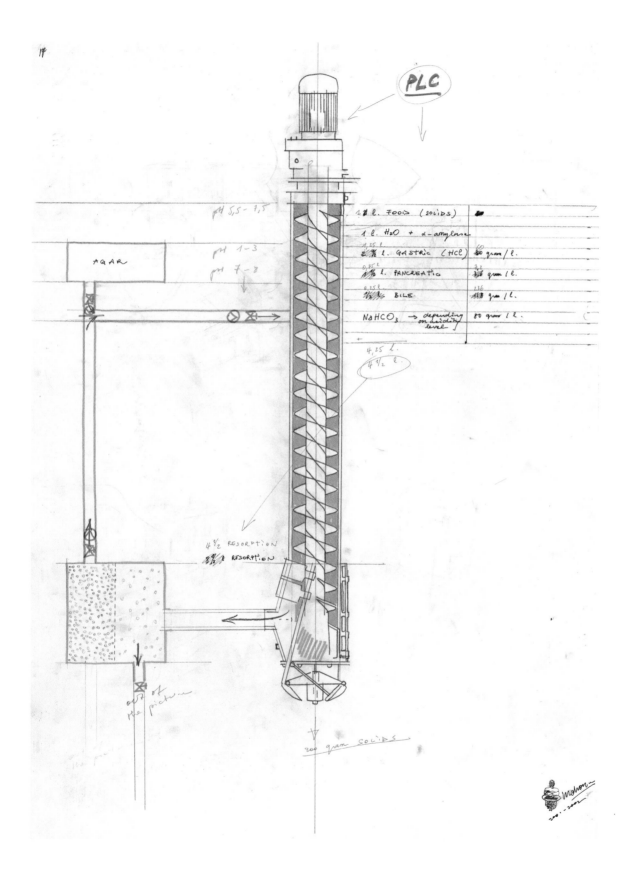

PLC

pH 5,5 - 7,5

AGAR

pH 1-3

pH 7-8

1 ½ l. FOOD (SOLIDS)

1 l. H₂O + α-amylase

4,25 l.
2 ½ l. GASTRIC (HCl) 60 gram / l.

0,25 l.
1 ½ l. PANCREATIC 32 gram / l.

0,25 l.
½ ½ l. BILE 236 118 gram / l.

NaHCO₃ → depending on acidity level 80 gram / l.

4,25 l.
4 ½ l.

4 ½ RESORPTION
8 ½ RESORPTION

out of the picture

200 gram SOLIDS

2002, 65 X 50 CM (29 5/8 X 19 5/8 INCHES), PENCIL, COLOUR PENCIL & MARKER ON PAPER
(PRIVATE COLLECTION, BELGIUM)

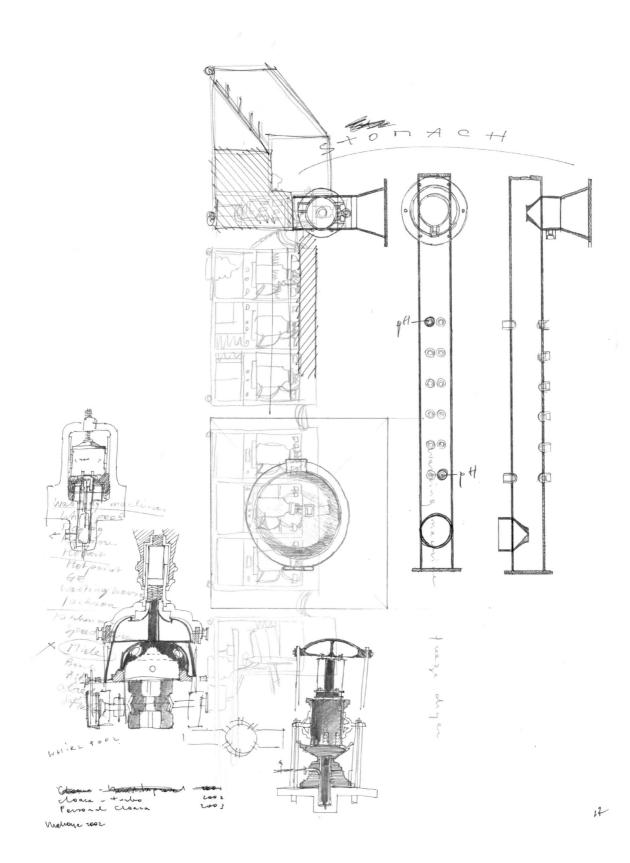

2002, 65 X 50 CM (29 5/8 X 19 5/8 INCHES), PENCIL, MARKER & STAMP INK ON PAPER
(PRIVATE COLLECTION, FRANCE)

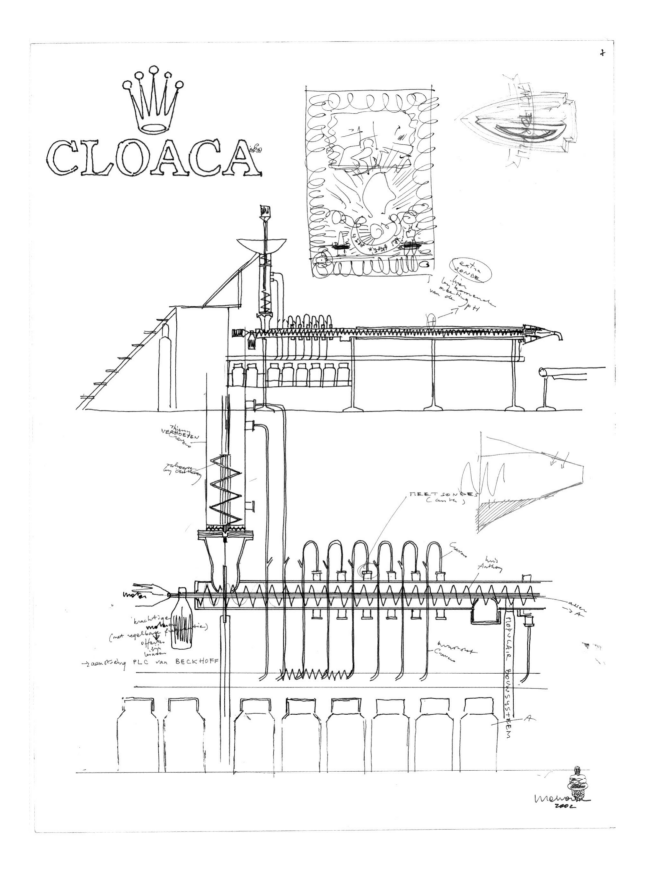

2002, 65 X 50 CM (29 5/8 X 19 5/8 INCHES), PENCIL, COLOUR PENCIL & MARKER ON PAPER
(PRIVATE COLLECTION, BELGIUM)

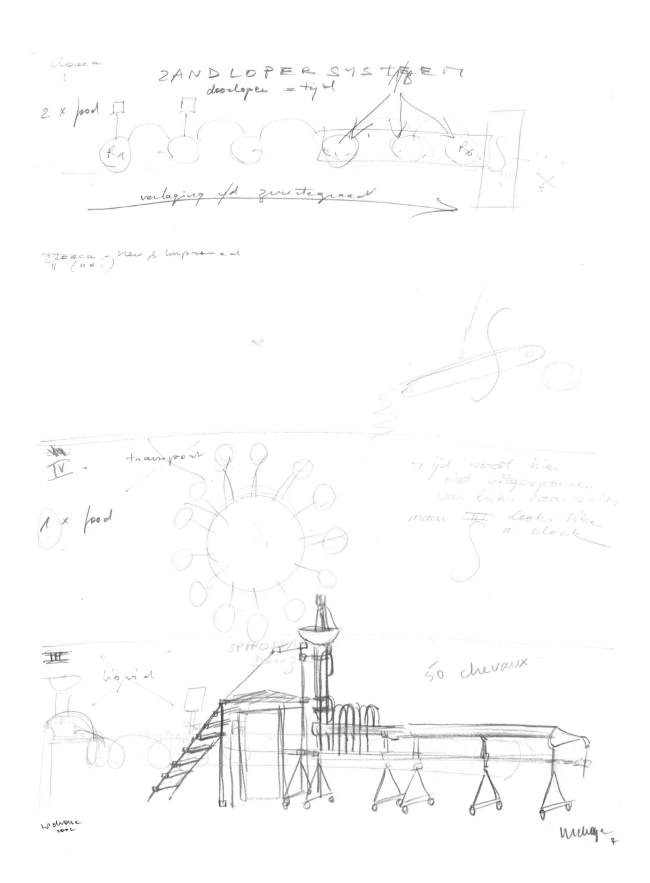

ZANDLOPER SYSTEEM
doorlopen = tijd

50 chevaux

2002, 65 X 50 CM (29 5/8 X 19 5/8 INCHES), PENCIL & COLOUR PENCIL ON PAPER
(PRIVATE COLLECTION, BELGIUM)

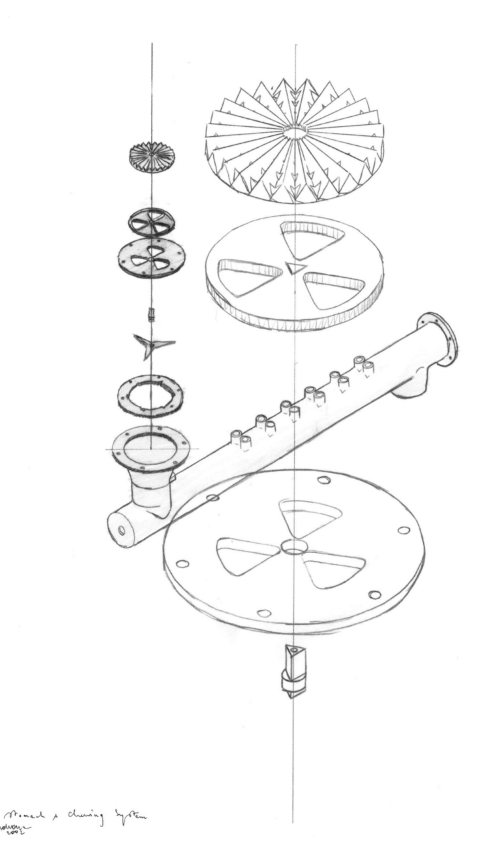

Stomach & Chewing System
malваgе
2002

Malvoye

9

2002, 65 X 50 CM (29 5/8 X 19 5/8 INCHES), PENCIL, COLOUR PENCIL & MARKER ON PAPER
(PRIVATE COLLECTION, BELGIUM)

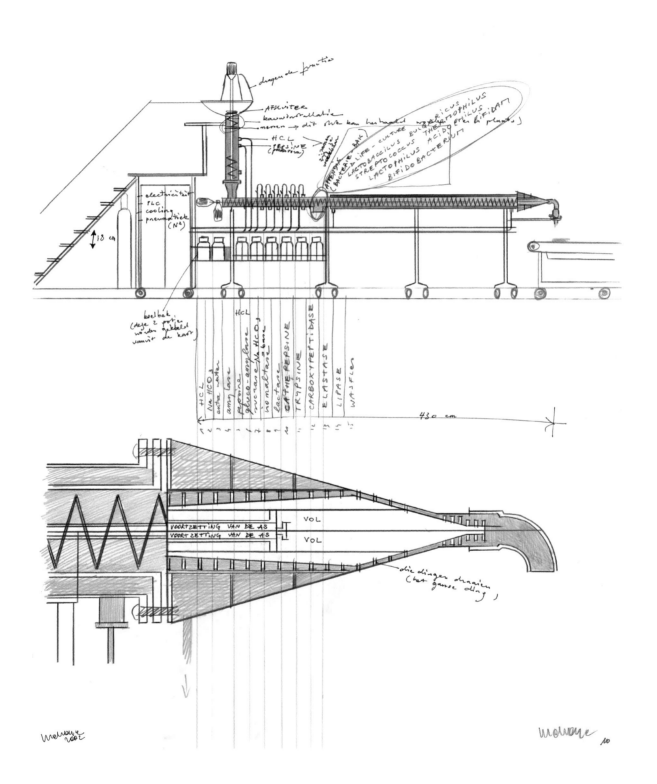

2002, 65 X 50 CM (29 5/8 X 19 5/8 INCHES), PENCIL, COLOUR PENCIL & MARKER ON PAPER
(PRIVATE COLLECTION, BELGIUM)

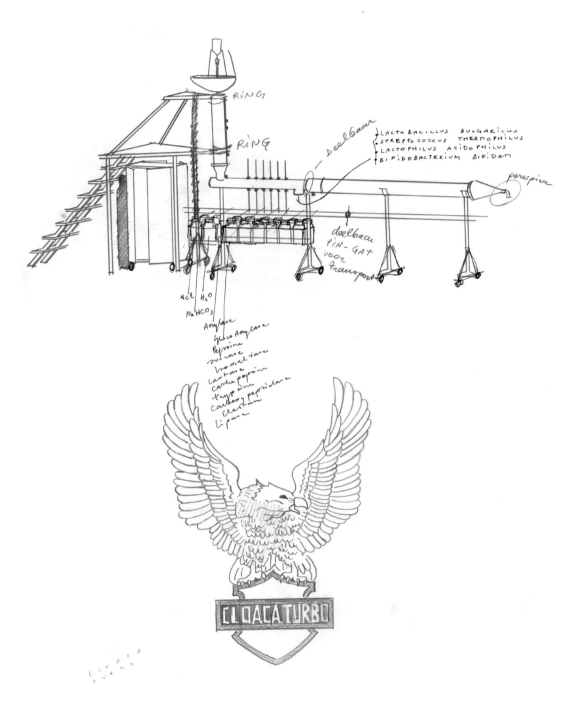

2002, 65 X 50 CM (29 5/8 X 19 5/8 INCHES), PENCIL, COLOUR PENCIL & MARKER ON PAPER
(PRIVATE COLLECTION, BELGIUM)

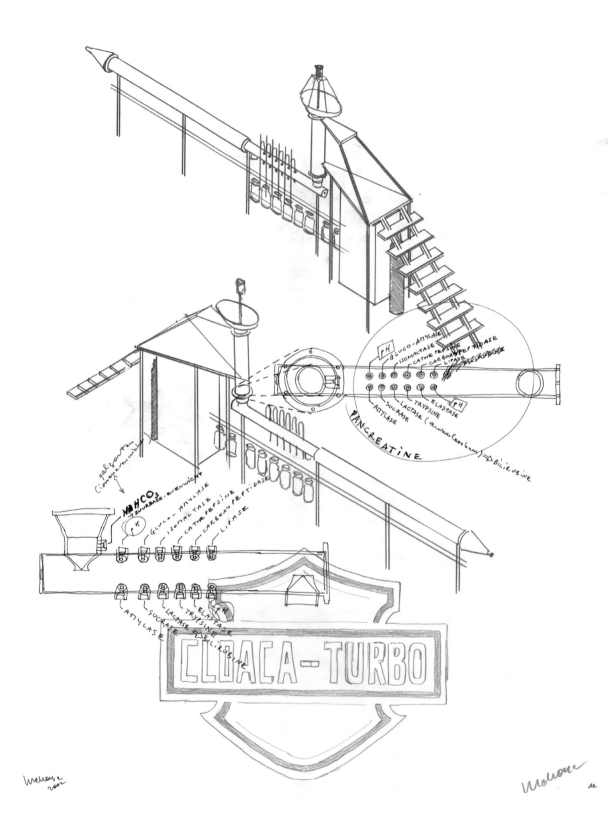

2002, 65 X 50 CM (29 5/8 X 19 5/8 INCHES), PENCIL & COLOUR PENCIL ON PAPER
(PRIVATE COLLECTION, BELGIUM)

CLOACA - TURBO STOMACH

study for stomach

2002 – 2003, 55 X 75 CM (21 5/8 X 29 1/2 INCHES), PENCIL, COLOUR PENCIL & MARKER ON PAPER
(PRIVATE COLLECTION, FRANCE)

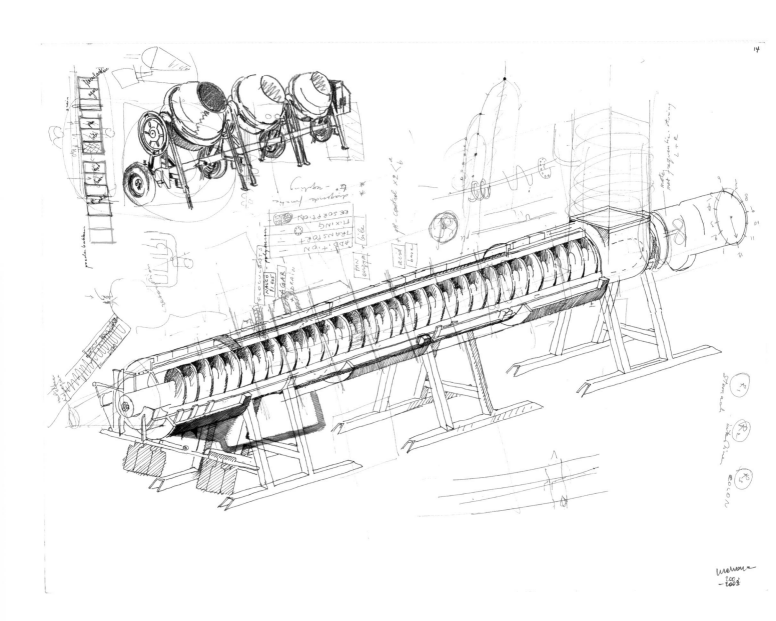

2003, 75 X 55 CM (29 1/2 X 21 5/8 INCHES), PENCIL, WATERCOLOUR, MARKER & STAMP INK ON PAPER

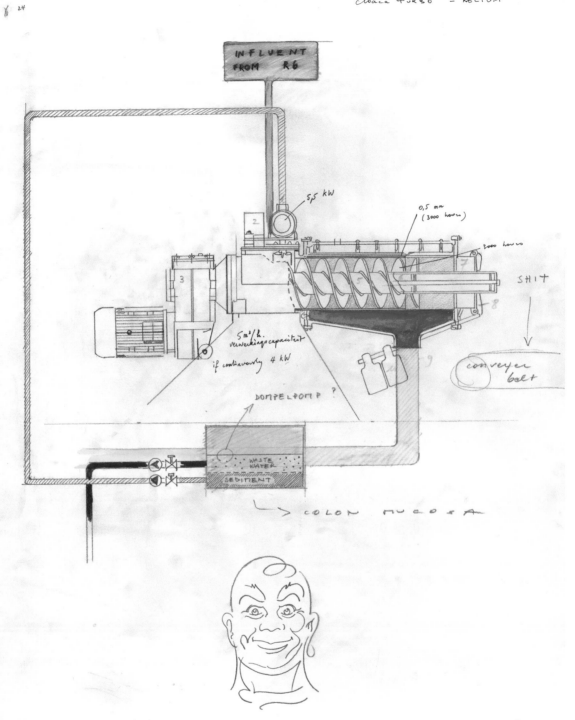

Cloaca TURBO — RECTUM

2003, 75 X 55 CM (29 1/2 X 21 5/8 INCHES), PENCIL, COLOUR PENCIL, MARKER & STAMP INK ON PAPER

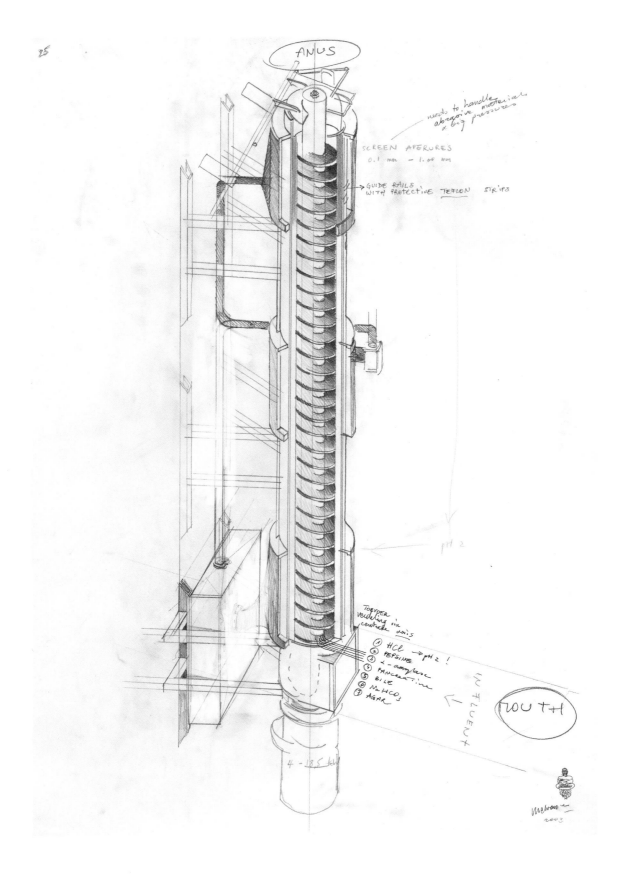

2003, 75 X 55 CM (29 1/2 X 21 5/8 INCHES), PENCIL, COLOUR PENCIL & STAMP INK ON PAPER

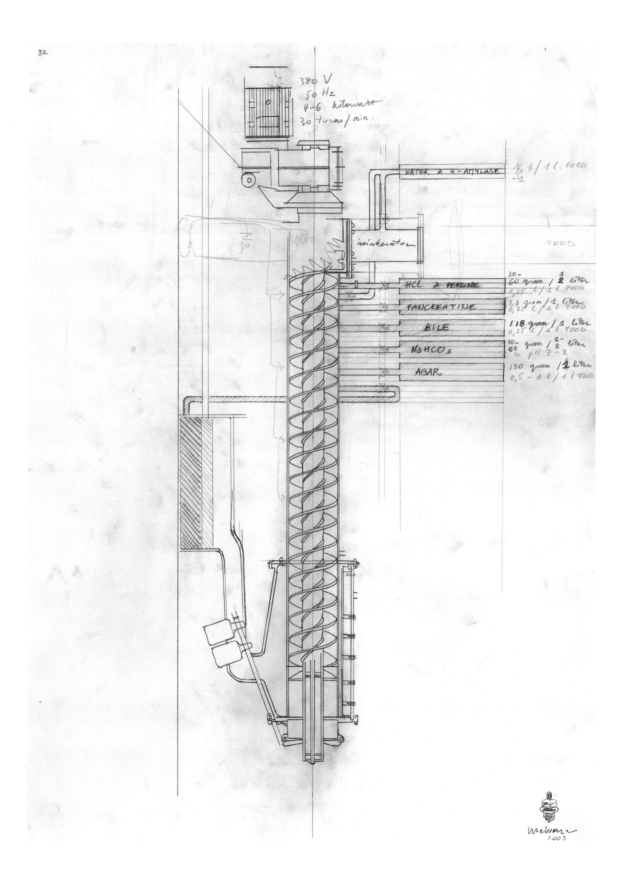

2003, 75 X 55 CM (29 1/2 X 21 5/8 INCHES), PENCIL, COLOUR PENCIL, MARKER & STAMP INK ON PAPER

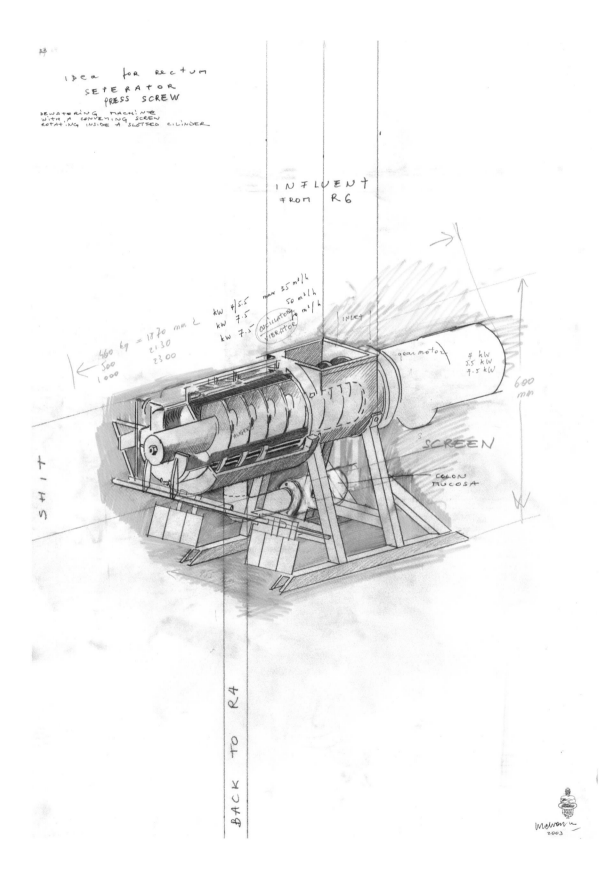

idea for rectum
SEPERATOR
PRESS SCREW

DEWATERING MACHINE
WITH A CONVEYING SCREEN
ROTATING INSIDE A SLOTTED CILINDER

INFLUENT
FROM R6

BACK TO R4

SHIT

SCREEN

COLON
MUCOSA

gear motor

INLET

OSCILLATOR
VIBRATOR

4 kW
5.5 kW
7.5 kW

kW 4/5.5 max 35 m³/h
kW 7.5 50 m³/h
kW 7.5 70 m³/h

460 kg = 1870 mm ℓ
500 2130
1000 2300

600 mm

2003, 75 X 55 CM (29 1/2 X 21 5/8 INCHES), PENCIL, MARKER & STAMP INK ON PAPER
(PRIVATE COLLECTION, BELGIUM)

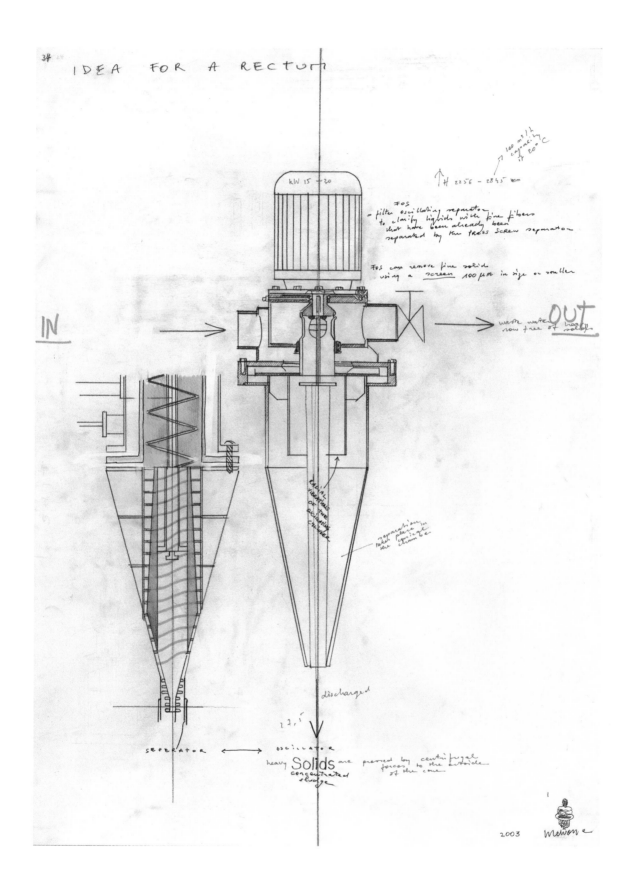

IDEA FOR A RECTUM

2003, 56.5 X 88.5 CM (22 1/4 X 34 7/8 INCHES), PENCIL, COLOUR PENCIL & MARKER ON PAPER

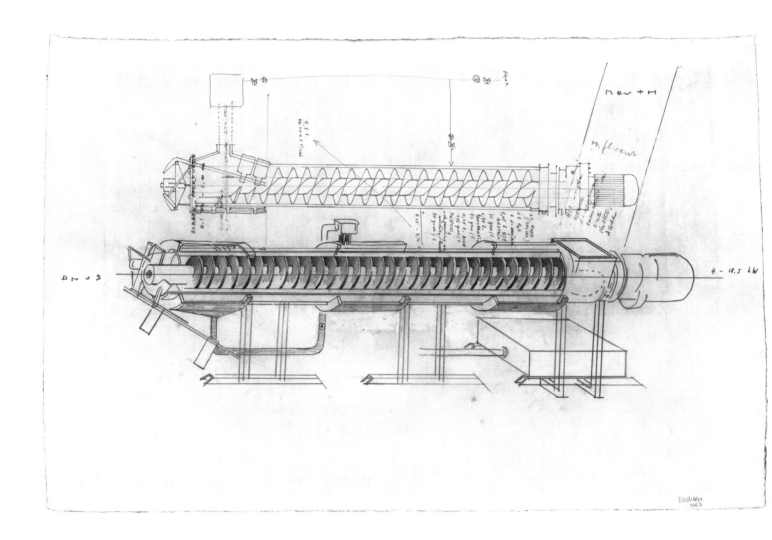

2003 – 2004, 56.5 X 88.5 CM (22 1/4 X 34 7/8 INCHES), PENCIL, COLOUR PENCIL & MARKER ON PAPER

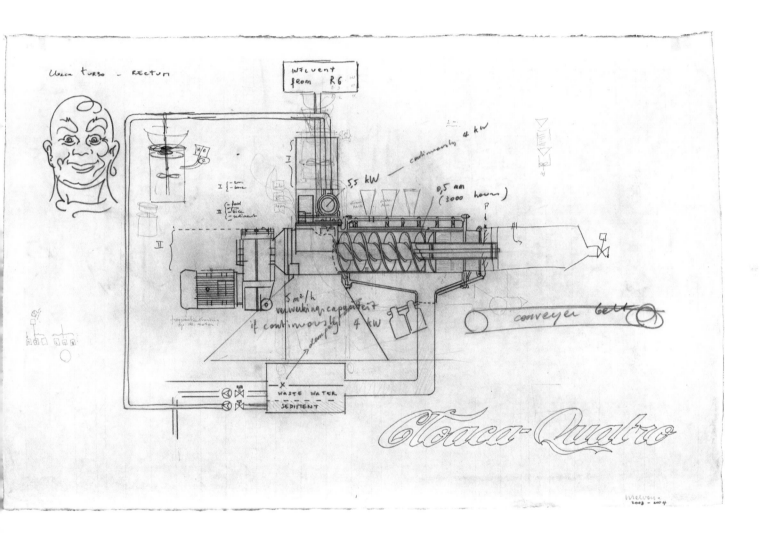

2005, 62 X 45 CM (24 3/8 X 17 3/4 INCHES), PENCIL, COLOUR PENCIL, WATERCOLOUR & STAMP INK ON PAPER
(PRIVATE COLLECTION, BELGIUM)

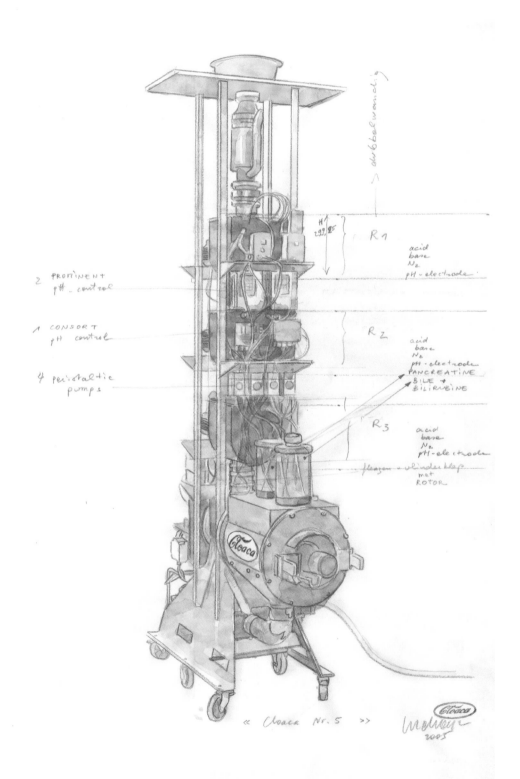

« Cloaca Nr. 5 »

2005, 62 X 45 CM (24 3/8 X 17 3/4 INCHES), PENCIL & COLOUR PENCIL ON PAPER
(PRIVATE COLLECTION, BELGIUM)

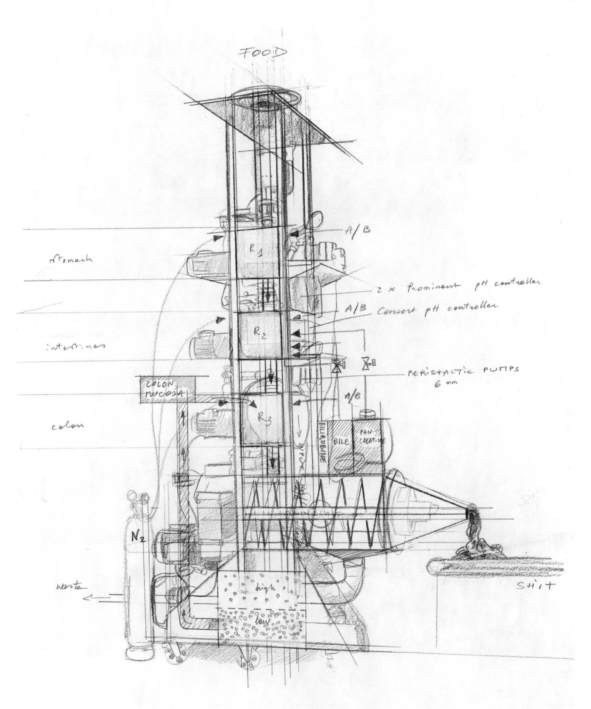

Cloaca Nr. 5

FOOD

A/B

stomach

R_1

2 × Prominent pH controller

A/B Consort pH controller

intestines

R_2

PERISTALTIC PUMPS
6 mm

COLON
MUCOSA

colon

A/B

R_3

BILIRUBINE BILE PAN
CREATINE

N_2

high

waste

low

SHIT

Melreren 2005

Cloaca No. 5

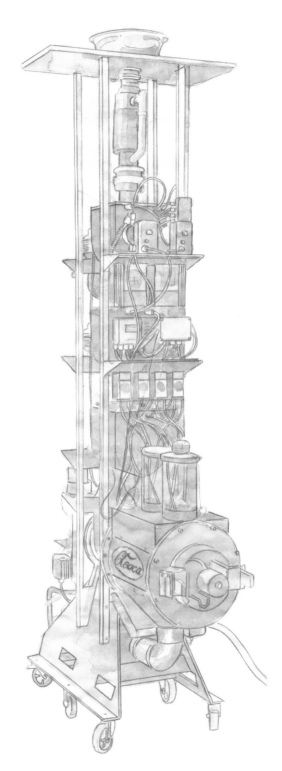

Wilvoorde 2005

2005, 62 X 45 CM (24 3/8 X 17 3/4 INCHES), PENCIL & STAMP INK ON PAPER
(PRIVATE COLLECTION, BELGIUM)

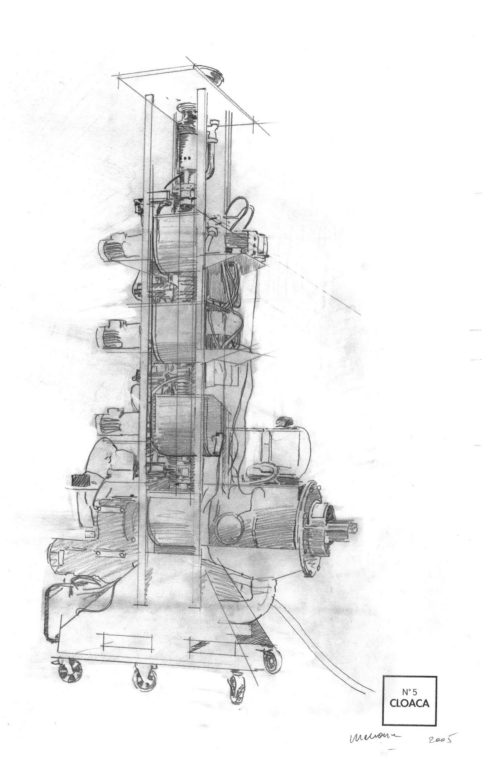

N° 5
CLOACA

2005

2006, 51 X 36.6 CM (20 X 14 3/8 INCHES), PENCIL ON PAPER
(PRIVATE COLLECTION, BELGIUM)

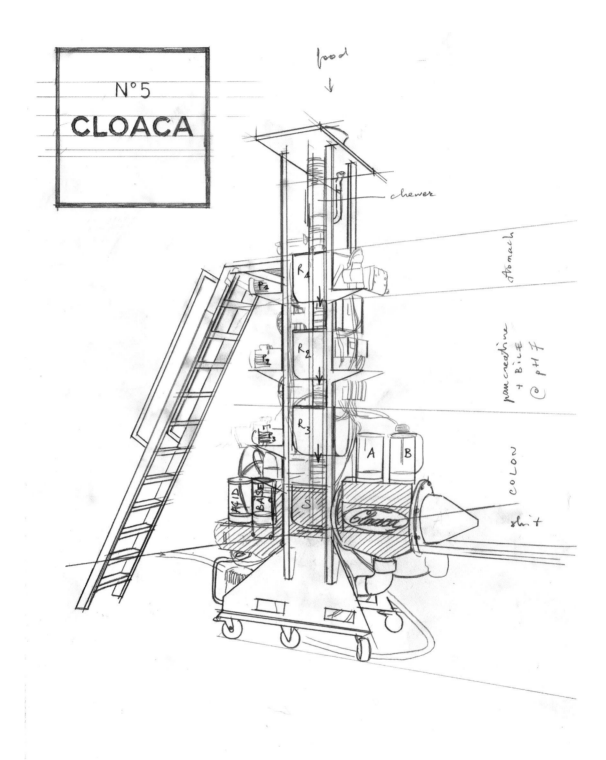

2006, 51 X 36.6 CM (20 X 14 3/8 INCHES), PENCIL ON PAPER
(PRIVATE COLLECTION, BELGIUM)

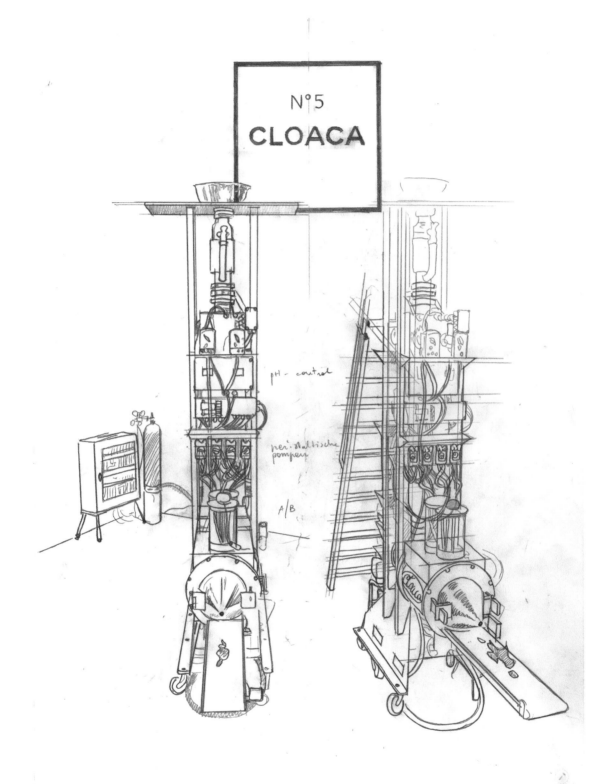

2006, 51 X 36.6 CM (20 X 14 3/8 INCHES), PENCIL & COLOUR PENCIL ON PAPER
(PRIVATE COLLECTION, BELGIUM)

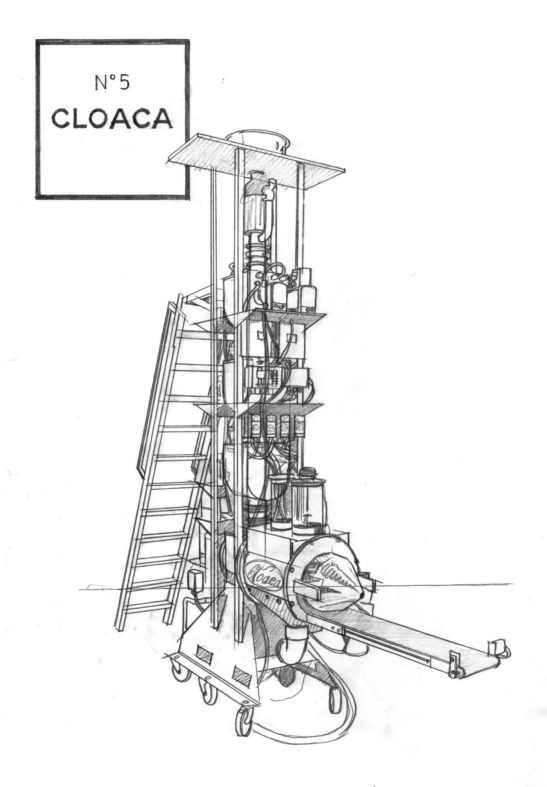

2006, 51 X 36.6 CM (20 X 14 3/8 INCHES, PENCIL & COLOUR PENCIL ON PAPER

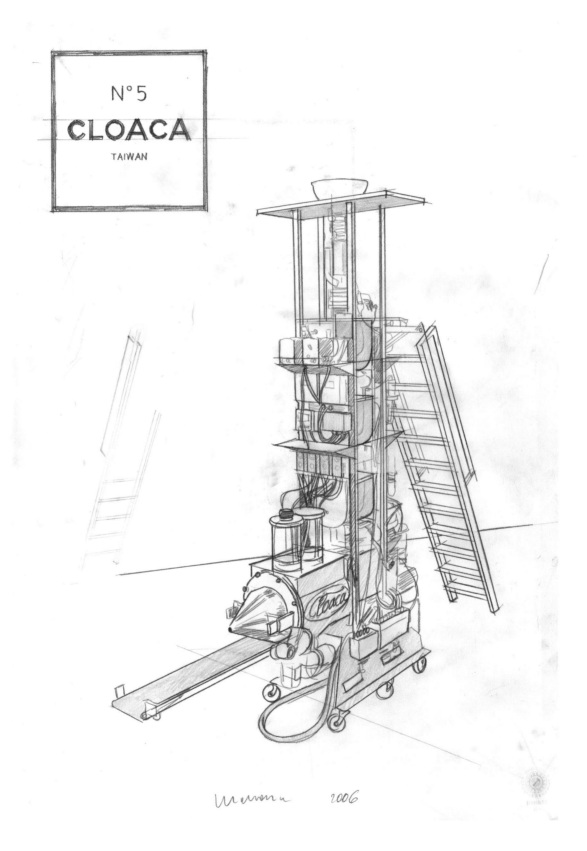

N° 5

CLOACA

TAIWAN

Studies for Cloaca Commercial

2001-2002

2001, 65 X 50 CM (29 5/8 X 19 5/8 INCHES), COLOUR PENCIL, WATERCOLOUR & MARKER ON PAPER
(ADDITIONAL COLOUR PENCIL, 2006)

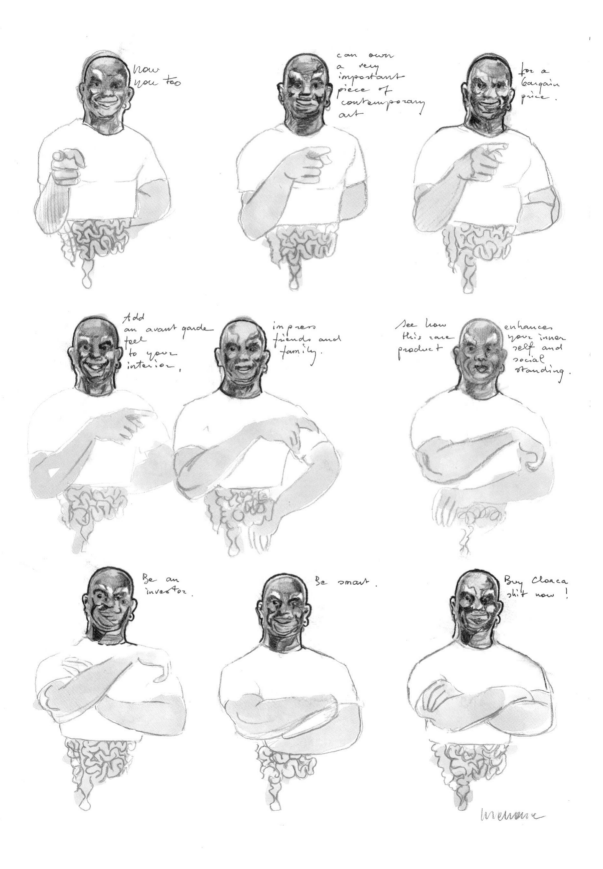

2001, 65 X 50 CM (29 5/8 X 19 5/8 INCHES), COLOUR PENCIL, WATERCOLOUR & MARKER ON PAPER
(ADDITIONAL COLOUR PENCIL, 2006)

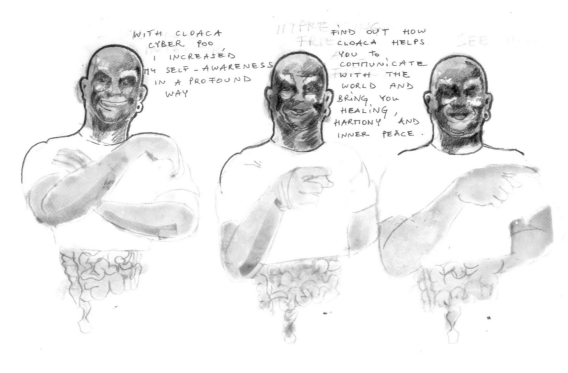

WITH CLOACA CYBER POO, I INCREASED MY SELF-AWARENESS IN A PROFOUND WAY

FIND OUT HOW CLOACA HELPS YOU TO COMMUNICATE WITH THE WORLD AND BRING YOU HEALING, HARMONY AND INNER PEACE.

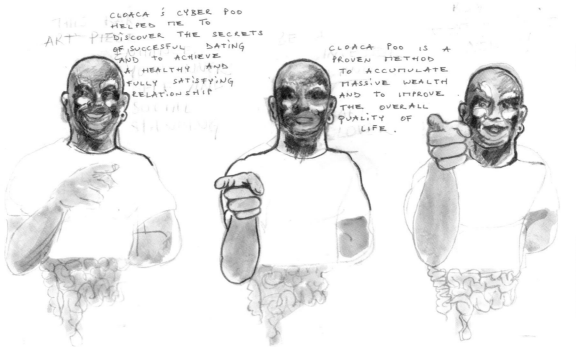

CLOACA'S CYBER POO HELPED ME TO DISCOVER THE SECRETS OF SUCCESFUL DATING AND TO ACHIEVE A HEALTHY AND FULLY SATISFYING RELATIONSHIP

CLOACA POO IS A PROVEN METHOD TO ACCUMULATE MASSIVE WEALTH AND TO IMPROVE THE OVERALL QUALITY OF LIFE.

2001, 65 X 50 CM (29 5/8 X 19 5/8 INCHES), COLOUR PENCIL, WATERCOLOUR & MARKER ON PAPER
(ADDITIONAL COLOUR PENCIL, 2006)

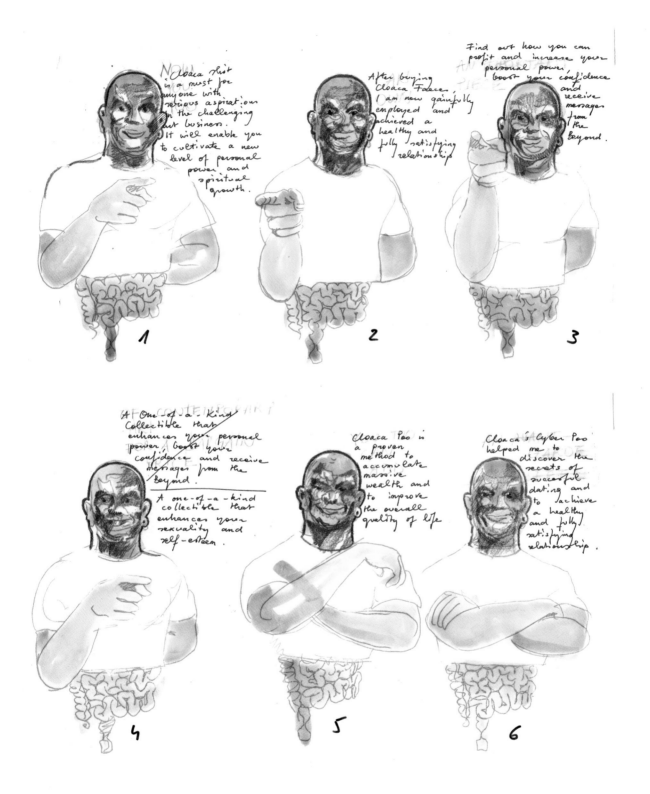

2001 – 2002, 65 X 50 CM (29 5/8 X 19 5/8 INCHES), COLOUR PENCIL, WATERCOLOUR, COLLAGE & MARKER ON PAPER (ADDITIONAL COLOUR PENCIL, 2006)

2001 - 2002
3-D animation
website CLOACA
— eCloaca —
A

NOW YOU TOO CAN OWN A VERY IMPORTANT PIECE OF

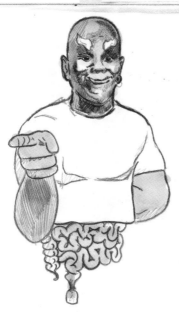

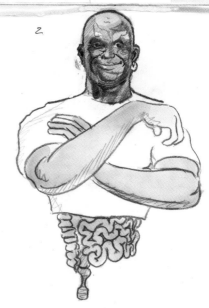

CONTEMPORARY ART FOR A BARGAIN PRICE.

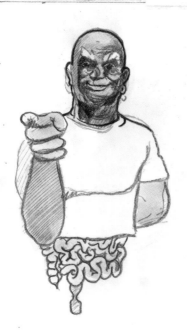

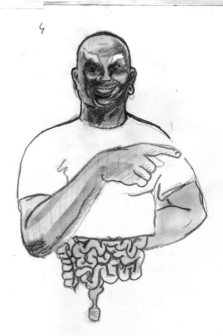

2001 – 2002, 65 X 50 CM (29 5/8 X 19 5/8 INCHES), COLOUR PENCIL, WATERCOLOUR, COLLAGE & MARKER ON PAPER
(ADDITIONAL COLOUR PENCIL, 2006)

ADD AN AVANT-GARDE FEEL TO YOUR INTERIOR,

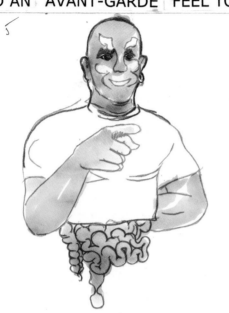

IMPRESS FRIENDS AND FAMILY. SEE HOW THIS

2001 – 2002, 65 X 50 CM (29 5/8 X 19 5/8 INCHES), COLOUR PENCIL, WATERCOLOUR, COLLAGE & MARKER ON PAPER
(ADDITIONAL COLOUR PENCIL, 2006)

RARE PRODUCT ENHANCES YOUR INNER SELF AND SOCIAL

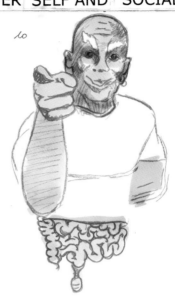

STANDING. BE AN INVESTOR. BE SMART.

**BUY CLOACA
SHIT NOW!**

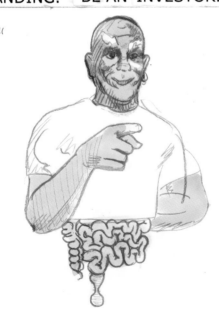
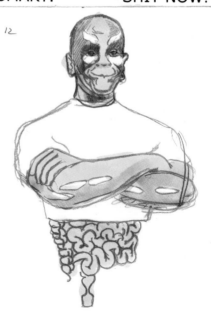

2002, 65 X 50 CM (29 5/8 X 19 5/8 INCHES), PENCIL, COLOUR PENCIL & MARKER ON PAPER
(PRIVATE COLLECTION, BELGIUM)

2002, 65 X 50 CM (29 5/8 X 19 5/8 INCHES), PENCIL & COLOUR PENCIL ON PAPER
(PRIVATE COLLECTION, BELGIUM)

MR CLEAN (3D)

FRONT SIDE

2002

2002, 65 X 50 CM (29 5/8 X 19 5/8 INCHES), PENCIL, MARKER & STAMP INK ON PAPER
(PRIVATE COLLECTION, BELGIUM)

CLOACA'S CYBER POO HELPED ME TO DISCOVER THE SECRETS OF SUCCESFUL DATING AND TO ACHIEVE A HEALTHY AND FULLY SATISFYING RELATIONSHIP

CLOACA SHIT IS A MUST FOR ANYONE WITH SERIOUS ASPIRATIONS IN THE CHALLENGING ART BUSINESS.

A ONE-OF-A-KIND COLLECTIBLE THAT ENHANCES YOUR SEXUALITY AND SELF-ESTEEM

IT WILL ENABLE YOU TO CULTIVATE A NEW LEVEL OF PERSONAL POWER AND SPIRITUAL GROWTH.

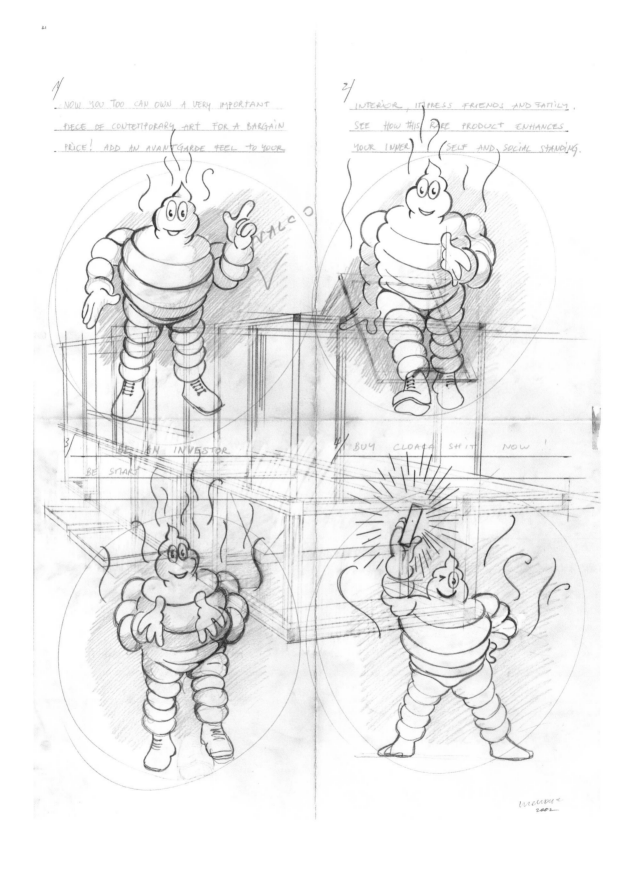

2002, 51 X 73 CM (20 1/8 X 28 3/4 INCHES), COLOUR PENCIL ON PAPER

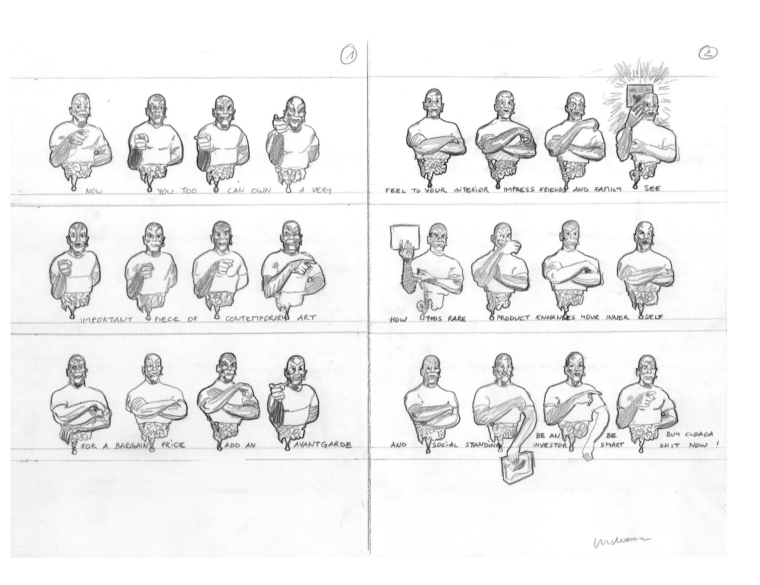

Designs for Cloaca
Faeces & Packaging

2001 – 2004

2001, 57 X 72 CM (22 3/8 X 28 3/8 INCHES), PENCIL, MARKER & TIPP-EX ON PAPER
(PRIVATE COLLECTION, BELGIUM)

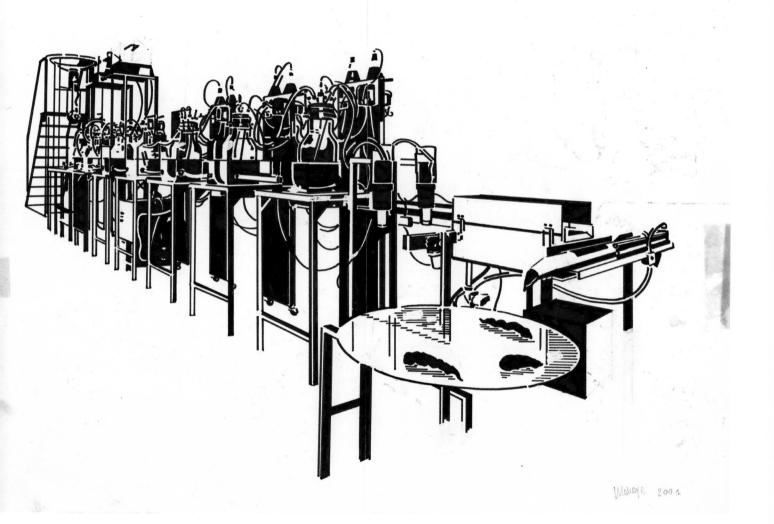

2001, 57 X 72 CM (22 3/8 X 28 3/8 INCHES), PENCIL, MARKER & TIPP-EX ON PAPER
(PRIVATE COLLECTION, BELGIUM)

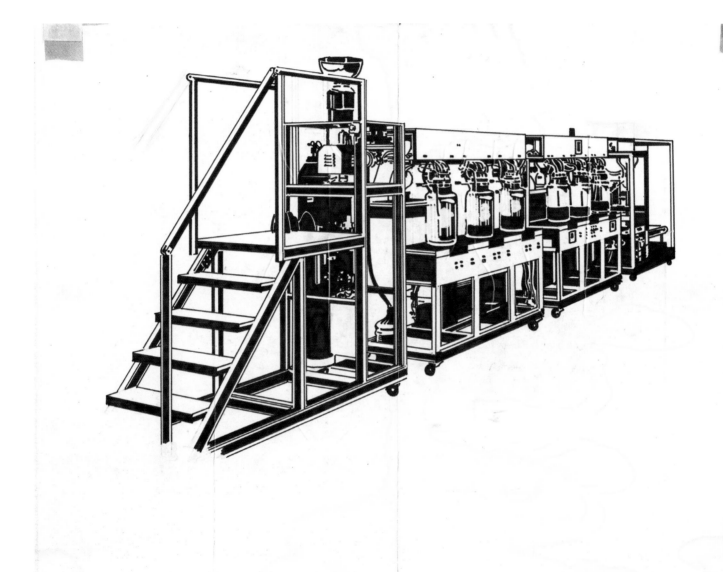

Melotte 2001

2001 – 2002, 65 X 50 CM (29 5/8 X 19 5/8 INCHES), PENCIL, MARKER & COLLAGE ON PAPER
(PRIVATE COLLECTION, BELGIUM)

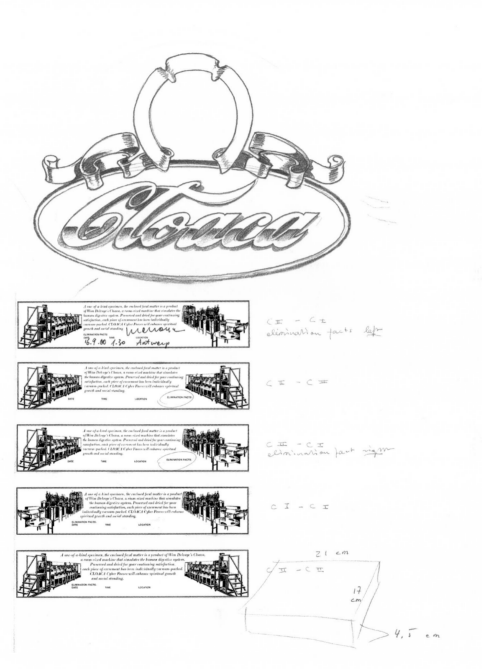

2002, 65 X 50 CM (29 5/8 X 19 5/8 INCHES), PENCIL, COLOUR PENCIL & MARKER ON PAPER
(PRIVATE COLLECTION, BELGIUM)

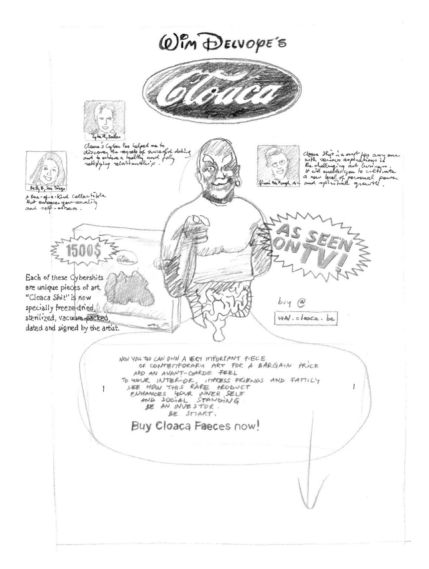

2002, 65 X 50 CM (29 5/8 X 19 5/8 INCHES), PENCIL, COLOUR PENCIL & MARKER ON PAPER
(PRIVATE COLLECTION, BELGIUM)

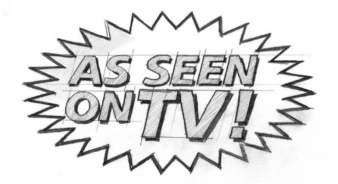

2003, 75 X 55 CM (29 1/2 X 21 5/8 INCHES), PENCIL ON PAPER
(PRIVATE COLLECTION, BELGIUM)

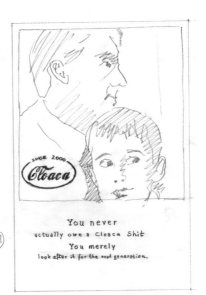

THERE IS A MOMENT WHEN YOU BECOME
PART OF TIME.
AND A MOMENT WHEN YOU BECOME
PART OF HISTORY.

SINCE 2000
Cloaca

You never
actually own a Cloaca Shit
You merely
look after it for the next generation.

①

② Begin your own tradition.

BUY ONE,
GET ONE *free!*

Cloaca
imagination at work

2003, 65 X 50 CM (29 5/8 X 19 5/8 INCHES), PENCIL, COLOUR PENCIL, MARKER & STAMP INK ON PAPER
(PRIVATE COLLECTION, FRANCE)

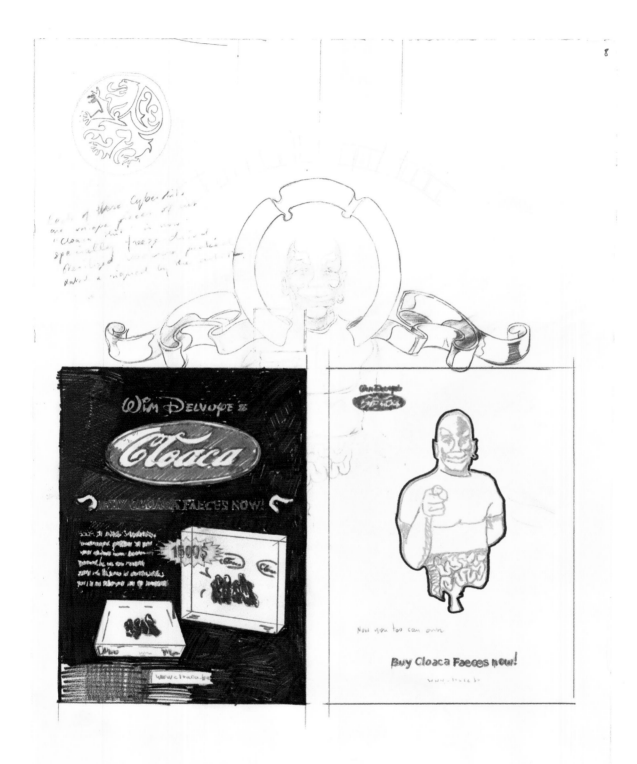

2004, 56.5 X 88.5 CM (22 1/4 X 34 7/8 INCHES), PENCIL, COLOUR PENCIL & MARKER ON PAPER (PRIVATE COLLECTION, FRANCE)

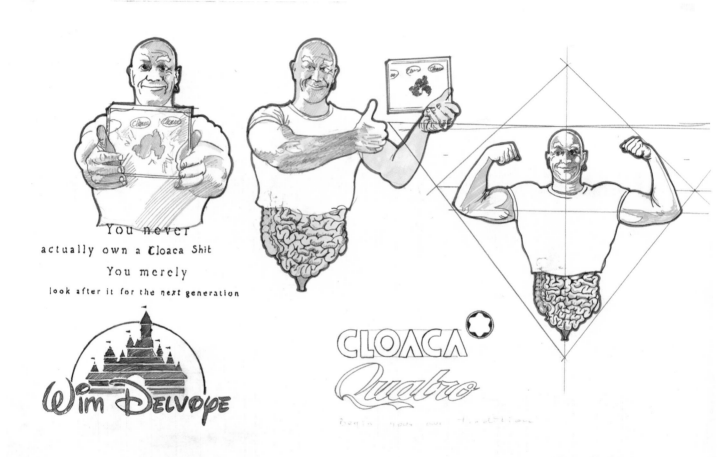

2004, 31 X 33 CM (12 1/4 X 13 INCHES), PENCIL, COLOUR PENCIL, COLLAGE & STAMP INK ON PAPER
(PRIVATE COLLECTION, BELGIUM)

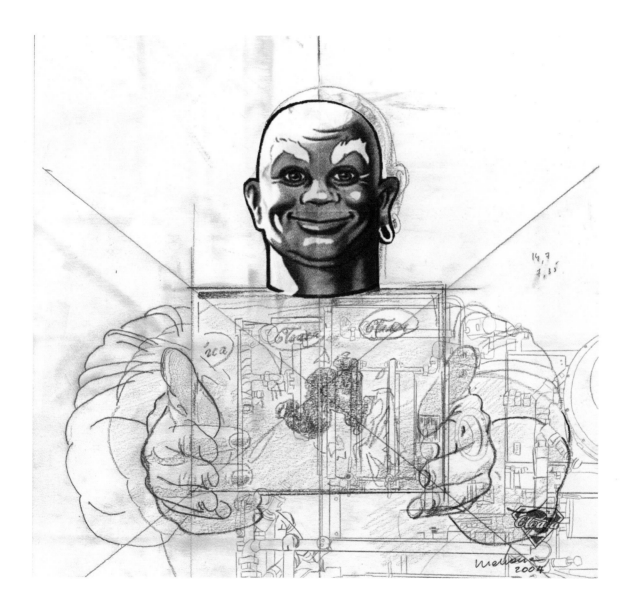

2004, 62 X 45 CM (24 3/8 X 17 3/4 INCHES), PENCIL & COLOUR PENCIL ON PAPER

210

2006, 50 X 70.5 CM (19 3/4 X 27 3/4 INCHES), PENCIL & COLOUR PENCIL ON PAPER

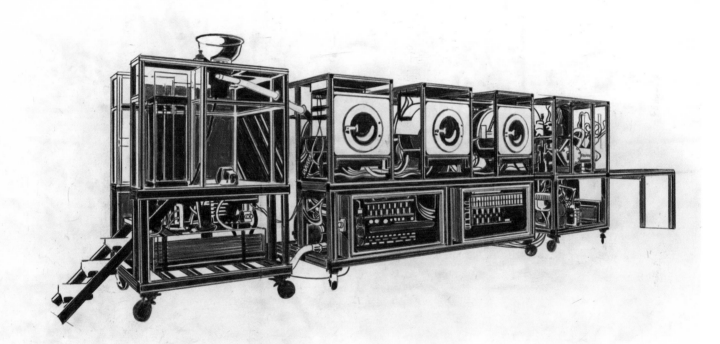

Melville 2004

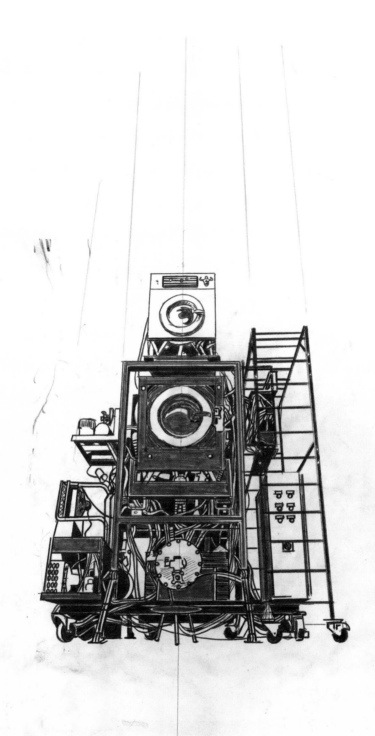

Melvoye 2004

2006, 62.5 X 45 CM (24 5/8 X 17 3/4 INCHES), PENCIL & COLOUR PENCIL ON PAPER

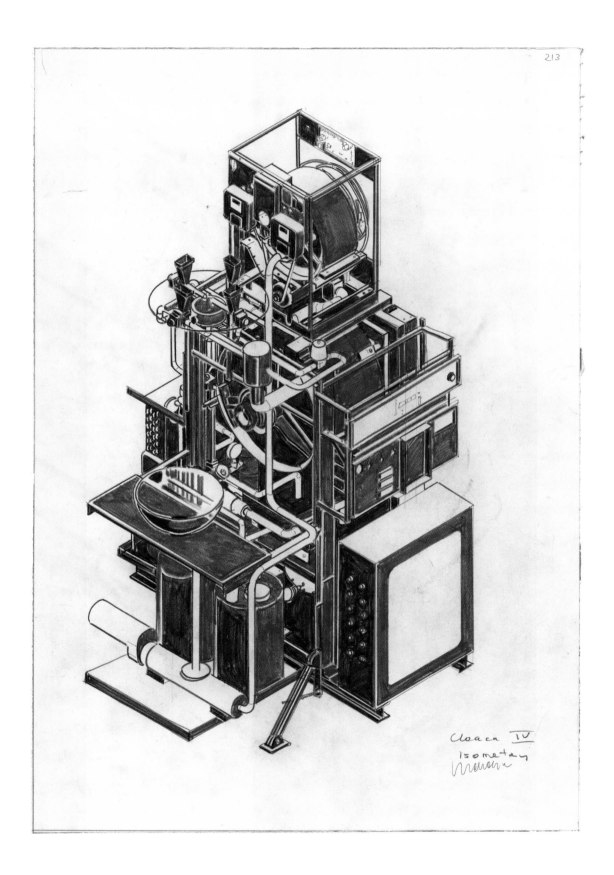

213

Cloaca IV
Isometry

Studies for Cloaca Turbo

2001-2004

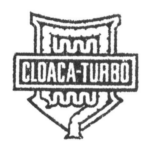

2001, 23.5 X 46 CM (9 1/4 X 18 1/8 INCHES), PENCIL, COLOUR PENCIL & MARKER ON PAPER
(PRIVATE COLLECTION, BELGIUM)

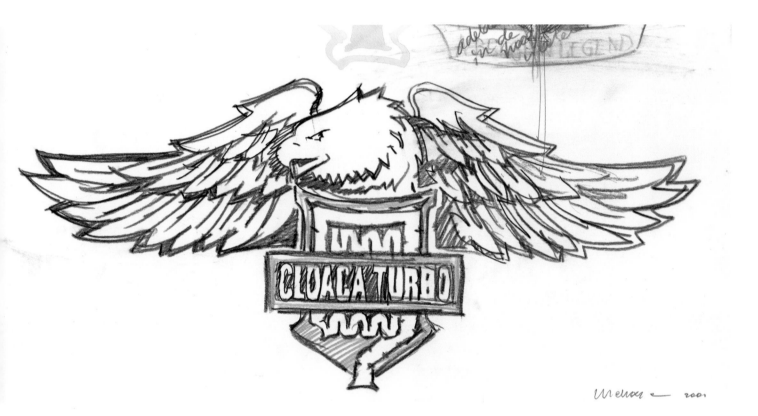

2002, 65 X 50 CM (29 5/8 X 19 5/8 INCHES), PENCIL & COLOUR PENCIL ON PAPER
(PRIVATE COLLECTION, BELGIUM)

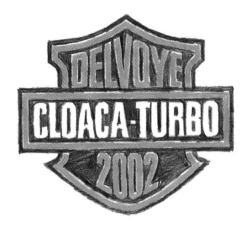

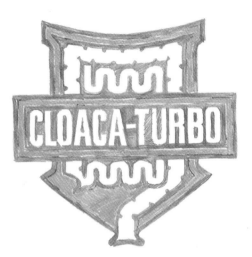

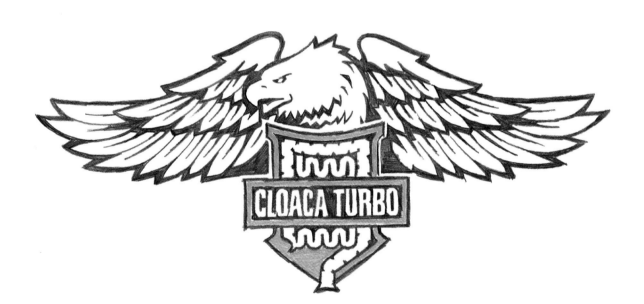

2002, 65 X 50 CM (29 5/8 X 19 5/8 INCHES), PENCIL, COLOUR PENCIL, WATERCOLOUR, MARKER & COLLAGE ON PAPER
(PRIVATE COLLECTION, BELGIUM)

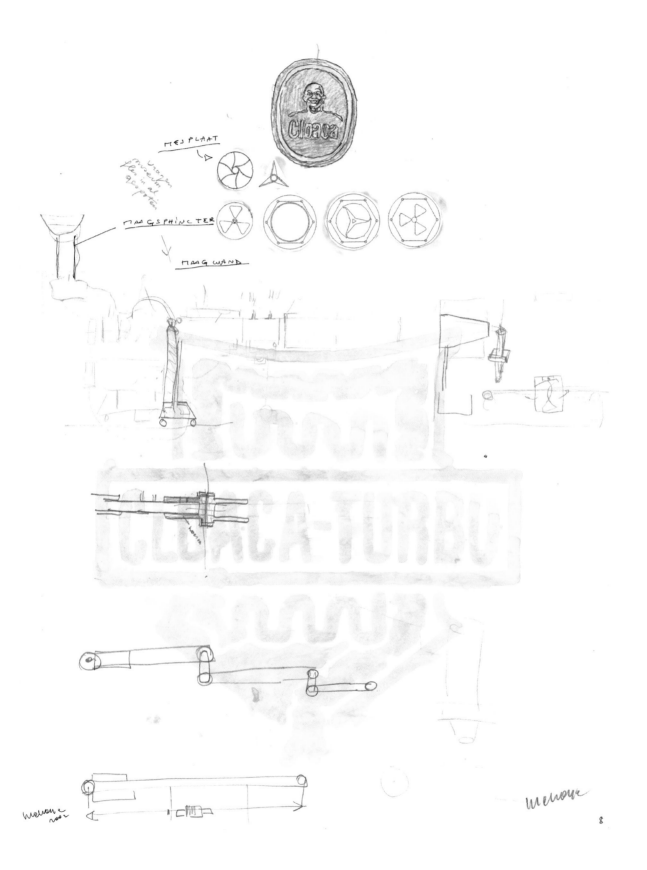

2002, 65 X 50 CM (29 5/8 X 19 5/8 INCHES), PENCIL & COLOUR PENCIL ON PAPER
(PRIVATE COLLECTION, BELGIUM)

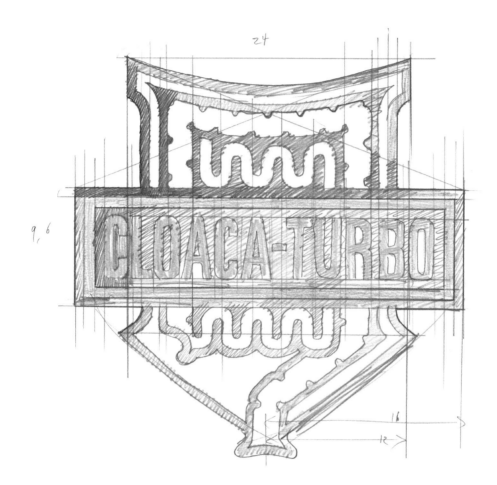

2002, 65 X 50 CM (29 5/8 X 19 5/8 INCHES), PENCIL, MARKER & STAMP INK ON PAPER
(PRIVATE COLLECTION, BELGIUM)

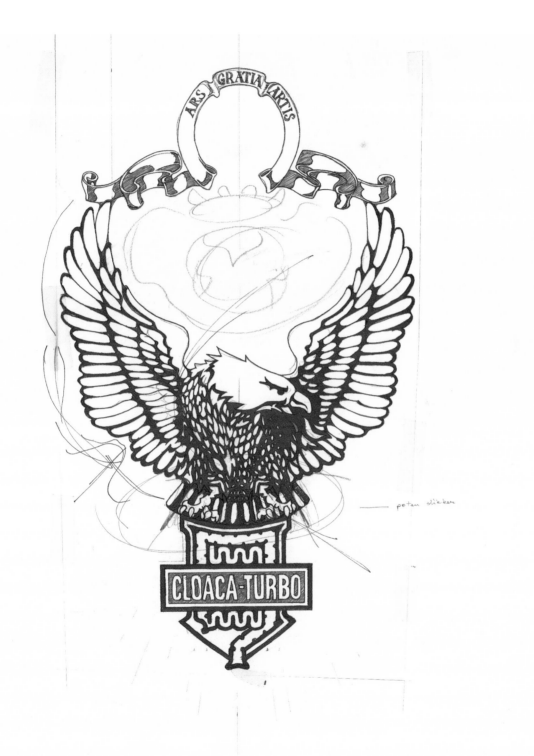

2002, 65 X 50 CM (29 5/8 X 19 5/8 INCHES), PENCIL, MARKER & STAMP INK ON PAPER

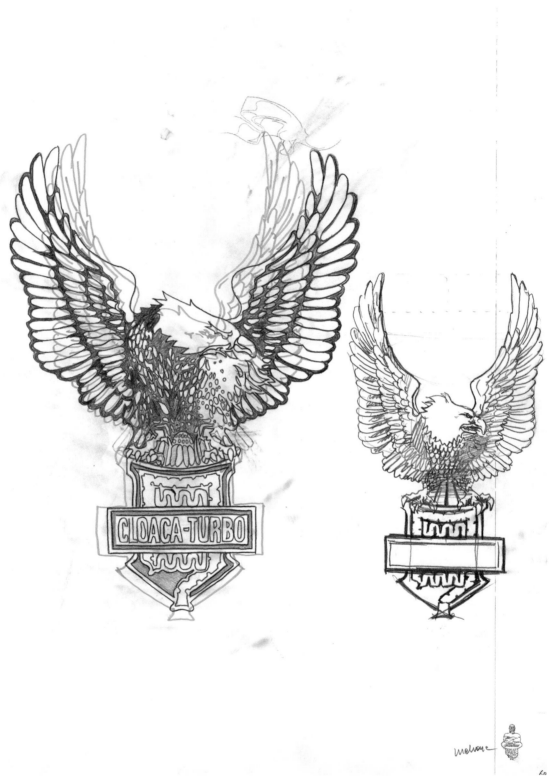

2002, 50 X 65 CM (19 5/8 X 29 5/8 INCHES), PENCIL & MARKER ON PAPER

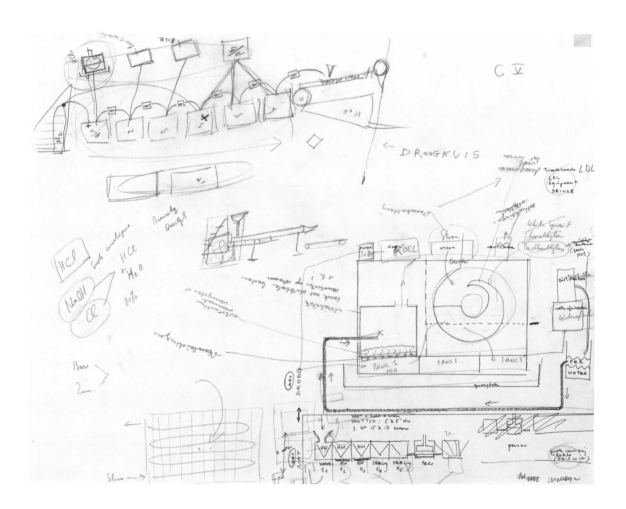

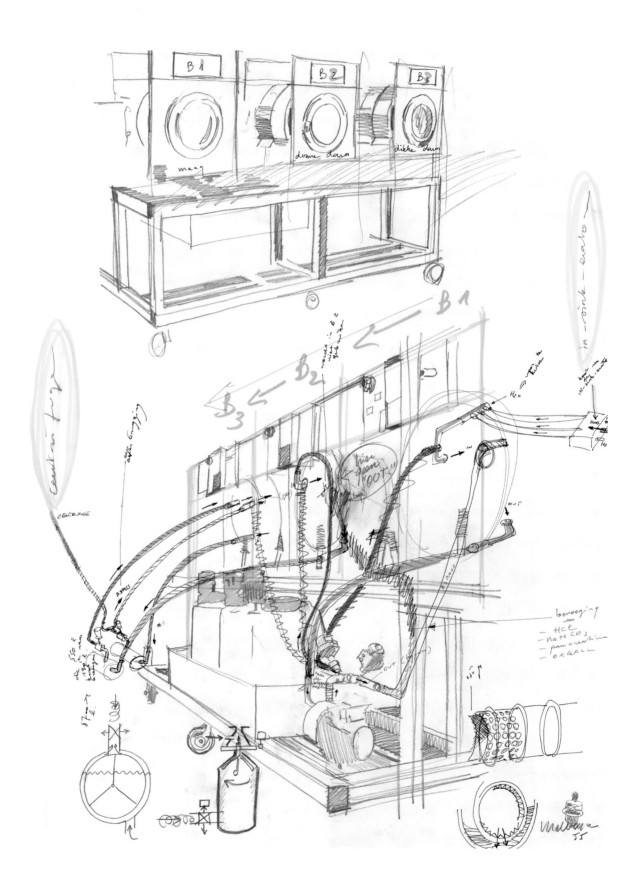

2002, 75 X 50 CM (29 1/2 X 19 5/8 INCHES), PENCIL & MARKER ON PAPER

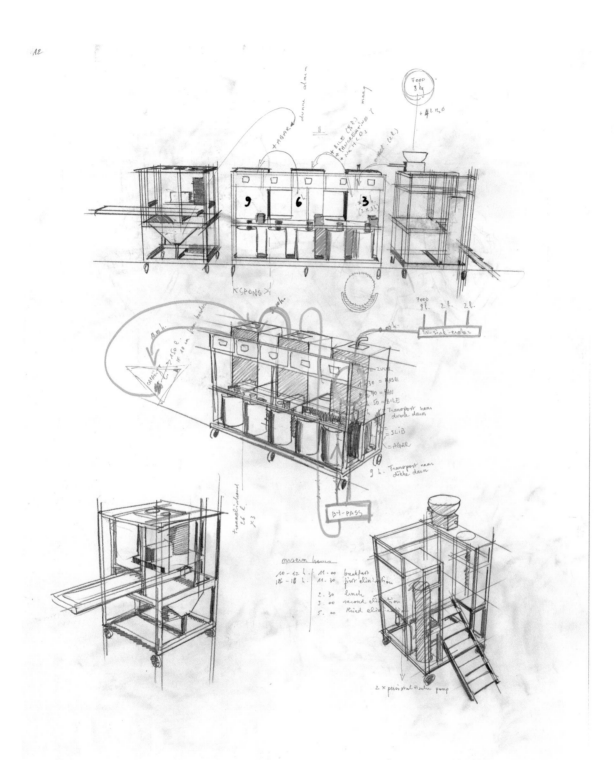

2002, 75.5 X 55.5 CM (29 3/4 X 21 7/8 INCHES), PENCIL & MARKER ON PAPER
(PRIVATE COLLECTION, BELGIUM)

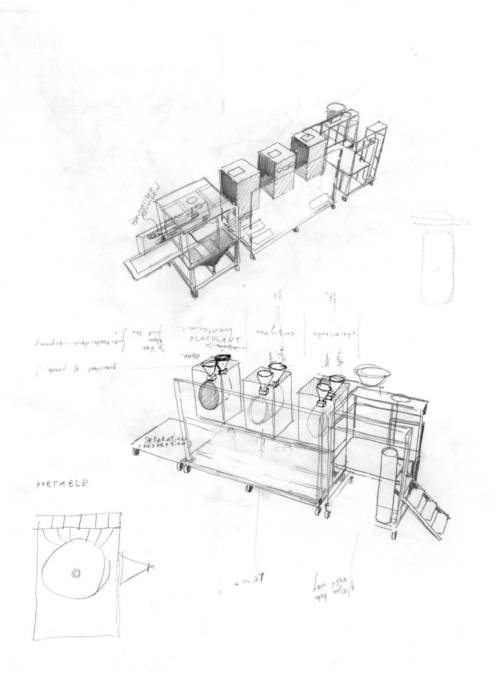

2002, 75.5 X 55.5 CM (29 3/4 X 21 7/8 INCHES), PENCIL, MARKER & COLLAGE ON PAPER
(PRIVATE COLLECTION, BELGIUM)

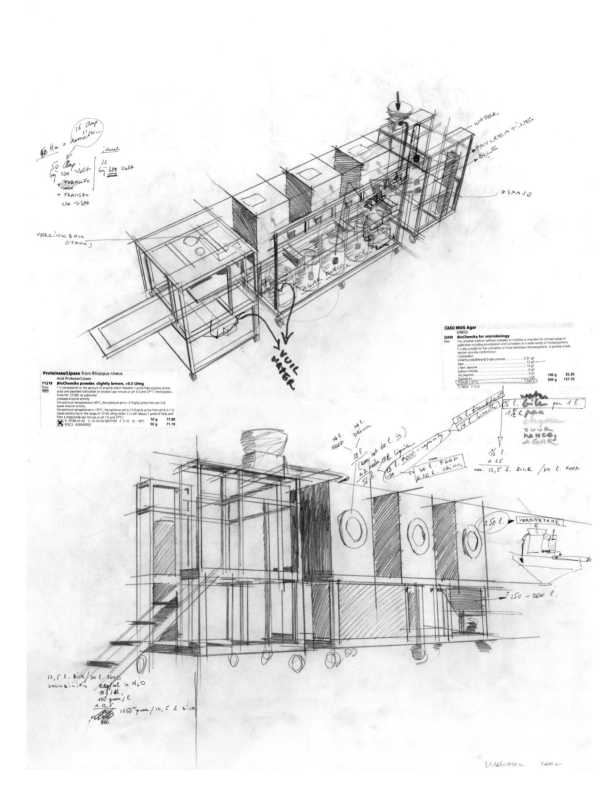

2002, 23.5 X 46 CM (9 1/4 X 18 1/8 INCHES), PENCIL, COLOUR PENCIL, MARKER, COLLAGE & STAMP INK ON PAPER (PRIVATE COLLECTION, BELGIUM)

Meick - System

meelsoffen

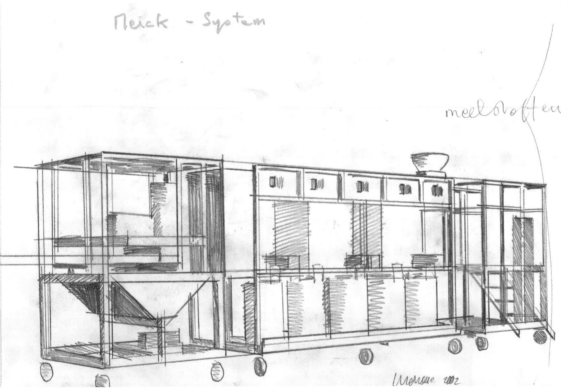

Meese 2002

631. Amylase. Enzymes catalyzing the hydrolysis of α-1→4 glucosidic linkages of polysaccharides such as starch, glycogen, or their degradation products. *Endoamylases* attack the α-1→4 linkage at random. A single type of endoamylase is known, i.e., α-amylases (α-1,4-glucan 4-glucano-hydrolases), so named, because the reducing hemiacetal group liberated by the hydrolysis has α optical configuration and mutarotates downward. The more common α-amylases include those isolated from human saliva, human, hog and rat pancreas, *Bacillus subtilis*, *B. coagulans*, *Aspergillus oryzae* (*Taka-amylase*), *A. candidus*, *Pseudomonas saccharophila*, and barley malt. *Exoamylases* attack the α-1→4 linkages only from the non-reducing outer polysaccharide chain ends. Those breaking every glucosidic bond to produce solely α-glucose are known as *glucoamylases* (γ-*amylases*). Those breaking every alternate bond to produce maltose are known as β-amylases (α-1,4-glucan maltohydrolases). Exoamylases are exclusively of vegetable or microbial origin. *Reviews:* Fischer, Stein, "α-Amylases" and French, "β-Amylases", in *The Enzymes*, Vol. 4, P. D. Boyer et al., Eds., (Academic Press, New York, 2nd ed., 1960) pp 313-343, 345-368; J. A. Thoma et al., ibid. Vol. V (3rd ed., 1971) pp 115-189; W. M. Fogarty, C. T. Kelly, *Microbial Enzymes and Bioconversions*, A. H. Rose, Ed. (Academic Press, New York, 1980) pp 115-170.
USE: In starch processing, brewing, distilling, baking, animal feed, sewage treatment.

632. α-Amylase (Bacterial). Agrozyme; Amylo-Liquifase; Biolase; Diasmen; Grozyme; Rapidase; Superclastase. Usually prepd using *Bacillus subtilis, e.g.*, by submerged fermentation of wheat bran and peanut meal medium by a strain of *B. subtilis*: Babbar et al., *Biochim. Biophys. Acta* 65, 347 (1962). Purification and crystallization of α-amylase: from *B. subtilis*, Stein, Fischer, *Helv. Chim. Acta* 40, 529 (1957), Babbar et al., loc. cit.; from *B. subtilis* or *B. mesentericus*, Meyer et al., *Experientia* 3, 411 (1947). Mol wt about 15,500 (from *B. subtilis*) about 48,700 (from *B. stearothermophilus*). *Reviews:* Fischer, Stein, "α-Amylases" in *The Enzymes* vol. 4, P. D. Boyer et al., Eds. (Academic Press, New York, 2nd ed., 1960) pp 313-343; M. Dixon, E. Webb, *Enzymes* (Academic Press, New York, 2nd ed., 1964). *See also Amylase.*
Needle-shaped crystals (from *B. subtilis*).

633. α-Amylase (Swine Pancreas). Amylopsin; Buclamase; Fortizyme; Maxilase. Mol wt about 45,000; Danielsson, *Nature* 160, 899 (1947). Prepn from hog pancreas and crystallization: Caldwell et al., *J. Am. Chem. Soc.* 74, 4033 (1952). *Review:* Fischer, Stein, "α-Amylases" in *The Enzymes*, vol. 4, P. D. Boyer et al., Eds. (Academic Press, New York, 2nd ed., 1960) pp 313-343; M. Dixon, E. Webb, *Enzymes* (Academic Press, New York, 2nd ed., 1964). *See also Amylase.*
Crystals. Ultraviolet absorption spectra and other properties: Caldwell et al., loc. cit.
THERAP CAT: Enzyme (digestive aid; anti-inflammatory).

634. β-Amylase (Sweet Potato). Mol wt about 152,000. Prepn of crystalline material from sweet potatoes: Balls et al., *J. Biol. Chem.* 173, 9 (1948). Review: French, "β-Amylases" in *The Enzymes* vol 4, P. D. Boyer et al., Eds. (Academic Press, New York, 2nd ed., 1960) pp 345-368; M. Dixon, E. Webb, *Enzymes* (Academic Press, New York, 2nd ed., 1964).

2002, 75.5 X 55.5 CM (29 3/4 X 21 7/8 INCHES), PENCIL & MARKER ON PAPER
(PRIVATE COLLECTION, BELGIUM)

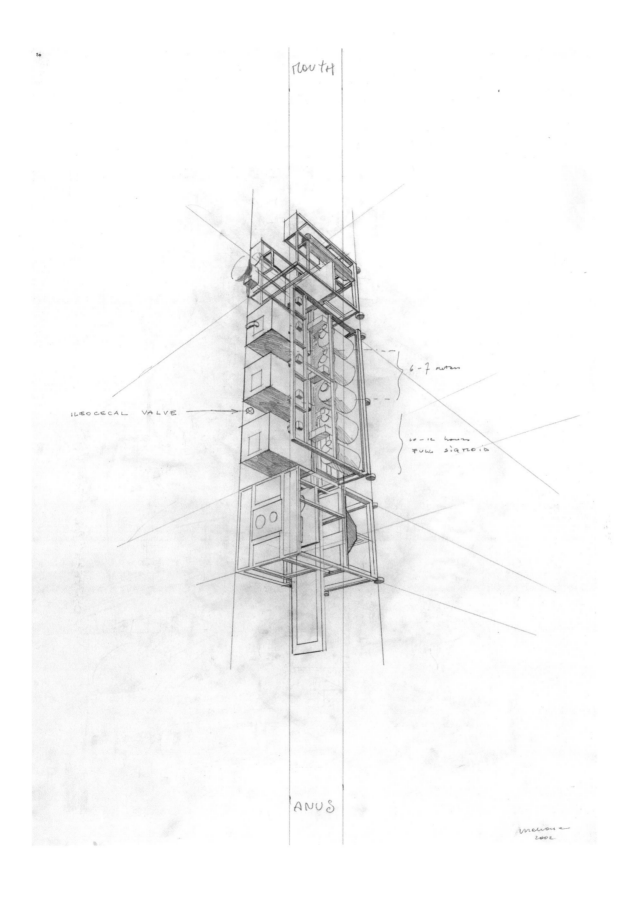

2002 – 2003, 75.5 X 55.5 CM (29 3/4 X 21 7/8 INCHES), PENCIL, COLLAGE & MARKER ON PAPER
(PRIVATE COLLECTION, BELGIUM)

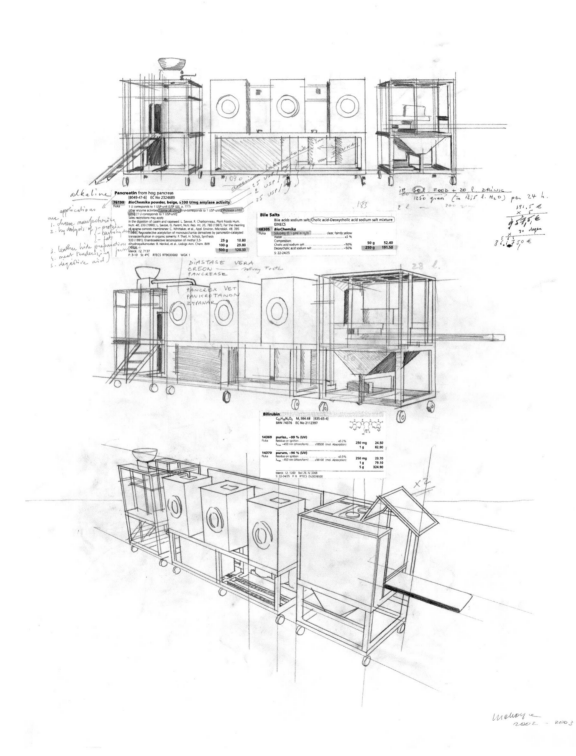

2003, 75.5 X 55.5 CM (29 3/4 X 21 7/8 INCHES), PENCIL & MARKER ON PAPER
(PRIVATE COLLECTION, BELGIUM)

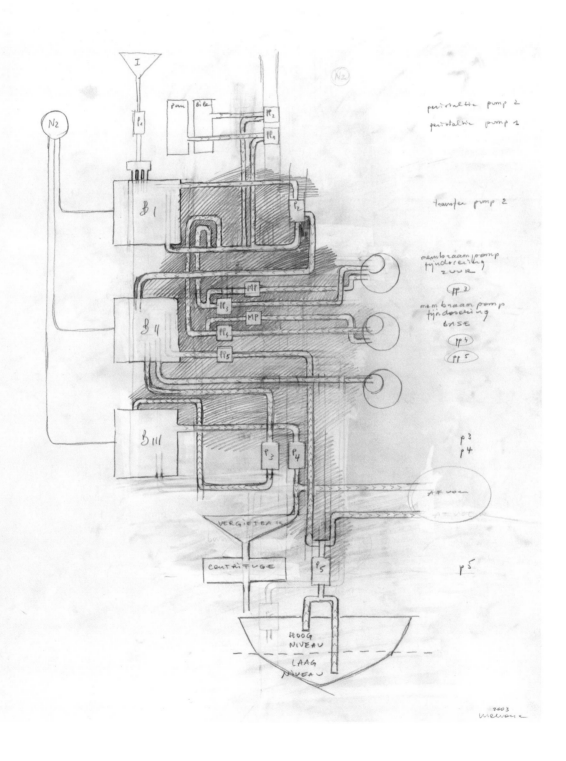

2003, 75.5 X 55.5 CM (29 3/4 X 21 7/8 INCHES), PENCIL, COLOUR PENCIL & MARKER ON PAPER

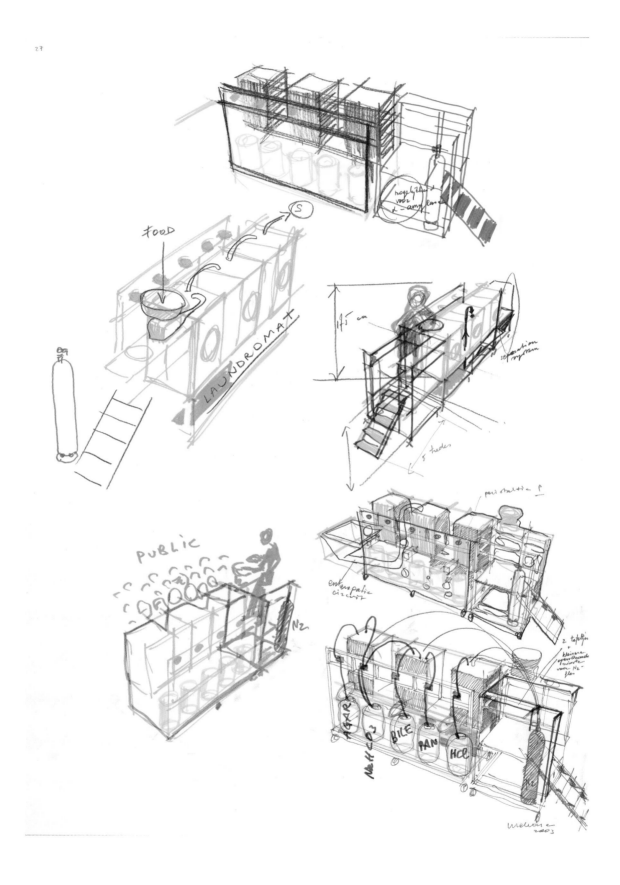

2003, 75.5 X 55.5 CM (29 3/4 X 21 7/8 INCHES), PENCIL, COLOUR PENCIL, COLLAGE & MARKER ON PAPER
(PRIVATE COLLECTION, BELGIUM)

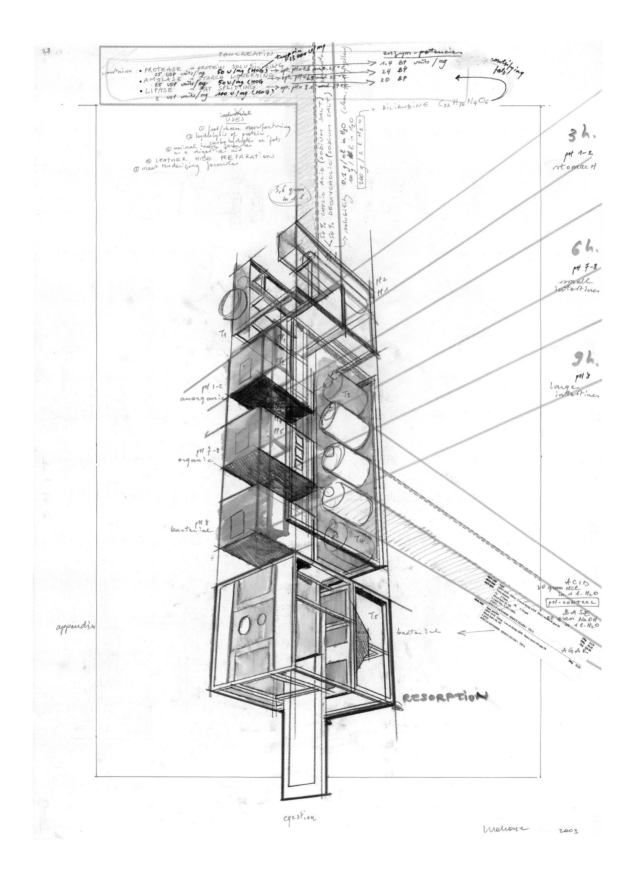

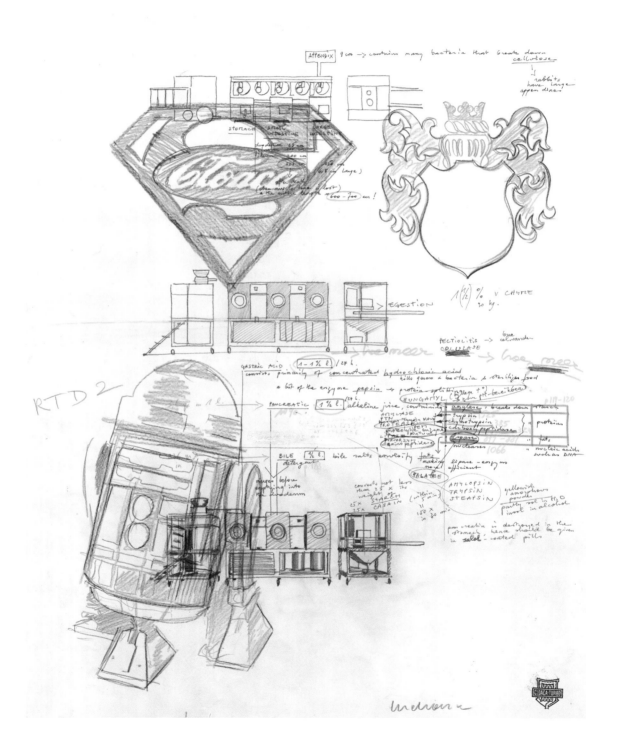

2003, 65 X 50 CM (29 5/8 X 19 5/8 INCHES), PENCIL, MARKER, COLLAGE & STAMP INK ON PAPER
(PRIVATE COLLECTION, FRANCE)

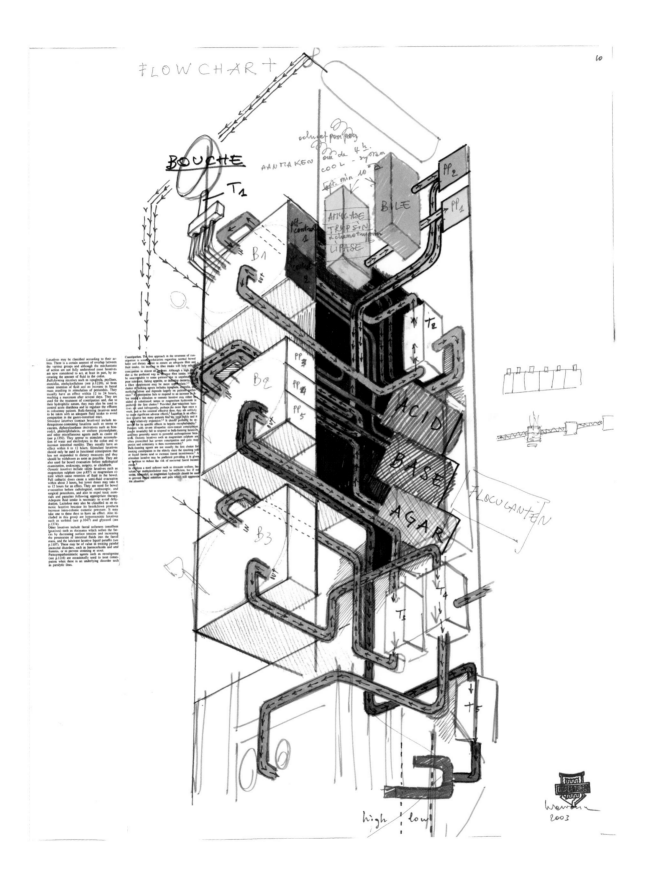

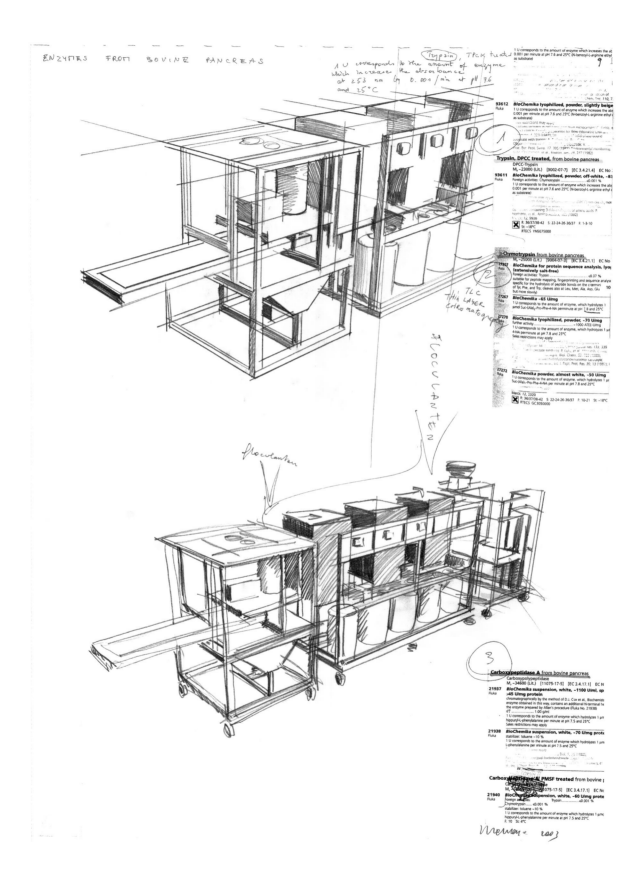

ENZYMES FROM BOVINE PANCREAS

2000 - 2003, 72.5 X 106.5 CM (28 1/2 X 41 7/8 INCHES), PENCIL, COLOUR PENCIL & STAMP INK ON PAPER
(PRIVATE COLLECTION, FRANCE)

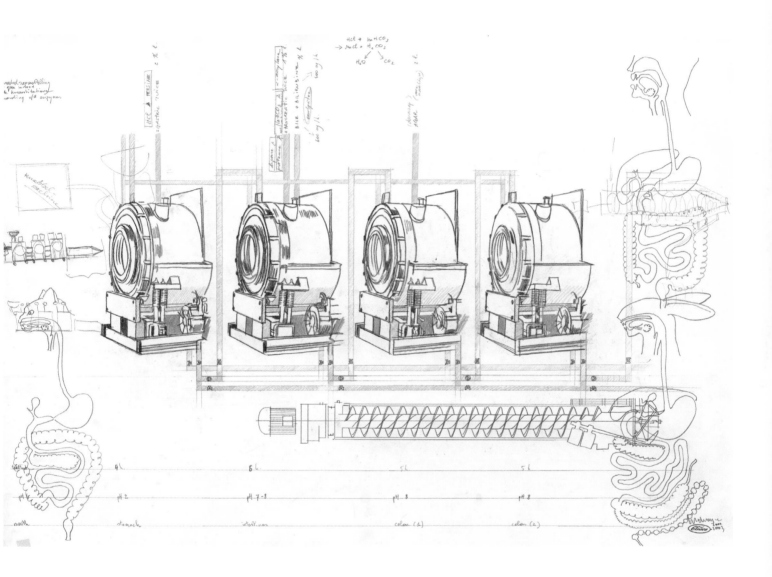

2003, 65 X 50 CM (29 5/8 X 19 5/8 INCHES), PENCIL, COLOUR PENCIL, COLLAGE, MARKER & STAMP INK ON PAPER
(PRIVATE COLLECTION, FRANCE)

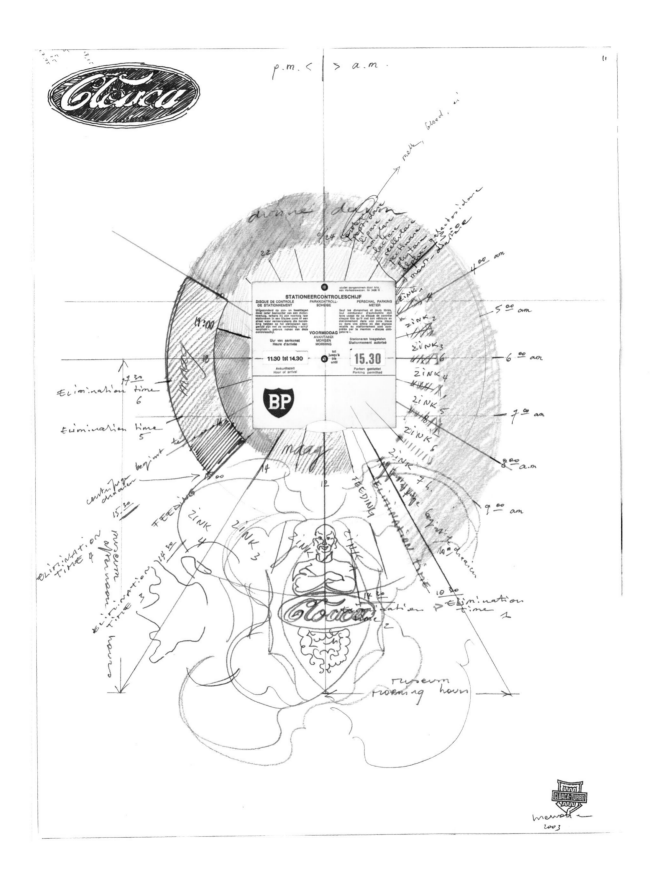

2003, 55 X 75 CM (21 5/8 X 29 1/2 INCHES), PENCIL, COLOUR PENCIL, MARKER & STAMP INK ON PAPER

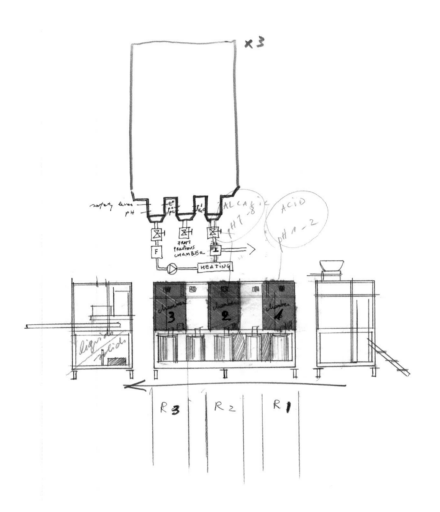

2004, 56.5 X 88.5 CM (22 1/4 X 34 7/8 INCHES), PENCIL, COLOUR PENCIL & MARKER ON PAPER

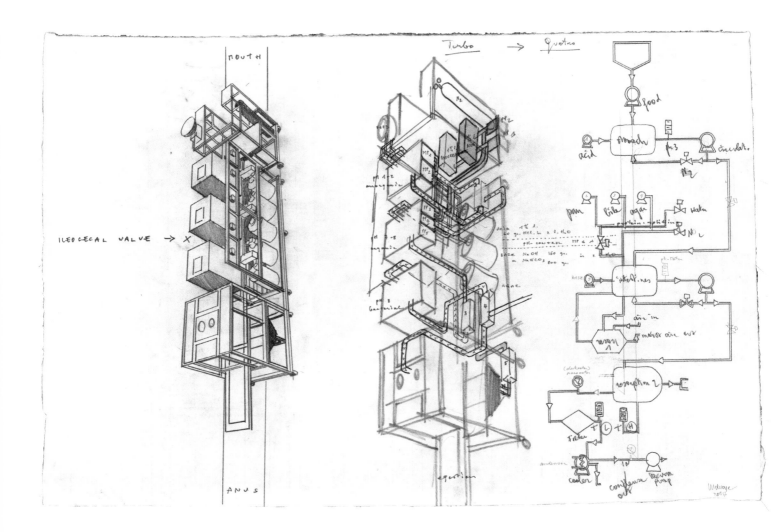

2004, 51 X 73 CM (20 X 28 3/4 INCHES), PENCIL, COLOUR PENCIL & STAMP INK ON PAPER

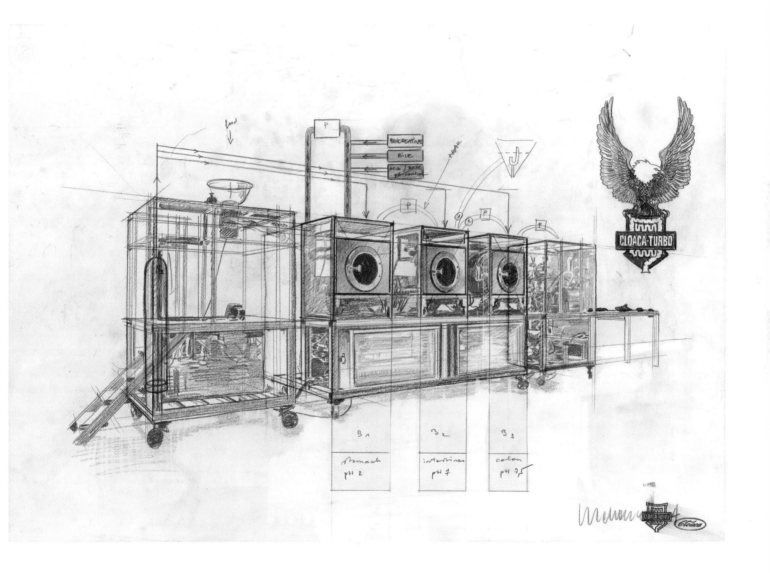

Studies for Cloaca Gates

2003-2006

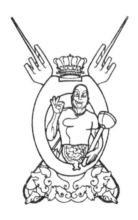

2003 – 2004, 75.5 X 55.5 CM (29 3/4 X 21 7/8 INCHES), PENCIL & COLOUR PENCIL ON PAPER
(COLLECTION LINDA & GUY PIETERS, BELGIUM)

The gates

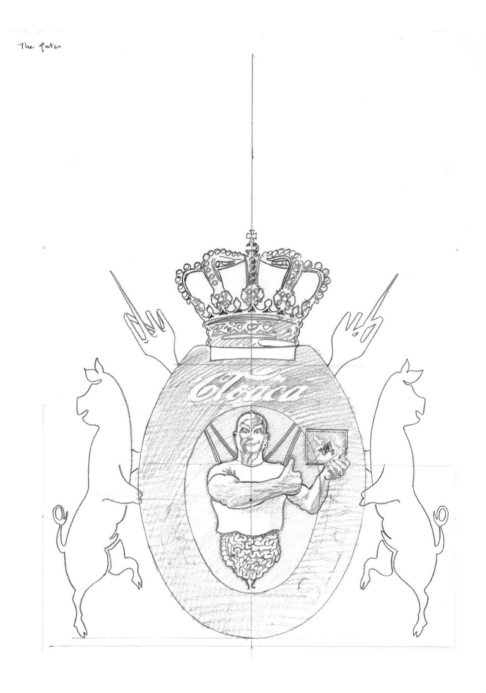

2004, 75.5 X 55.5 CM (29 3/4 X 21 7/8 INCHES), PENCIL & COLOUR PENCIL ON PAPER
(COLLECTION LINDA & GUY PIETERS, BELGIUM)

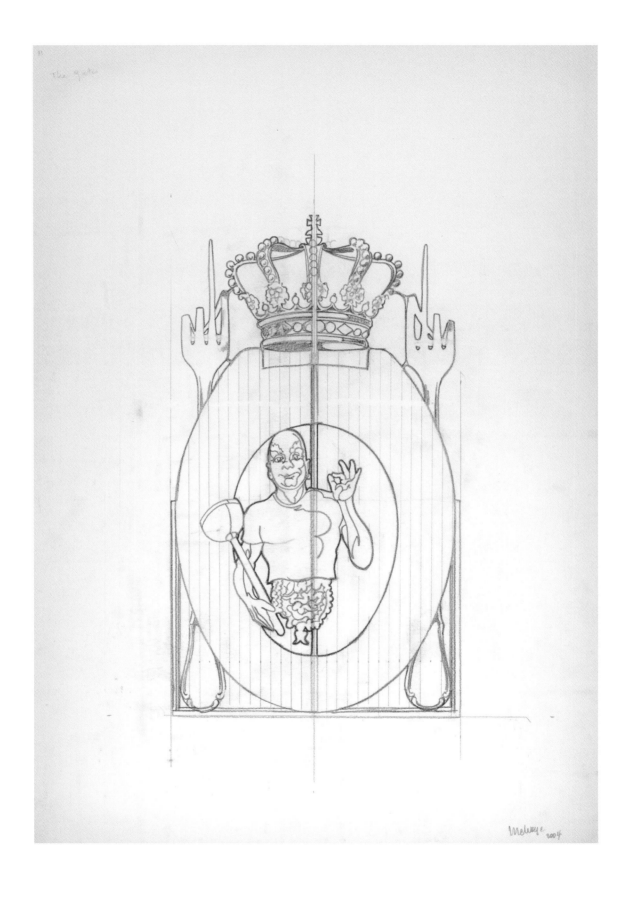

2004, 75.5 X 55.5 CM (29 3/4 X 21 7/8 INCHES), PENCIL & COLOUR PENCIL ON PAPER
(COLLECTION LINDA & GUY PIETERS, BELGIUM)

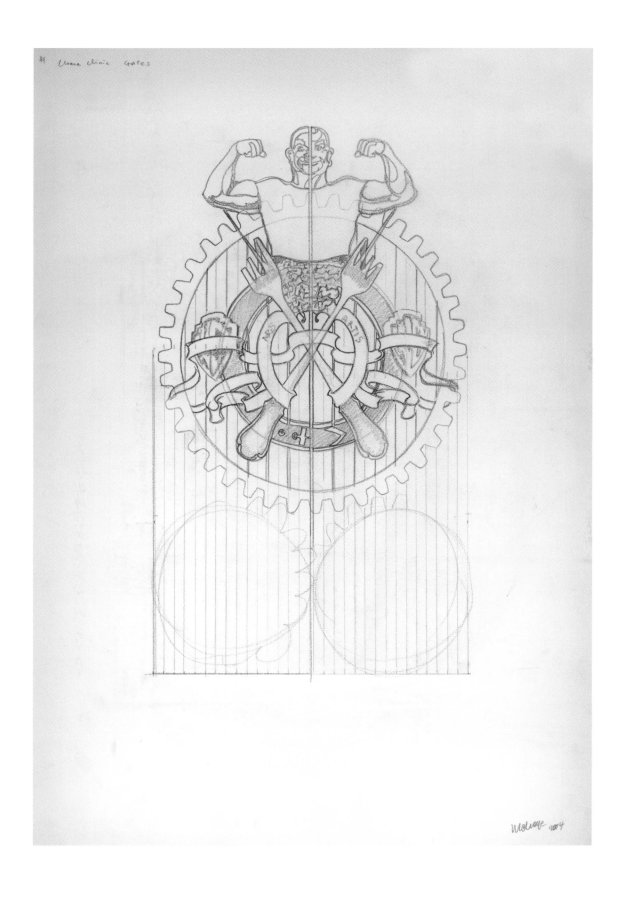

2004, 75.5 X 55.5 CM (29 3/4 X 21 7/8 INCHES), PENCIL & COLOUR PENCIL ON PAPER
(COLLECTION LINDA & GUY PIETERS, BELGIUM)

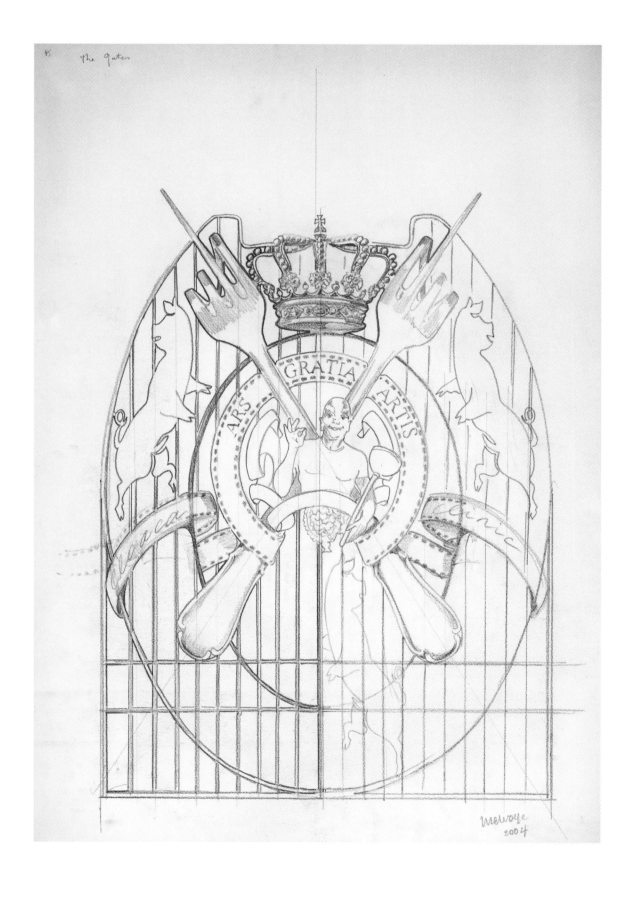

2004, 75.5 X 55.5 CM (29 3/4 X 21 7/8 INCHES), PENCIL & COLOUR PENCIL ON PAPER
(COLLECTION LINDA & GUY PIETERS, BELGIUM)

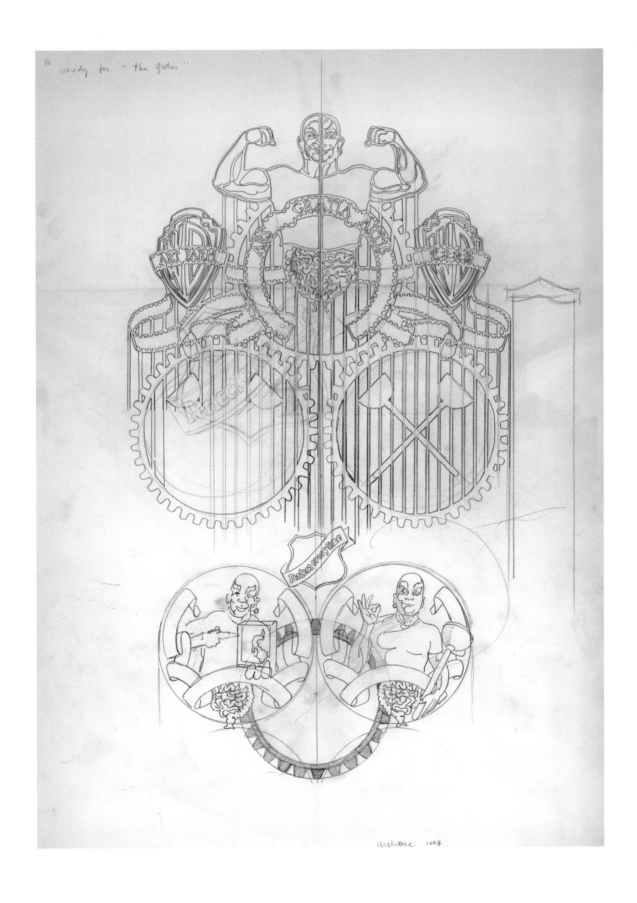

2004, 75.5 X 55.5 CM (29 3/4 X 21 7/8 INCHES), PENCIL & COLOUR PENCIL ON PAPER
(COLLECTION LINDA & GUY PIETERS, BELGIUM)

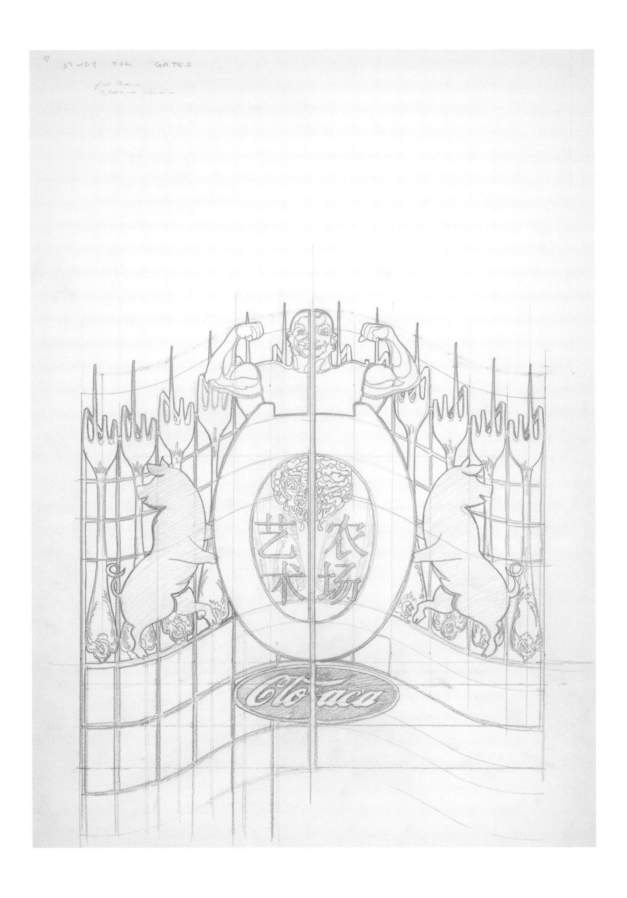

2004, 75.5 X 55.5 CM (29 3/4 X 21 7/8 INCHES), PENCIL & COLOUR PENCIL ON PAPER
(COLLECTION LINDA & GUY PIETERS, BELGIUM)

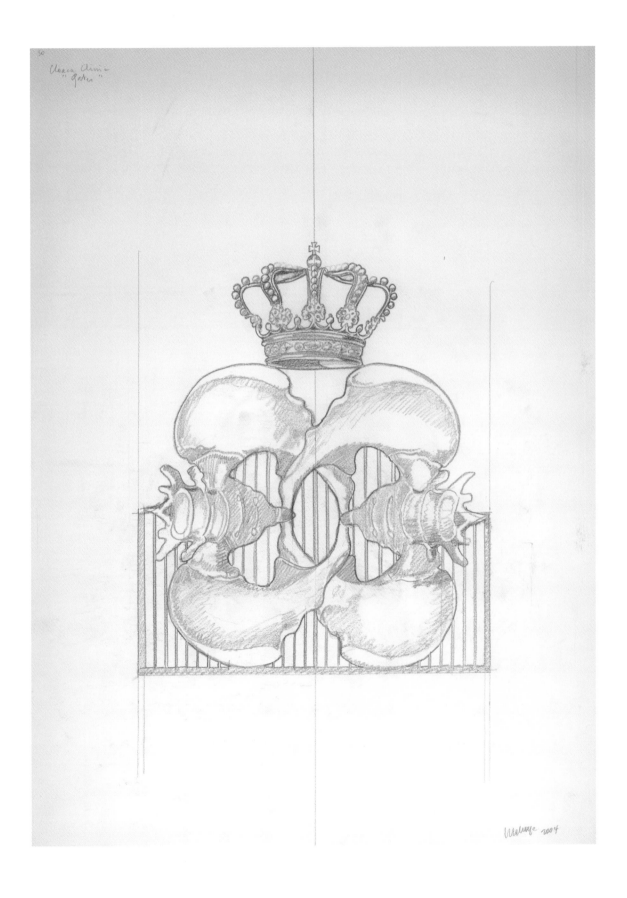

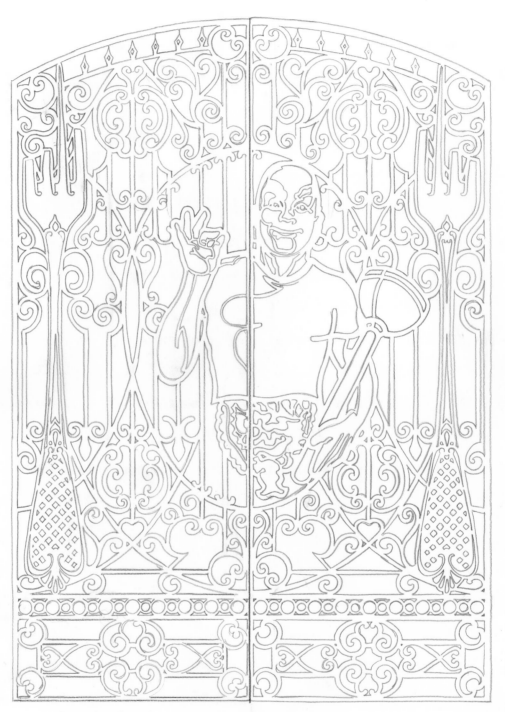

DVOR fo. GATES
CLOACA CLINIC 2004

2004 – 2005, 31 X 45 CM (12 1/4 X 17 3/4 INCHES) , COLOUR PENCIL & MARKER ON PAPER
(PRIVATE COLLECTION, BELGIUM)

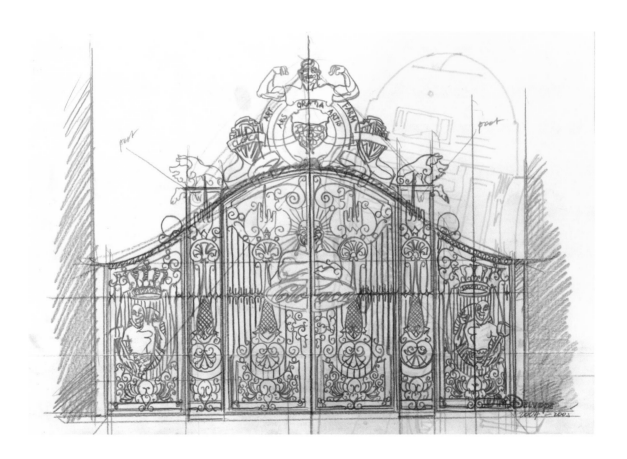

2004 – 2005, 62 X 45 CM (24 3/8 X 17 3/4 INCHES), PENCIL & COLOUR PENCIL ON PAPER
(COLLECTION LINDA & GUY PIETERS, BELGIUM)

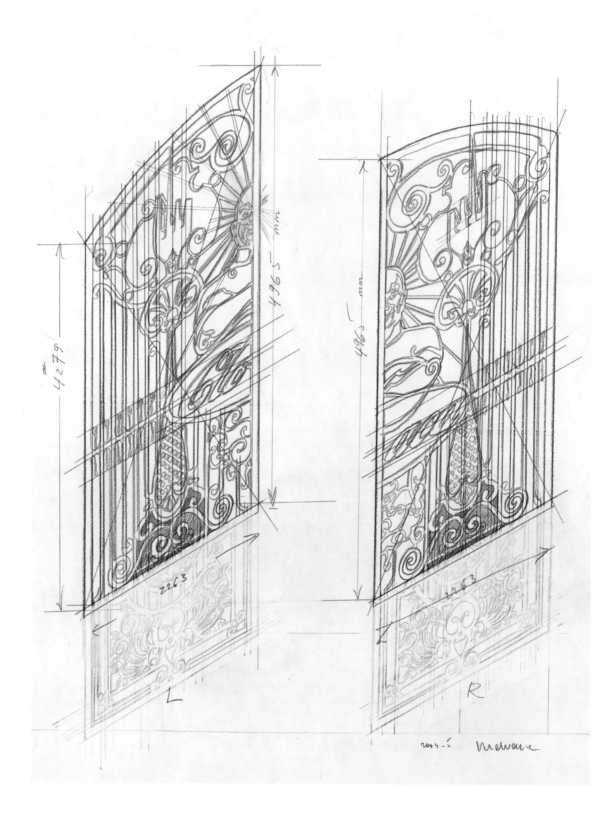

2004 – 2005, 45 X 62 CM (17 3/4 X 24 3/8 INCHES), PENCIL & WATERCOLOUR ON PAPER
(PRIVATE COLLECTION, BELGIUM)

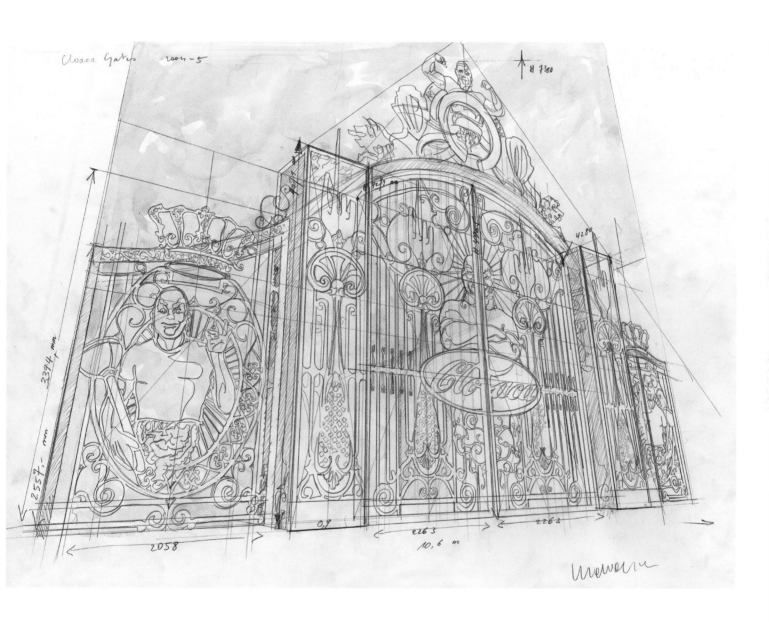

2005, 62 X 45 CM (24 3/8 X 17 3/4 INCHES), PENCIL, COLOUR PENCIL & STAMP INK ON PAPER
(COLLECTION LINDA & GUY PIETERS, BELGIUM)

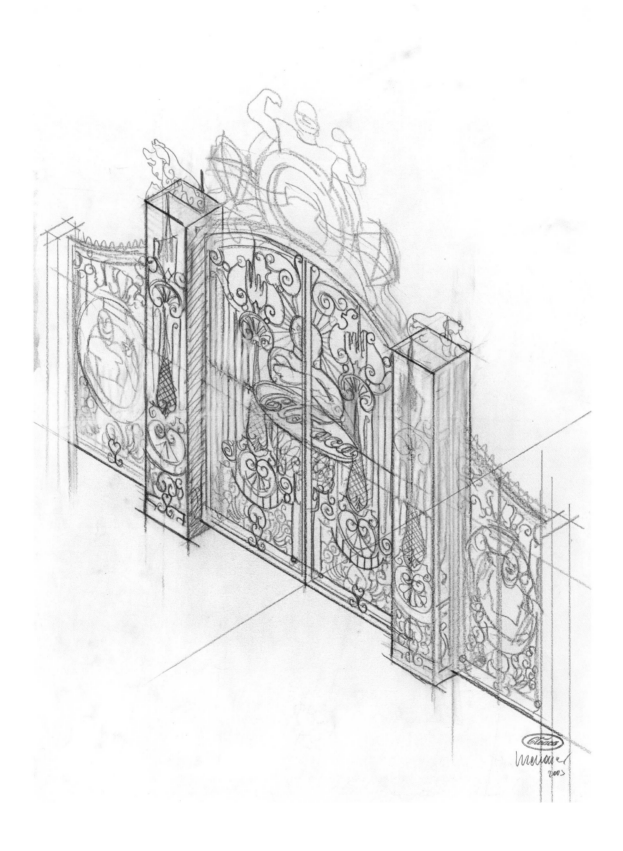

2005, 62 X 45 CM (24 3/8 X 17 3/4 INCHES), PENCIL & STAMP INK ON PAPER
(COLLECTION LINDA & GUY PIETERS, BELGIUM)

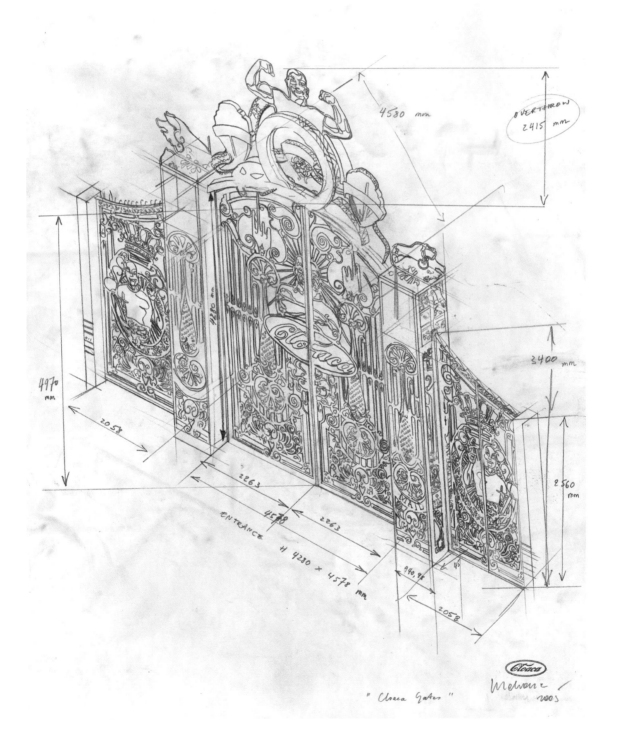

" Cloaca Gates "

2005, 62 X 45 CM (24 3/8 X 17 3/4 INCHES), PENCIL, COLOUR PENCIL, WATERCOLOUR & STAMP INK ON PAPER
(COLLECTION LINDA & GUY PIETERS, BELGIUM)

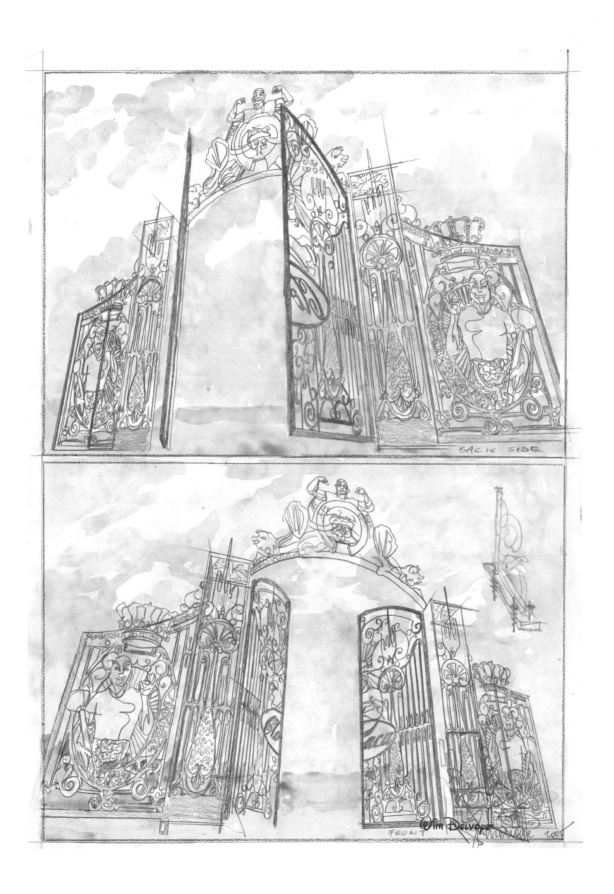

2005, 46 X 23.5 CM (18 1/8 X 9 1/4 INCHES), PENCIL, COLOUR PENCIL, MARKER & STAMP INK ON PAPER

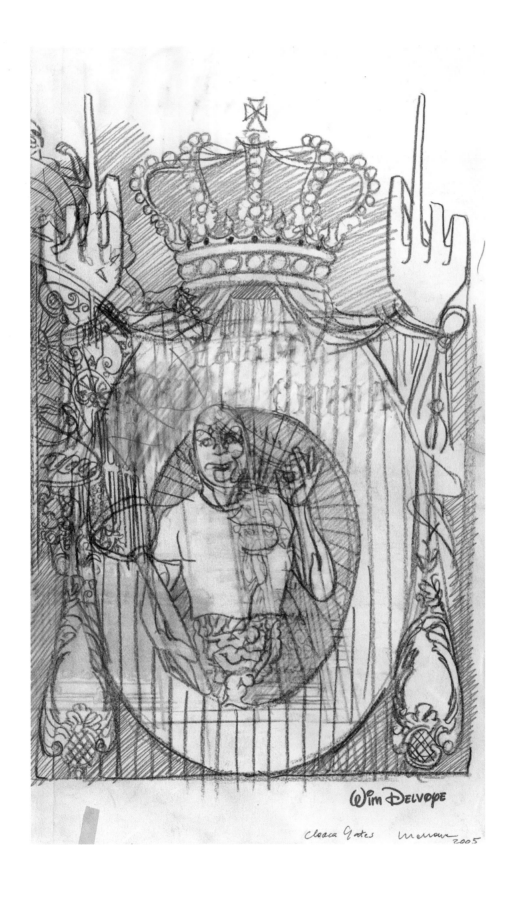

2005, 54.5 X 31 CM (21 ¹/₂ X 12 ¹/₄ INCHES), PENCIL, COLOUR PENCIL & STAMP INK ON PAPER

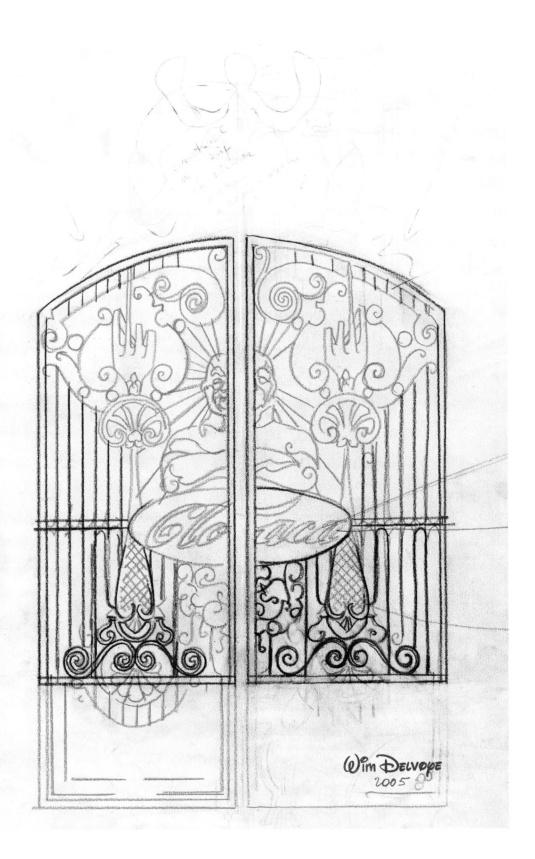

2005, 45 X 62 CM (17 3/4 X 24 3/8 INCHES), PENCIL, COLOUR PENCIL & STAMP INK ON PAPER
(COLLECTION LINDA & GUY PIETERS, BELGIUM)

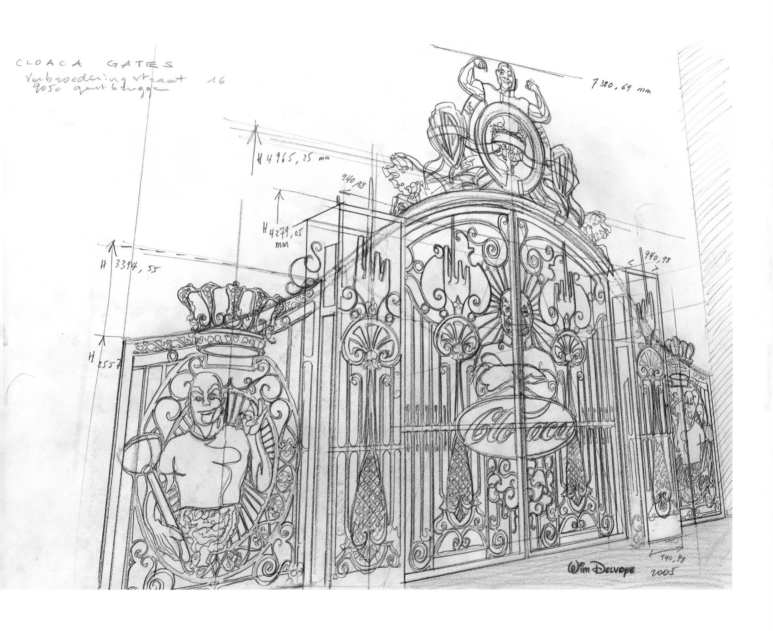

2005, 45 X 62 CM (17 3/4 X 24 3/8 INCHES), PENCIL, COLOUR PENCIL & STAMP INK ON PAPER
(COLLECTION LINDA & GUY PIETERS, BELGIUM)

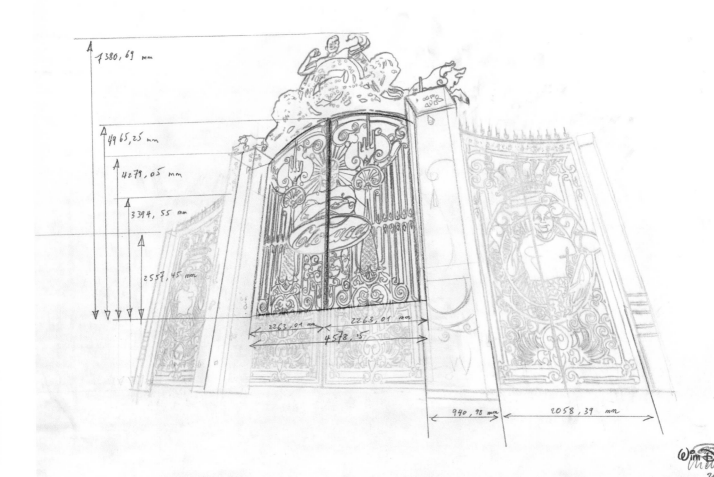

2005, 62 X 45 CM (24 3/8 X 17 3/4 INCHES), PENCIL, COLOUR PENCIL & STAMP INK ON PAPER
(COLLECTION LINDA & GUY PIETERS, BELGIUM)

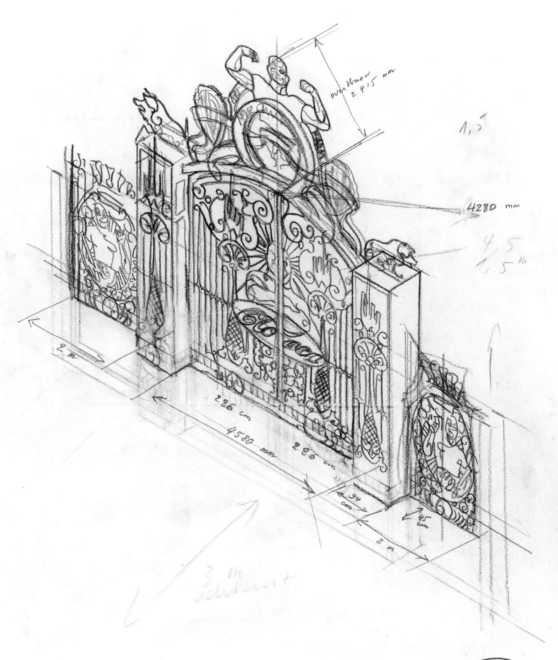

2005, 45 X 62 CM (17 3/4 X 24 3/8 INCHES), PENCIL, COLOUR PENCIL & STAMP INK ON PAPER
(COLLECTION LINDA & GUY PIETERS, BELGIUM)

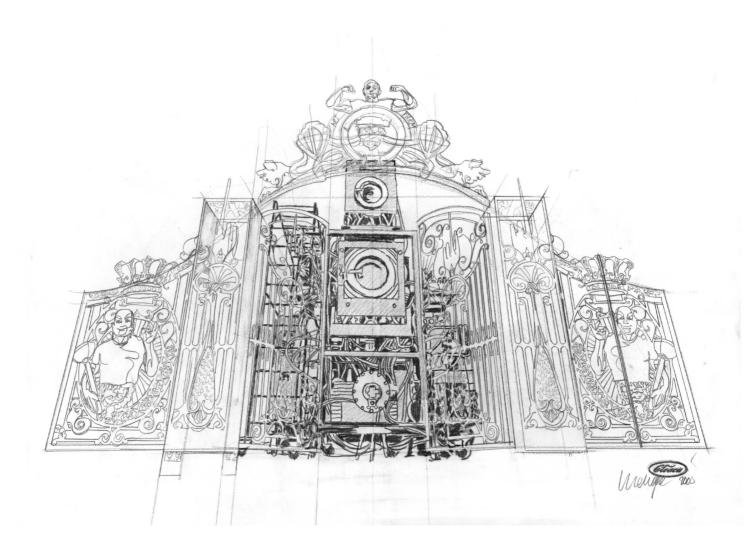

2006, 45 X 62 CM (17 3/4 X 24 3/8 INCHES), PENCIL, COLOUR PENCIL & STAMP INK ON PAPER
(PRIVATE COLLECTION, BELGIUM)

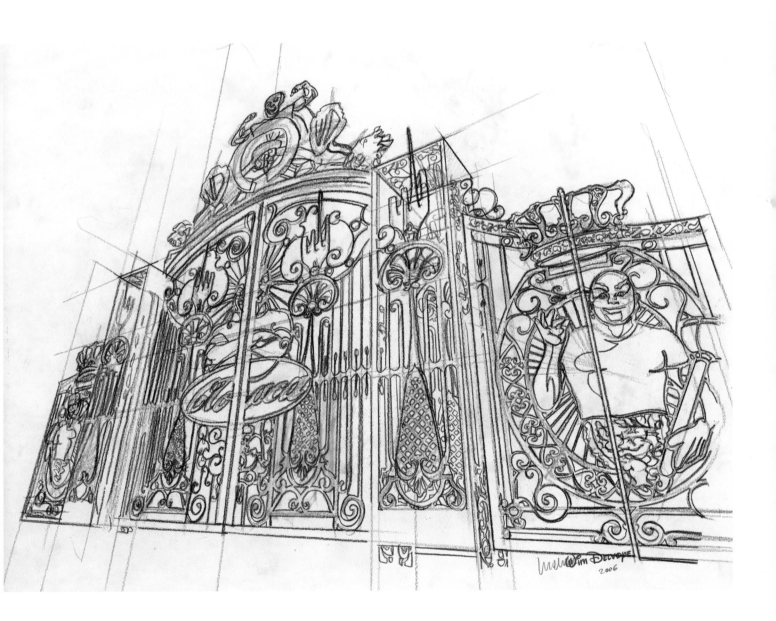

2006, 70.5 X 50 CM (27 3/4 X 19 5/8 INCHES), PENCIL, COLOUR PENCIL & STAMP INK ON PAPER
(COLLECTION LINDA & GUY PIETERS, BELGIUM)

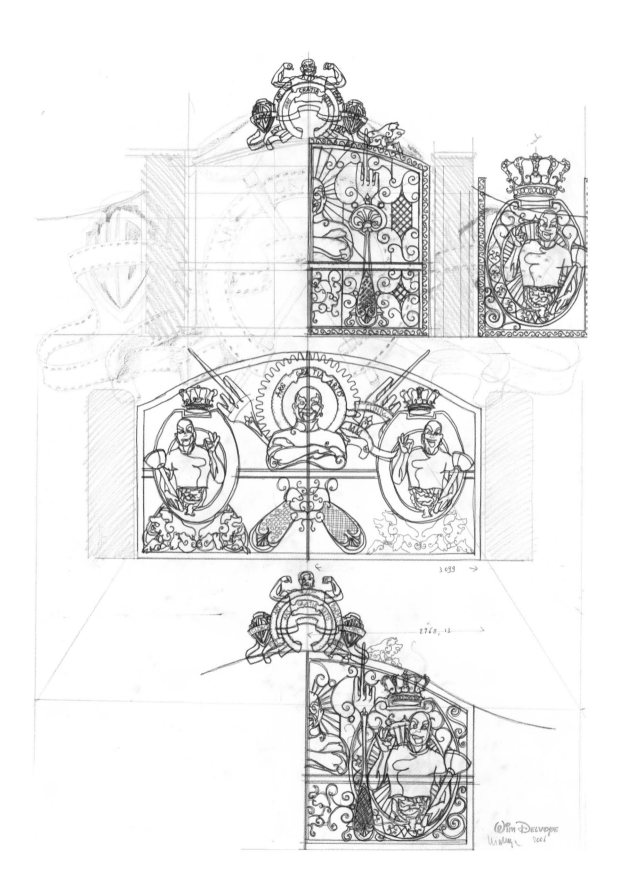

2006, 70.5 X 50 CM (27 3/4 X 19 5/8 INCHES), PENCIL, COLOUR PENCIL & STAMP INK ON PAPER
(COLLECTION LINDA & GUY PIETERS, BELGIUM)

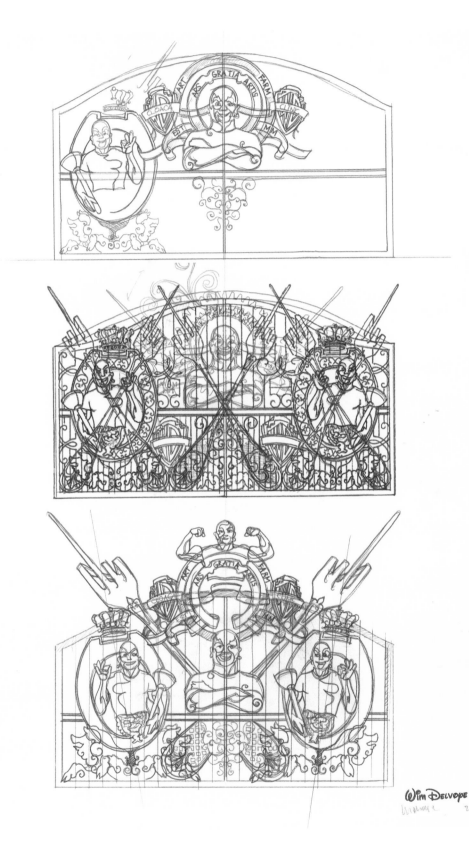

2006, 70.5 X 50 CM (27 3/4 X 19 5/8 INCHES), PENCIL, COLOUR PENCIL, TIPP-EX, MARKER & STAMP INK ON PAPER
(COLLECTION LINDA & GUY PIETERS, BELGIUM)

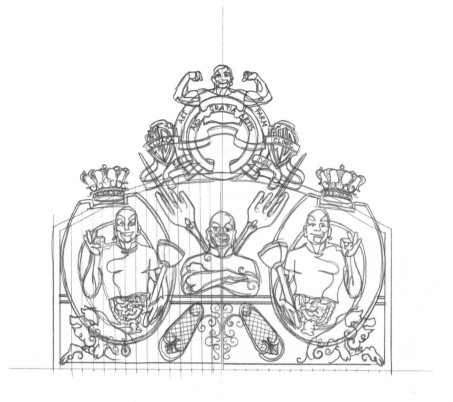

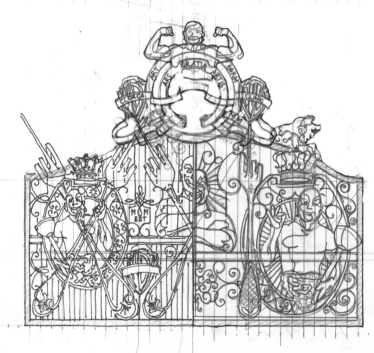

2006, 70.5 X 50 CM (27 3/4 X 19 5/8 INCHES), PENCIL, COLOUR PENCIL, MARKER & STAMP INK ON PAPER
(COLLECTION LINDA & GUY PIETERS, BELGIUM)

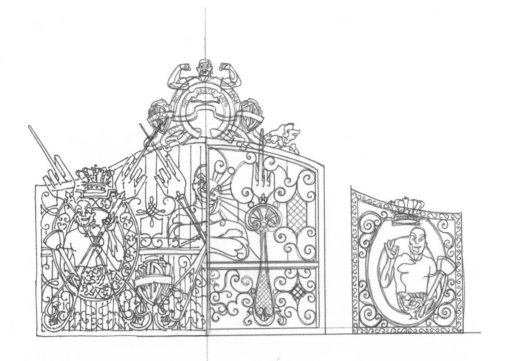

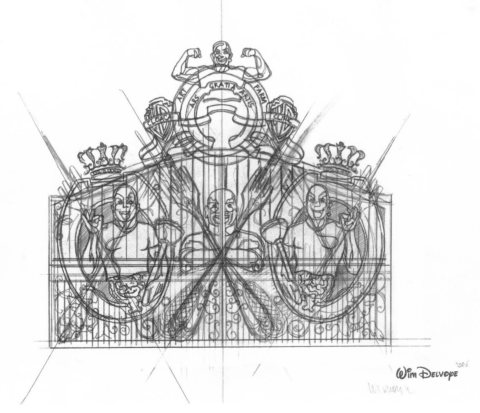

2006, 70 X 50 CM (27 ½ X 19 5/8 INCHES), PENCIL, COLOUR PENCIL, WATERCOLOUR, MARKER & STAMP INK ON PAPER
(COLLECTION LINDA & GUY PIETERS, BELGIUM)

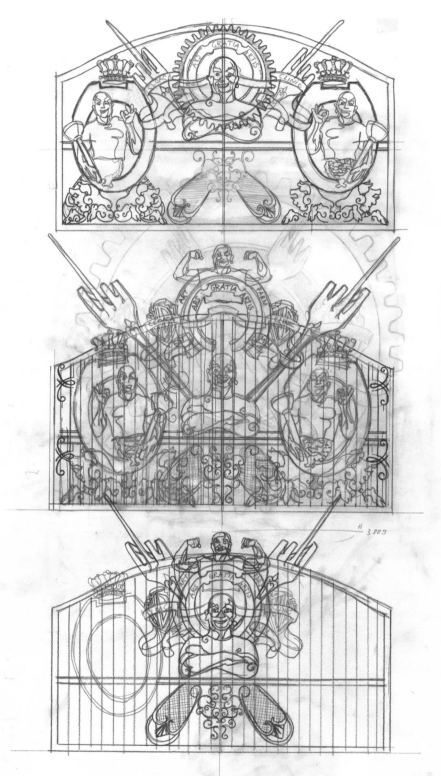

2006, 50 X 70 CM (19 5/8 X 27 ½ INCHES), PENCIL & COLOUR PENCIL ON PAPER.

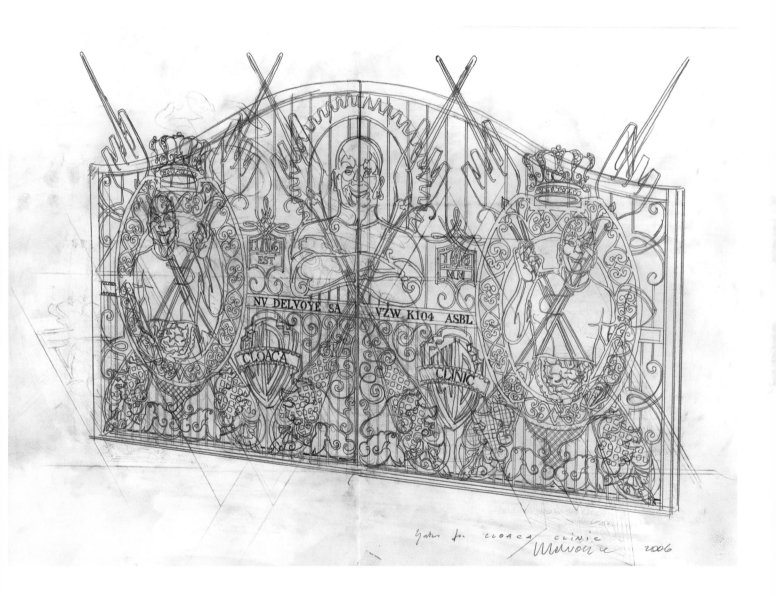

Cloaca
Exhibition List

Cloaca – Original (2000)

MuHKA, Antwerp (BE)	16.09.2000 – 31.12.2000
Eine Barocke Party, Kunsthalle Wien (AT)	12.06.2001 – 16.09.2001
Museum Kunst-Palast, Düsseldorf (DE)	02.02.2002 – 05.05.2002
Casino Luxembourg – Forum d'art contemporain, Luxemburg (LU)	29.09.2007 – 06.01.2008

Cloaca – New and Improved (2001)

Migros Museum, Zürich (CH)	25.08.2001 – 14.10.2001
New Museum, New York (US)	25.01.2002 – 28.04.2002
Musée d'Art Contemporain, Lyon (FR)	21.05.2003 – 10.08.2003
The Power Plant, Toronto (CA)	26.03.2004 – 23.05.2004
Casino Luxembourg – Forum d'art contemporain, Luxemburg (LU)	29.09.2007 – 06.01.2008

Cloaca – Turbo (2003)

C-Arte, Prato (IT)	31.10.2003 – 18.01.2004
Hors d'Oeuvres, CAPC Musée de Bordeaux (FR)	08.10.2004 – 13.02.2005
Casino Luxembourg – Forum d'art contemporain, Luxemburg (LU)	29.09.2007 – 06.01.2008

Cloaca – Quattro (2004)

Visionary Belgium, Bozar, Brussels (BE)	03.03.2005 – 15.05.2005
Xin Beijing Gallery, Beijing (CN)	12.05.2007 – 26.05.2007
Casino Luxembourg – Forum d'art contemporain, Luxemburg (LU)	29.09.2007 – 06.01.2008

Cloaca V (2006)

Museum of Fine Arts, Kaohsiung (TW)	01.06.2006 – 30.06.2006
Casino Luxembourg – Forum d'art contemporain, Luxemburg (LU)	29.09.2007 – 06.01.2008

Personal Cloaca (2006)
Super Cloaca (2007)

Casino Luxembourg – Forum d'art contemporain, Luxemburg (LU)	29.09.2007 – 06.01.2008